Drawing the Male Figure

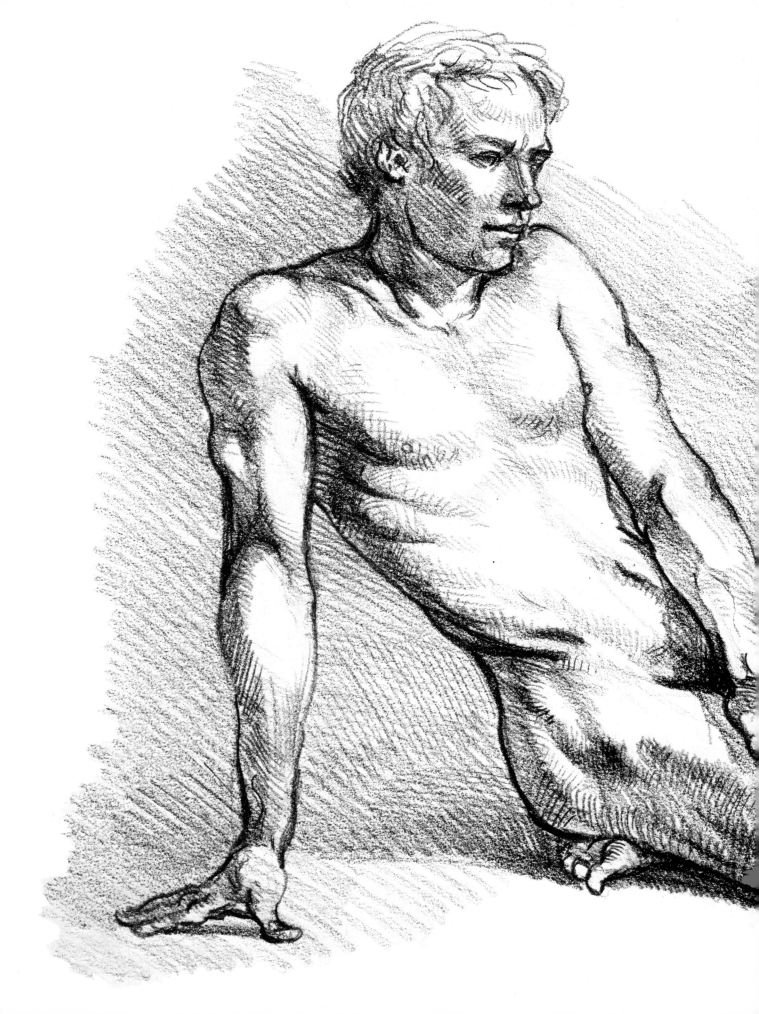

Drawing the Male Figure

by Joseph Sheppard

WATSON-GUPTILL PUBLICATIONS/NEW YORK

PITMAN PUBLISHING/LONDON

Copyright © 1976 by Watson-Guptill Publications

First published 1976 in the United States and Canada by Watson-Guptill Publications
a division of Billboard Publications, Inc.
1515 Broadway, New York, N.Y. 10036

Library of Congress Cataloging in Publication Data
Sheppard, Joseph, 1930–
 Drawing the male figure.
 Bibliography: p.
 1. Nude in art. 2. Men in art. 3. Drawing—
Instruction. I. Title.
NC765.S44 1976 743'.43 76-22733
ISBN 0-8230-1405-3

Published in Great Britain by Sir Isaac Pitman & Sons Ltd.
39 Parker Street, London WC2B 5PB
ISBN 0-273-00974-5

Manufactured in U.S.A.

First Printing, 1976

To my wife Marlene, and Firenze

CONTENTS

INTRODUCTION

Drawing the Male Figure is a natural sequel to my book *Drawing the Female Figure*. Because of the similarities in their anatomy it's necessary to repeat some of the information from my first book. At the same time, there are so many differences that the need for a separate book seems obvious.

I've put in as much information as I could, even at the risk of being redundant, feeling that there'd be readers owning only one of the books.

When you draw the human figure you draw something alive, and not a still life. I recommend drawing from the live model first using quick poses of one to three minutes, and then longer poses up to twenty minutes. If you try to draw the entire figure including hands and feet in the quick sketches, you will eventually find that twenty-minute poses will give you ample time in which to complete the whole figure. Very few of the drawings in this book took more time. Over-rendering can freeze the figure and make it look like a statue—dead.

It is extremely important to place a single source of light on the model. The Old Masters discovered that one light source, preferably high and slightly to the front and side, gives the best light for creating depth and form.

An understanding of anatomy and proportion is a must. You will soon discover that you draw and see only what you already know. In my teaching I find that when a student first starts drawing from the model, he only sees outline. After the shadows are pointed out to him, he tries to render form. Once a muscle, tendon, or bone is explained, he will always recognize it and include it in his drawing. The more he learns about the figure, the more he sees.

The great figure draftsmen—Michelangelo, da Vinci, Durer, and Rubens—all knew their anatomy. This knowledge gave them great authority in rendering their drawings. Their anatomical knowledge was so complete that they could draw correct figures in

any position from their minds, without a model. This freedom enabled them to truly create.

Unlike the giant drawings of today, most of the Master drawings were small. At a glance a sketch 4 to 8 inches/10 to 20 cm large could be quickly judged for attitude and proportion. The only exception to this was when drawings were enlarged to cartoon size to be traced for painting purposes.

This book has been designed much like *Drawing the Female Figure*. Each pose and viewpoint presents a different problem for discussion. The drawings in this book are arranged first by position—standing, sitting, and kneeling—and then by viewpoints—front, back, and side. Each drawing dictates what should be said about it. One time I'll speak on anatomy, another time, proportion. Or attitude. Or rendering.

The result will be that in the course of discussing the many positions and viewpoints shown in the book, most of the important aspects of drawing the male figure will be covered.

At the beginning of each chapter there's a section on procedure: how to start drawing a standing figure, or seated figure, or kneeling figure, etc. These sections are illustrated with four or five progressive steps. I've deliberately used different mediums in order to give you as much variety as possible. There are unlimited techniques and mediums that you can draw with. Feel free to use whatever tools and techniques you desire. It's not what you draw with, but how you draw, that is important.

Additional help in technique, anatomy, and proportion can be gained by copying Old Master drawings, especially the 15th, 16th, and 17th century Italian, Dutch, German, and Flemish artists.

It's only through drawing from life, studying anatomy, and copying Old Masters that you will gain the solid foundation needed to render the figure with creativity and authority.

1
PROPORTIONS

Proportions vary from person to person. However, the classic Greek and Renaissance figure was eight heads in height, the head being used as the unit of measure. The Mannerist artists created elongated figures of nine or more head lengths. In nature, the average height is seven-and-a-half heads. The eight-head-long figure seems by far the best: it gives dignity to the figure and also seems to be the most convenient for measuring.

The classical male figure measured two heads across the shoulders and one-and-a-half across the hips. The female width measurements are just the opposite of the male's.

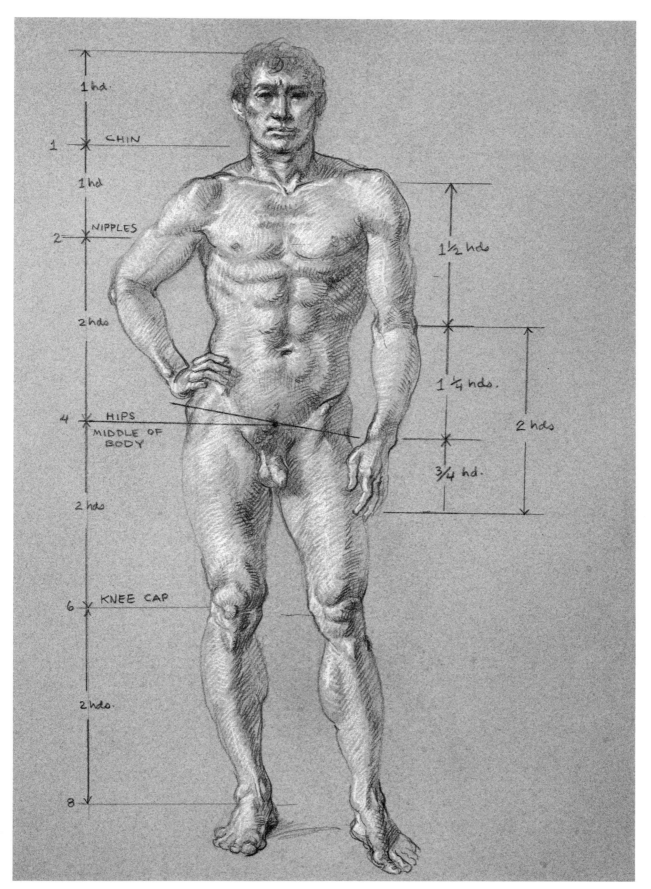

Standing, front view.

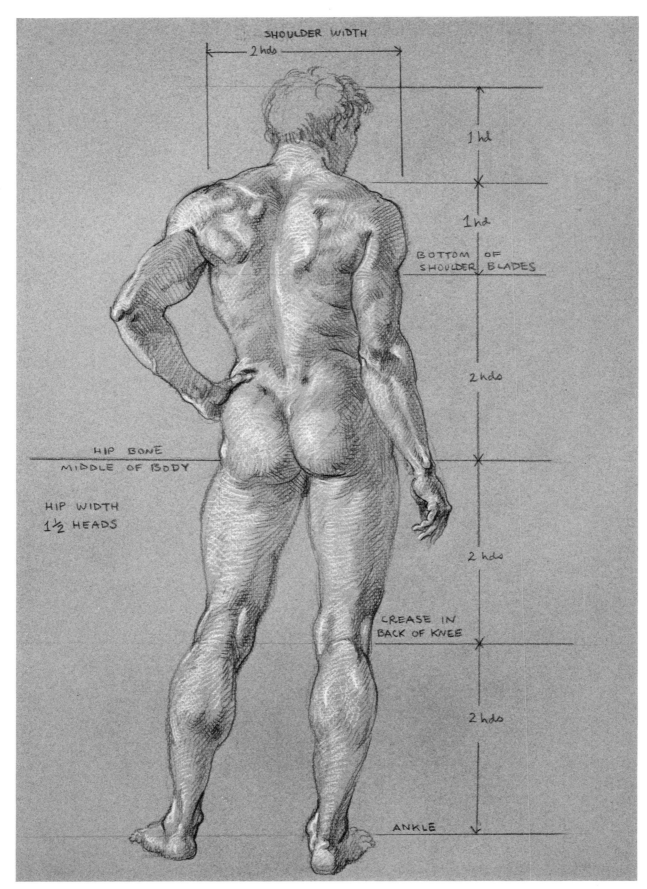

SHOULDER WIDTH

2 hds

1 hd

1 hd

BOTTOM OF
SHOULDER BLADES

2 hds

HIP BONE
MIDDLE OF BODY

HIP WIDTH
1½ HEADS

2 hds

CREASE IN
BACK OF KNEE

2 hds

ANKLE

Standing, back view.

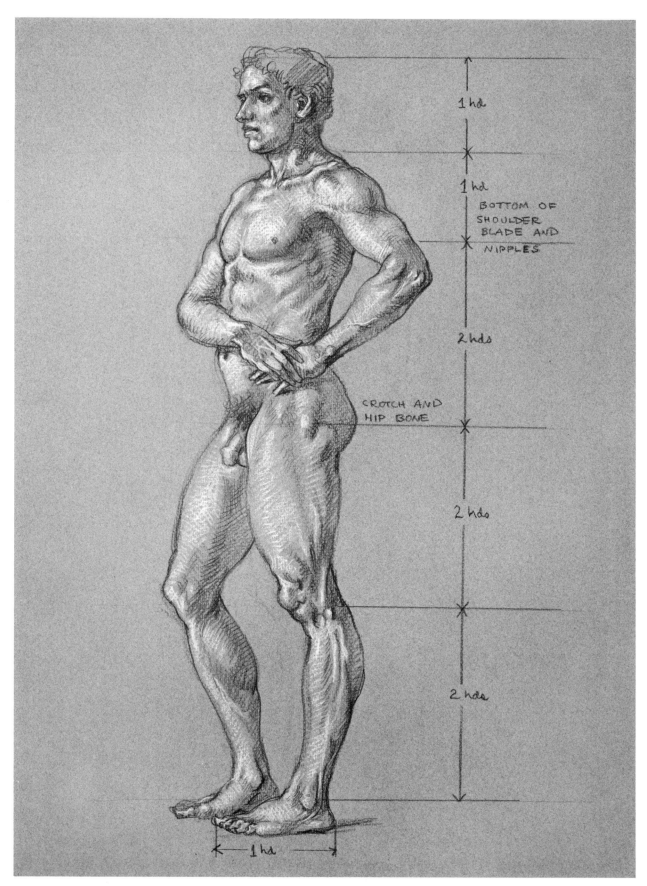

Standing, side view.

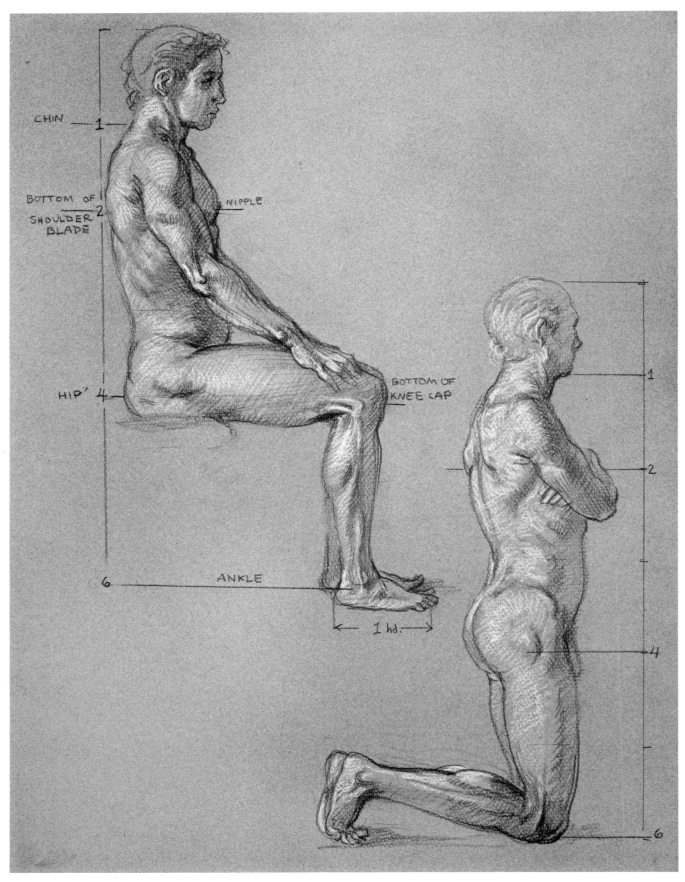

CHIN —1

BOTTOM OF
SHOULDER —2
BLADE

NIPPLE

HIP 4

BOTTOM OF
KNEE CAP

6 ——— ANKLE

1 hd.

1

2

4

6

Sitting. Kneeling.

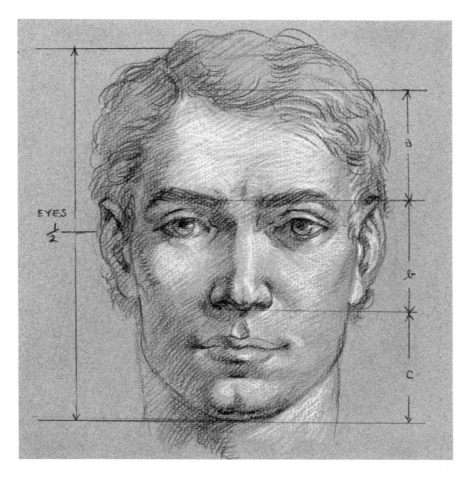

Head, full face. The eyes are halfway between the top of the head and the bottom of the chin. The face can be divided into three equal parts: (a) from the hairline to the eyebrows, (b) from the eyebrows to the bottom of the nose, and (c) from the nose to the bottom of the chin. The ears are in line with the eyebrows and the bottom of the nose. There is a space equal to the width of one eye, between the eyes.

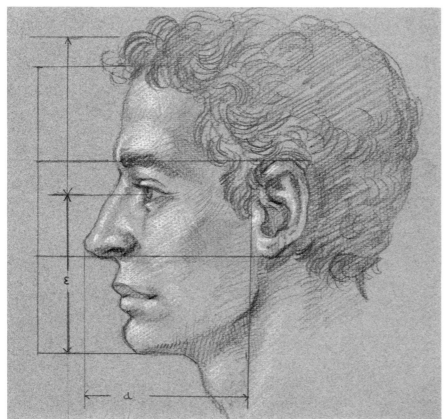

Head, profile. The distance from the tip of the nose to the end of the jaw (d) is equal to half the head height (e).

2
FORMS OF THE FIGURE

The male skeleton is larger, and his muscles more developed than the female. Also, the male figure carries less body fat, which gives him a more angular look. His shoulders are wide and his hips narrow. The female's wide hips tend to make her legs knock-kneed while the male's narrow hips make him more bowlegged

The male jaw is prominent and his nose angular and generous. His neck is thick and his shoulder muscles large, pulling the collar bones upward as they point out towards the shoulder tips. All of this gives his neck a shorter look than the female's. His feet and hands are larger in proportion to his body. He has a thin coat of body hair that becomes dense on his chest, pubic area, and under his arms and beard.

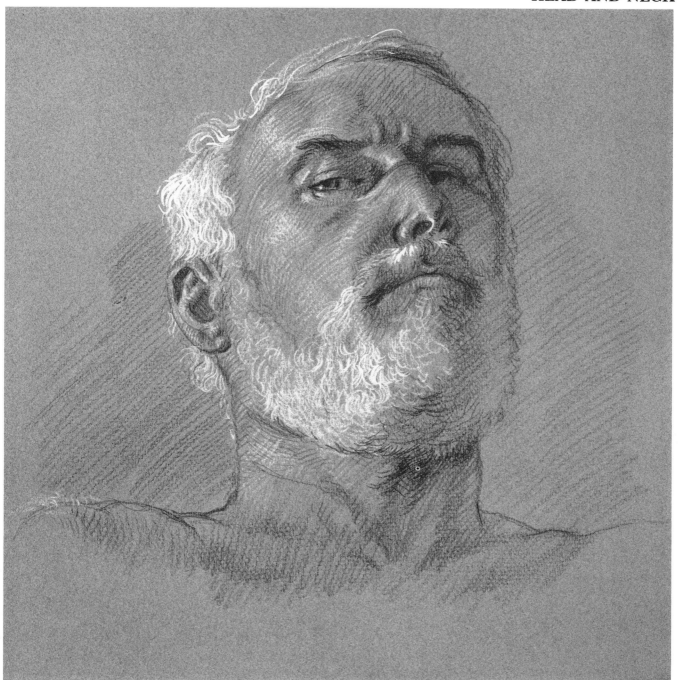

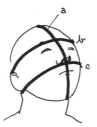

The foreshortened head can be started by drawing an oval and dividing it in half the long way (a). Then by drawing guidelines around it, from the top of the ear to the eyebrows (b) and from the bottom of the ear to the bottom of the nose (c) (see diagram).

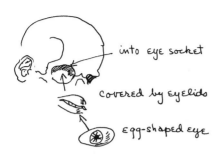

into eye socket

covered by eyelids

egg-shaped eye

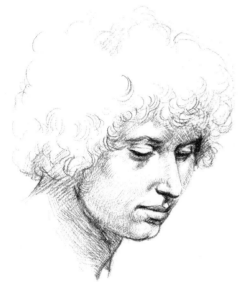

The eye is round like an egg and is covered by the eyelids that follow its contour. The eye and its eyelids sit back into the cavity of the eye socket (see diagram above).

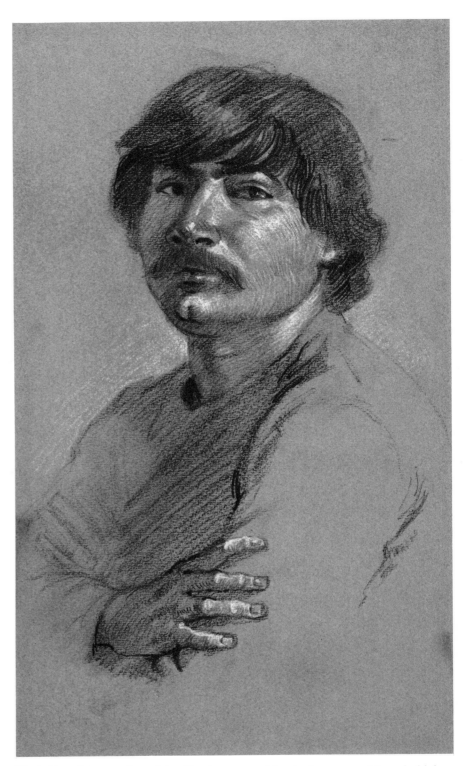

The bridge of the nose is explained by the accent of the shadow on one side and a highlight on the other. Very often the chin has an indentation or cleft in the center. The lower lip also has a small indentation dividing it into two equal sections.

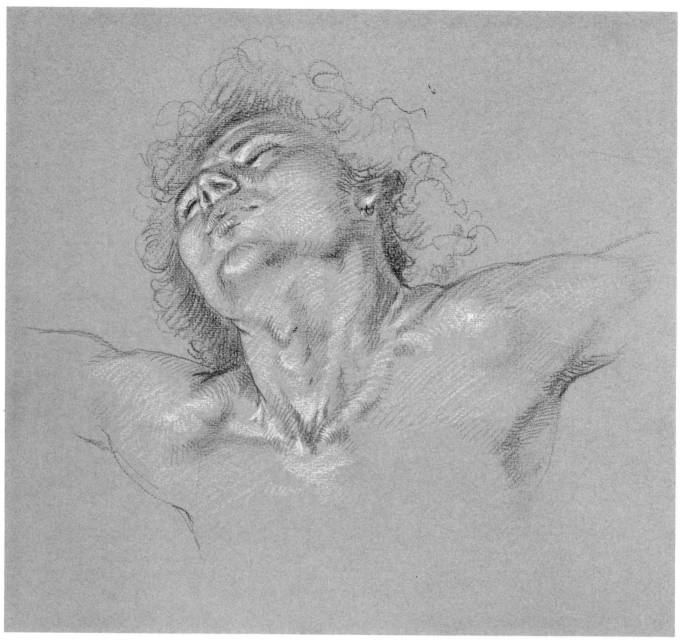

adam's apple

large V shape

attachments make M shape

A set of muscles start behind each ear and connect at the base of the neck forming a large *V* shape. At the attachment at the base, these same tendons split into two separate parts creating an *M* shape (see diagram at left). In the center of the large *V* is the Adam's apple.

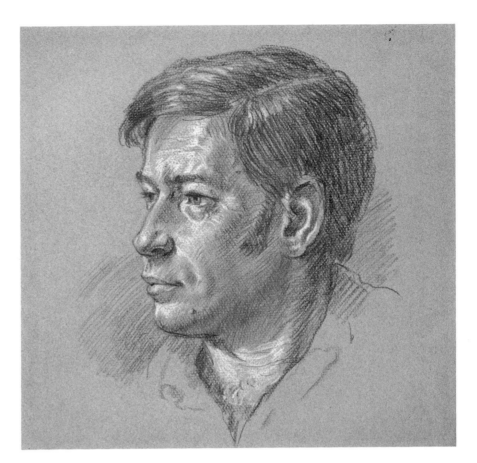

A division of the two cartilages on the end of the nose is visible. An indented upside-down *V* shape called the philtrum is between the upper lip and base of the nose. The bone of the brow and the cheekbone create the socket for the eye.

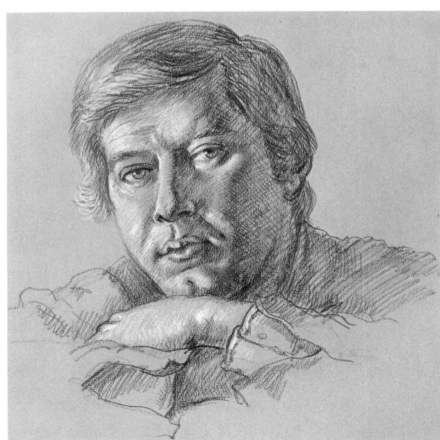

When the eye is open, the upper lid covers the top of the iris. Descending from the wings of the nose, defining the cheeks, are two deep creases.

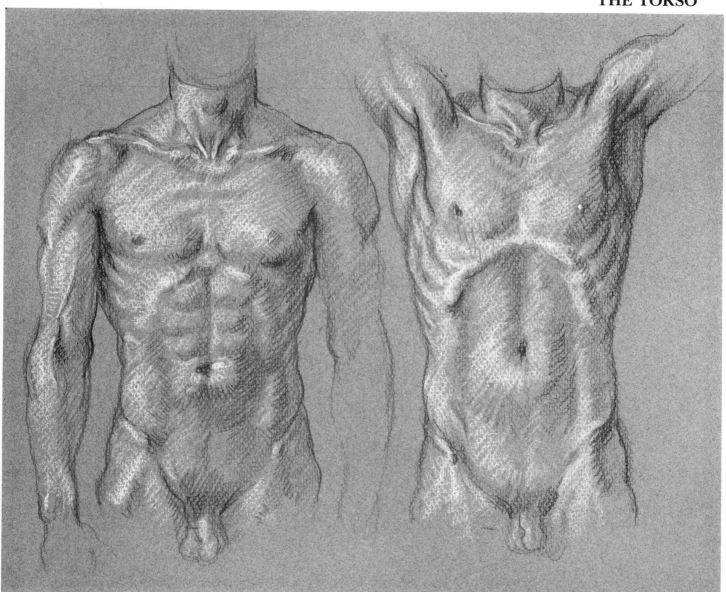

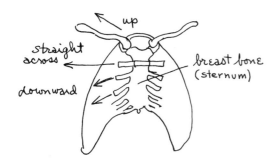

Left: The collarbones angle upward away from the base of the neck. The ribs attach to the breastbone or sternum. The ribcage and pelvic basin form a violin shape (see diagrams at left).

Right: The chest muscles flatten and stretch up into the arms. The ribs start high in the back and extend downward toward the front. The ribcage becomes prominent when the arms are raised.

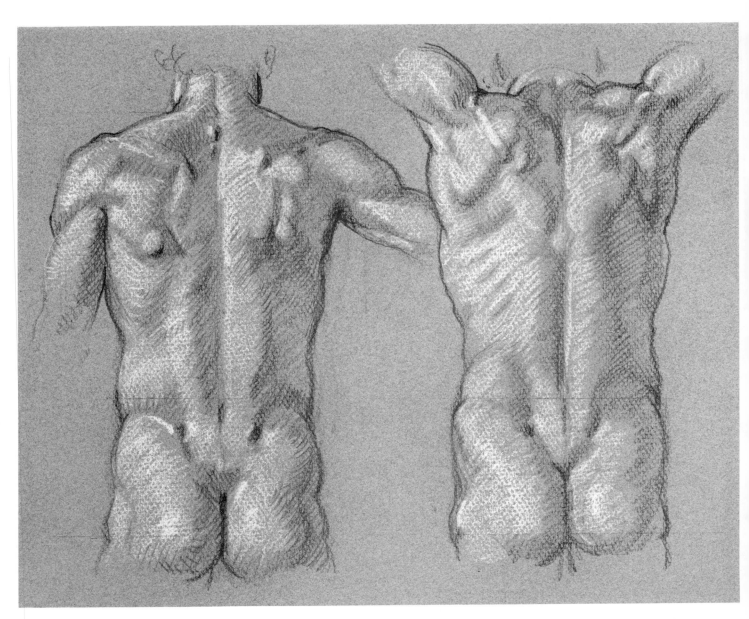

flat triangle

butterfly wings of the buttocks

Left: The seventh cervical vertebra is visible on the back of the neck. The shoulder blades are prominent, and two dimples are formed by the pelvic crests. A flat triangle is formed by the two dimples and the crease in the buttocks. The buttock muscles form the shape of butterfly wings (see diagram at left).

Right: When the arms are raised, the angle of the shoulder blades follows the arms.

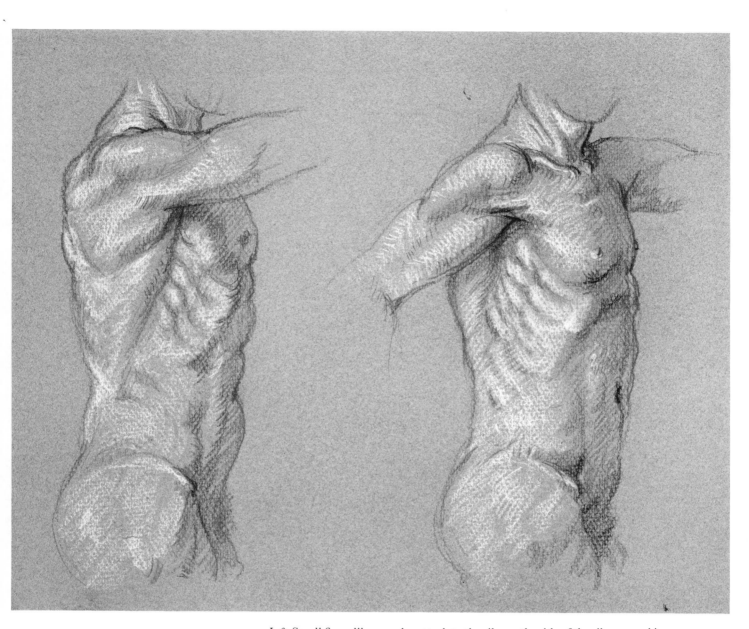

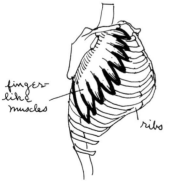

finger-
like
muscles

ribs

Left: Small fingerlike muscles attach to the ribs on the side of the ribcage making a break in the line of their downward slant (see diagram at left). When the arm is raised forward, the muscles of the back extend out into the arm.

Right: When the arm is pulled back, the chest muscle forming the front wall of the armpit extends out into the arm.

THE ARMS

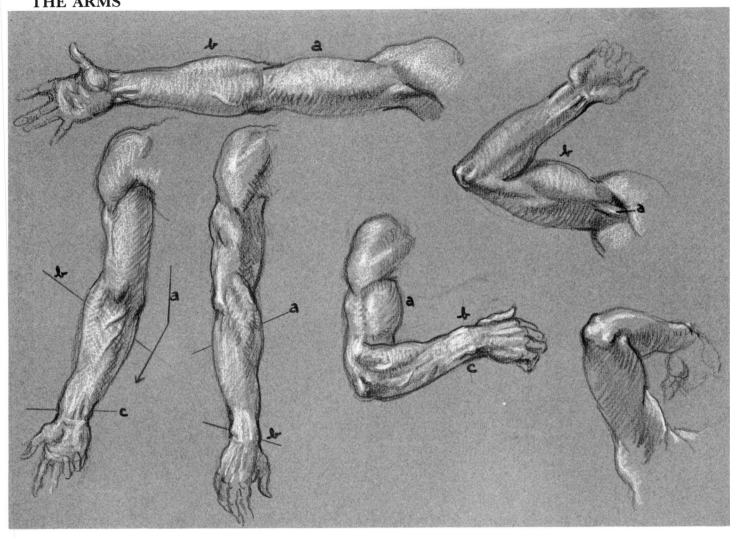

three prominent bones make a triangle

Top left: The biceps of the arm (a) emerge from underneath the shoulder muscles. The top of the forearm makes a high silhouette (b).

Lower left: When the palm of the hand is forward, the forearm angles away from the body (a). The outside of the forearm attaches high above the elbow and creates an angle with the inside (b) that is opposite the angle of the bones at the wrist (c).

Center left: When the palm is turned in, the arm straightens and the two angles of the forearm (a) and wrist exchange direction (b).

Center: When the arm is bent, the bicep (a) swells and the bones of the elbow protrude. The bone on the thumb side of the wrist (b) is longer than the bone on the little finger side (c).

Top right: There is a small muscle (a) in the armpit that is exposed only when the arm is raised. The bicep (b) swells as it raises the arm.

Lower right: When the elbow is bent, the bones of the elbow form a triangle (see diagram).

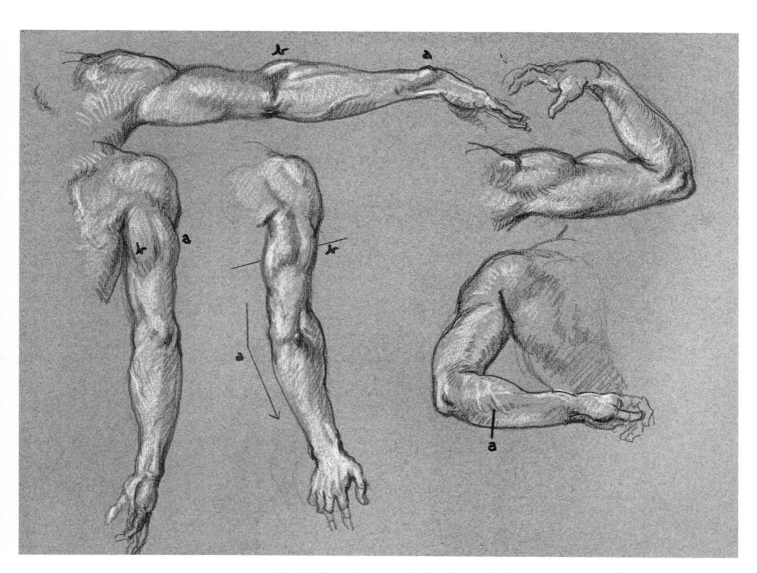

Top left: The wristbone on the little finger side is very prominent (a). There are two muscles on the top part of the forearm that create the high silhouette (b).

Lower left: When the palm is turned in, the arm hangs straight. The muscle on the outside of the upper arm (a) is more prominent and shorter than the one on the inside (b).

Center: The lower part of the arm angles out away from the body (a) when the palm faces foward. The outside of the upper arm is higher than the inside (b).

Top right: The back muscles attach out into the arm. The bicep bulges when it raises the arm.

Bottom right: The arm is bent behind the torso. The bones of the elbow protrude and a shadow (a) on the forearm indicates the direction of the bone.

THE HANDS

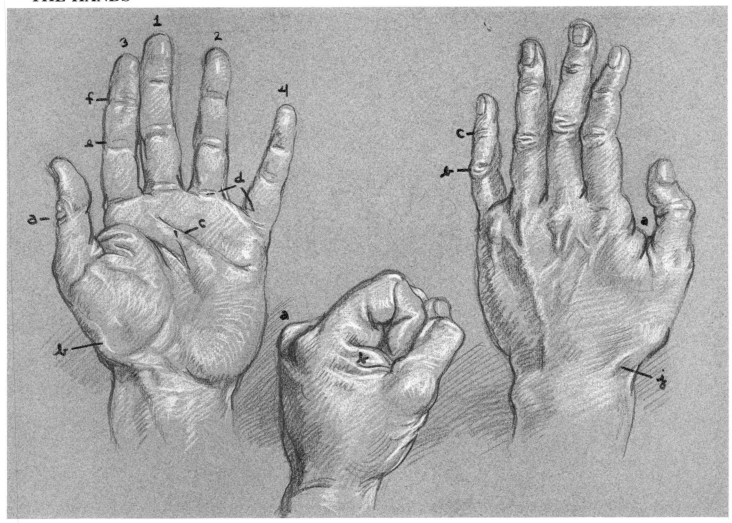

Left: Palm view of the hand. The thumb (a) has only two joints, the other fingers have three. The ball of the thumb (b) is separate from the rest of the hand. Folds in the palm (c) create the letter *M*. The fingers are numbered here in order of their length. Folds (d) are created on the palm where fingers bend: the two middle fingers have two folds: the little finger and the index fingers have one fold. The second joint (e) has two folds and the upper joint (f) has one fold.

Center: The middle knuckle (a) is the longest. Folds are created from the muscles (b) that draw the thumb across the hand.

Right: Back of the hand. Knuckle (c) has smooth creases and knuckle (b) has fleshy folds of skin. The muscle that pulls the thumb across the hand (a) is attached on the palm side. There is a small triangular depression, caused by tendons to the thumb, called the "snuff box" (j).

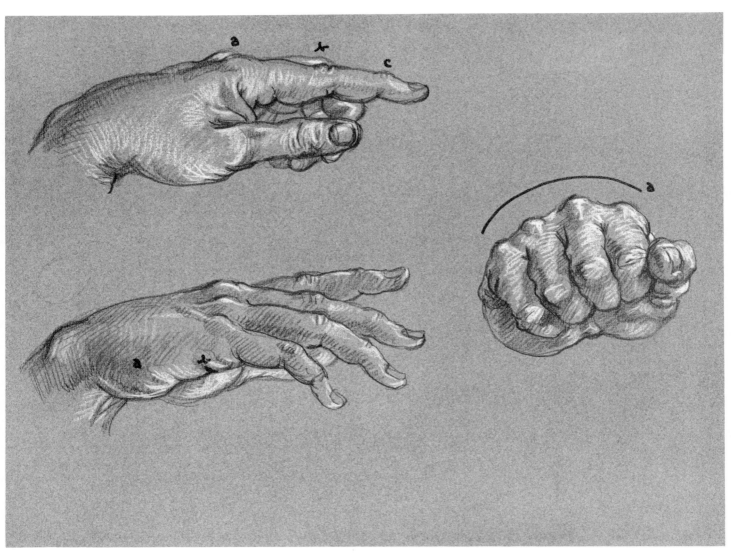

Top left: On top of the finger, the first joint (a) is rounded, the second (b) has fleshy folds, and the third (c) has creases. Underneath the fleshy folds, the joint has two creases. Underneath joint (c) there is one crease.

Bottom left: On the little finger side of the hand, the palm is well padded (a). There is one big crease in the pad before the finger starts (b).

Right: An arch is formed (a) when the hand is made into a fist, the middle knuckle being the highest point.

THE LEGS

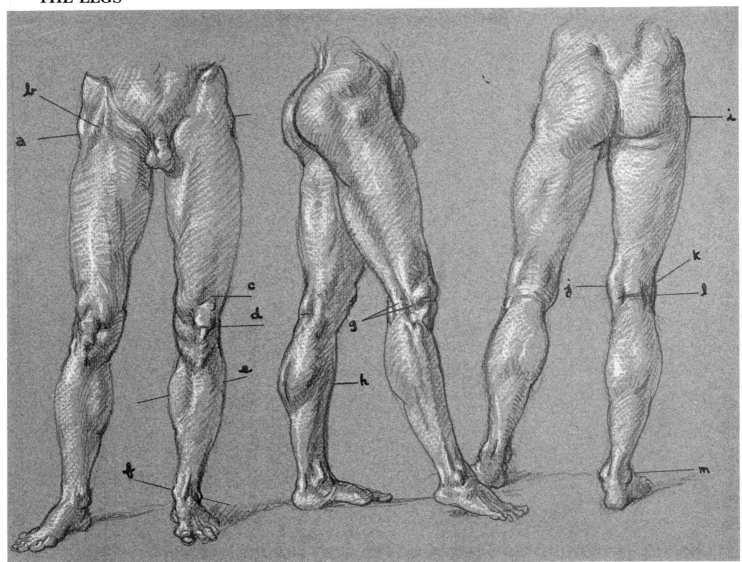

Left: The angle (a) is the midpoint of the body and goes from one hipbone through the pubic area to the other hipbone. Muscles attached to the pelvis create an upside down *V* shape (b). The locked knee creates a depression above the kneecap (c). The kneecap is rounded and its bottom is the sixth head measurement (d). The outside of the calf is higher than the inside (e). The angle (f) of the ankle runs the opposite way, with the inside of the ankle high and the outside low.

Center: Two straplike tendons from the upper leg attach to the top of the lower leg on the outside of the knee (g). The front of the shin has a slight *S* shape (h).

Right: The hipbone protrudes on the male figures (i). The inside of the knee has a sharp angle to it (j). The tendons on the back of the knee and the folding crease form the letter *H* (k). The midpoint of the leg (l) is the sixth head measurement. The ankle is the eighth head measurement and the inside is higher than the outside (m).

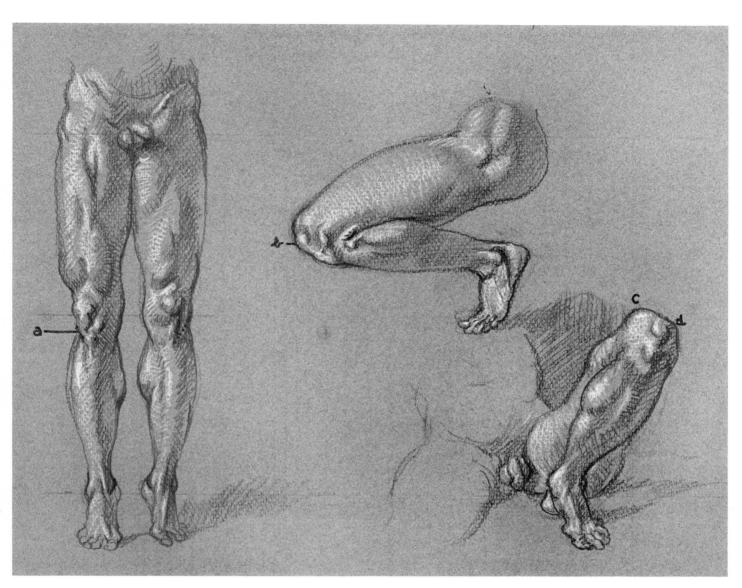

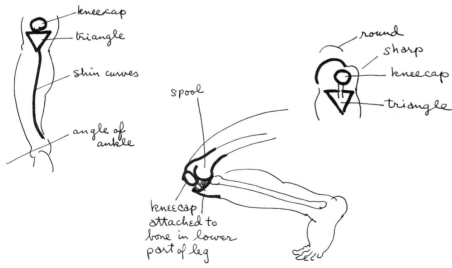

kneecap

triangle

shin curves

angle of ankle

round

sharp

kneecap

triangle

spool

kneecap attached to bone in lower part of leg

Left: Muscles bulge and become tense when the figure stands on his toes. Underneath the kneecap there is a triangular shape (a). The edge of the shin curves down the front of the lower leg to the inside ankle (see diagram far left).

Top right: The kneecap (b) protrudes on the bent knee and is attached to the lower part of the leg. It rides on the spool-shaped head of the upper bone of the leg (see diagram at center left).

Bottom right: The inside of the bent knee sits high and round (c) while the outside is sharp and hard (d). Underneath the kneecap attachment, the bone forms a triangular shape (see diagram at left).

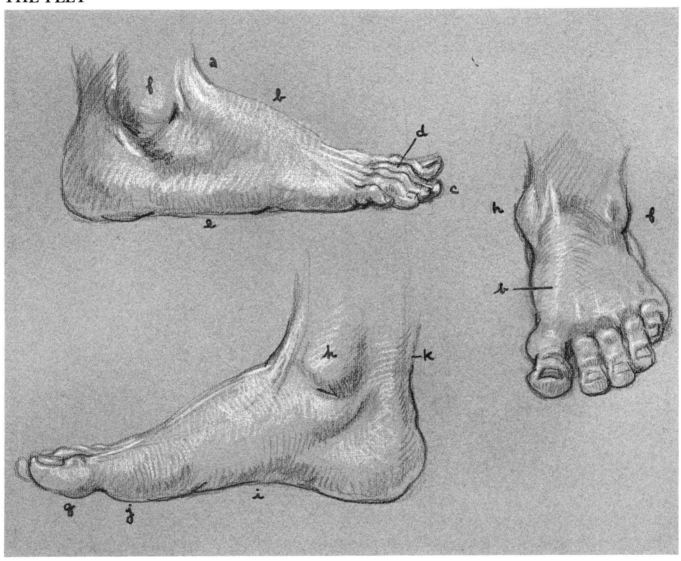

Top left: The outside of the foot. Tendons come down into the foot from the leg, forming a flat bridge on the front of the ankle (a). There is an arch on the top of the foot on the big-toe side (b). The toe next to the big toe (c) is the longest. Except for the big toe, the rest have a 'step-down' shape (d). The outside of the foot is padded and flat (e). The outside anklebone (f) is in the center of the ankle.

Bottom left: The inside of the foot. The big toe (g) has one joint fewer than the others. The inside of the ankle (h) is higher and farther forward than the outside. The inside of the foot has an arch (i) on the underside. The ball of the big toe (j) is round. The heel is attached by one large tendon (k).

Right: Front view of the foot. The inside anklebone (h) is higher than the outside (f), and a large tendon makes a ramp down the front of the foot to the big toe (b). The ends of the toes have rounded fatty pads.

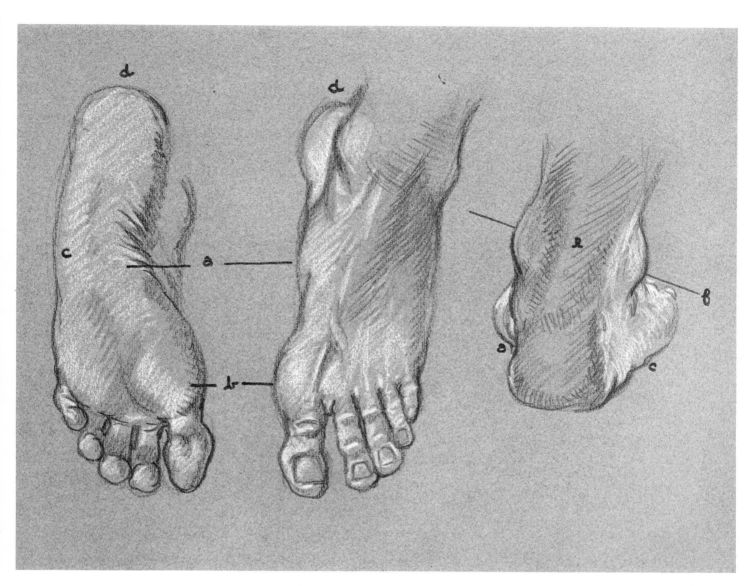

Left: Bottom of the foot. Wrinkles form around the arch (a) on the instep. There is a large pad (b) on the ball of the foot. A group of long pads cover the outside of the foot (c). The heel is also padded (d) and is toward the outside of the foot.

Center: Top view of the foot.

Right: Back view of the foot. One large tendon attaches to the heel (e). The flat pads on the outside of the foot (c) and the arch (a) on the inside can be seen. The angle of the ankle (f) is indicated.

3
RENDERING FORM
IN LIGHT AND SHADE

Human body forms are either cylindrical or spherical. Angular planes in the body always end in soft, rounded edges. The rendering of the torso or of a finger presents the same problems of rendering and has the same solutions.

If a sphere is lit from above and to one side, several areas of light and shade are created. The general area of tone in the light is considered the *middle tone*. The brightest section of this area of middle tone is the *highlight*; it is nearest to he light source. The area turned away from the light is the *shadow*. The shadow area is darkwst next to the middle tone, at a point called the *accent of the shadow*. Toward the outside of the shadow area, *reflected light* bounces off other objects or off the background and back to he sphere. Reflected light is never as bright as areas in the light. When the sphere touches or is near another object, it throws a cast shadow upon it. The cast shadow is darkest next to the object that is casting it; it starts out dark and then lightens and diffuses as it pulls away. To summarize, proceeding in order of values (not position) from the very lightest tones to the very darkest ones on the sphere, there is the highlight, the middle tone, reflected light, shadow and cast shadow, the accent of the shadow, and finally, the beginning of the cast shadow.

The Old Masters discovered that a single light source was the perfect light. Most of these painters used a light on their subject that would give them three-quarters light and one-quarter shadow.

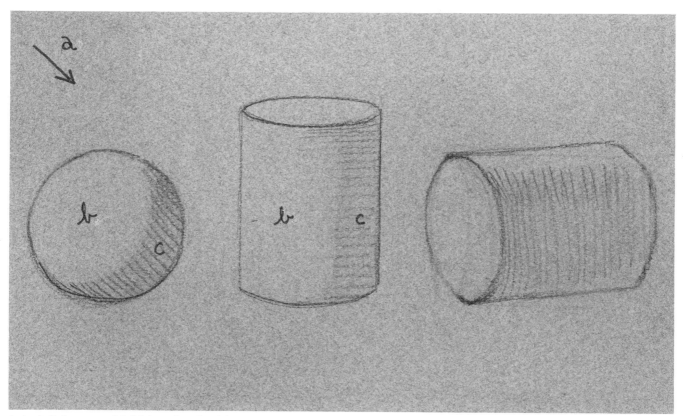

A single light source (a), high and to the side, creates an effect that is two-thirds light (b) and one-third shadow (c) on the cylinder. A somewhat different distribution of light and shadow appears on the cylinder when it's lying on its side (at right).

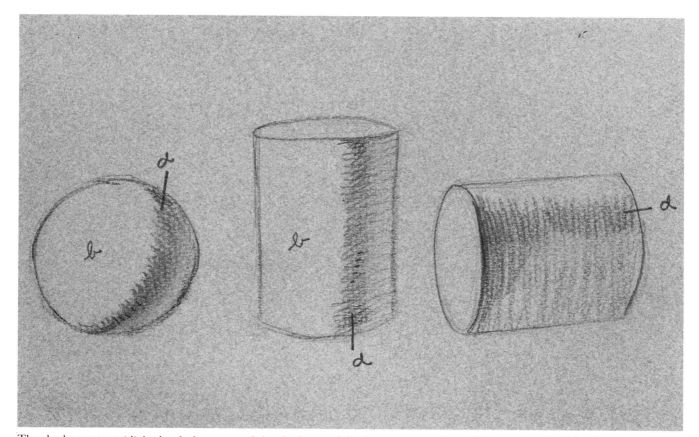

The shadow accent (d) is the darkest part of the shadow and is always next to the middle tone in the light (b).

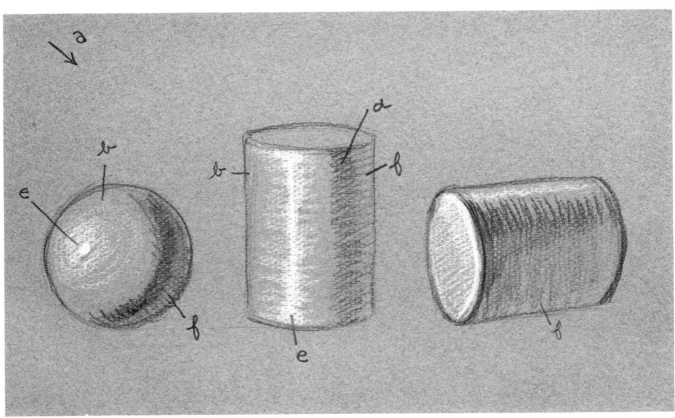

The highlight (e) is in the center of the middle tone in the light (b). The lighter part of the shadow is the reflected light (f).

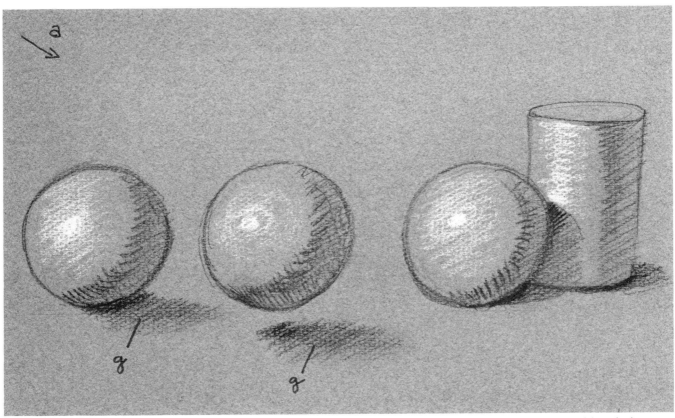

The cast shadow (g) is always darker next to the object casting the shadow. The cast shadow determines where the object sits in space and how it is related to other objects.

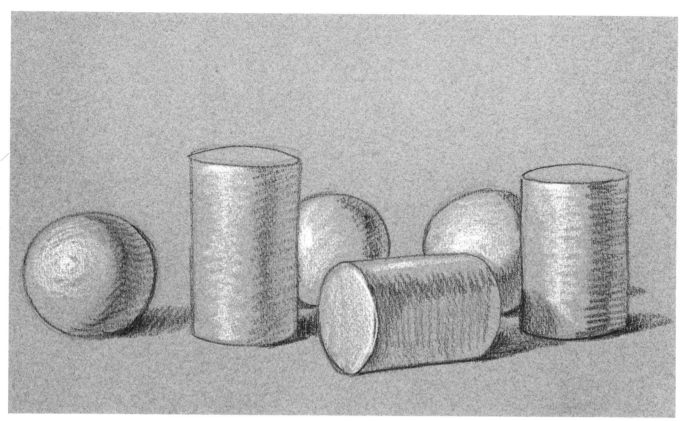

A group of objects. The cast shadows explain where objects are in relation to each other.

4
THE STANDING FIGURE

The standing position is usually the easiest to draw because the figure can be measured by the standard eight-head measurement.

The pose determines the first step in drawing the figure. If the figure has a sweeping line or rhythm this should be put down lightly; if not, it is usually best to determine how the weight is distributed.

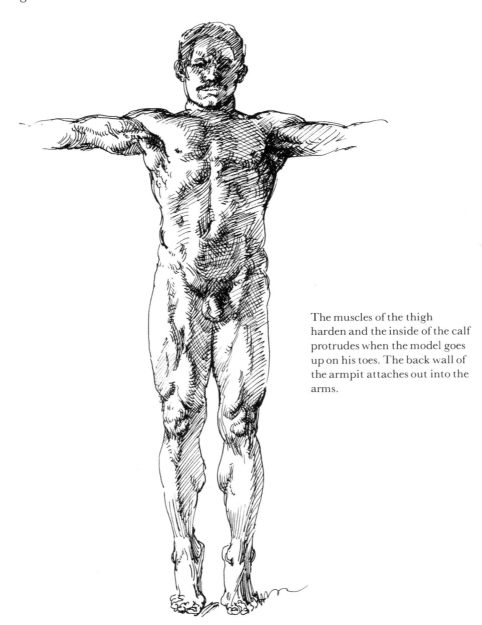

The muscles of the thigh harden and the inside of the calf protrudes when the model goes up on his toes. The back wall of the armpit attaches out into the arms.

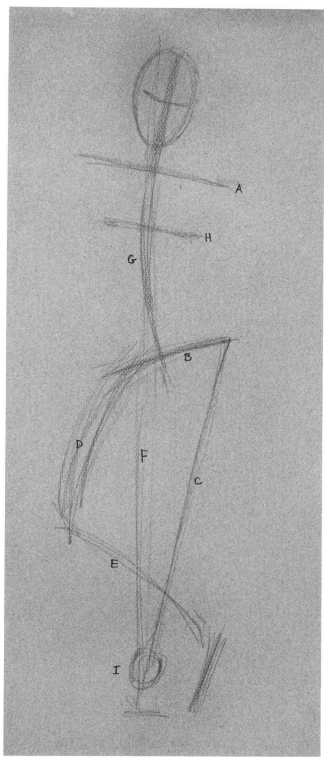

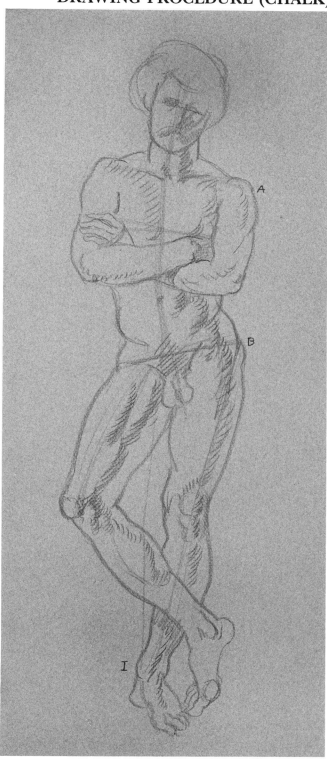

Step 1. The left leg (C) is drawn first because it carries the weight of the body. It angles in under the center of the figure (line F) so that the ankle (I) is directly under the head. The left leg forces the left hip upward and the angle of the hips (B) should be drawn next. The parallel lines of the shoulders (A) and nipples (H) are indicated next, countering the hip angle. The head and backbone (G) are suggested, and the leg (D, E) is added, which balances the figure. This pose is called "contraposto" and can be seen in most classical work.

Step 2. The outlines of the figure are drawn, paying close attention to where lines overlap. A dark line will come forward and a faint line will recede. The shadow accent is drawn next. This is the most difficult step to see; sometimes the accent is sharp while other times it can be very diffused.

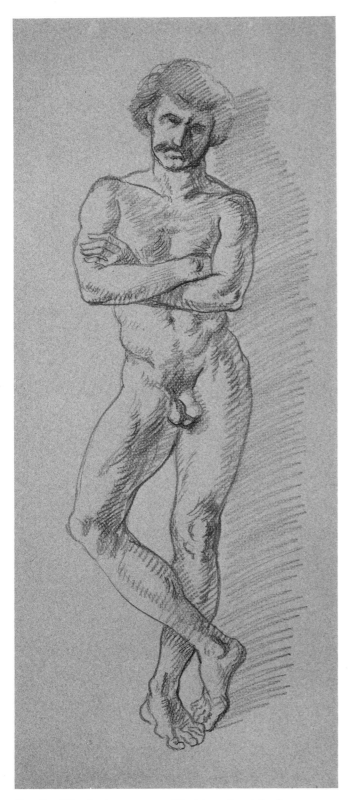 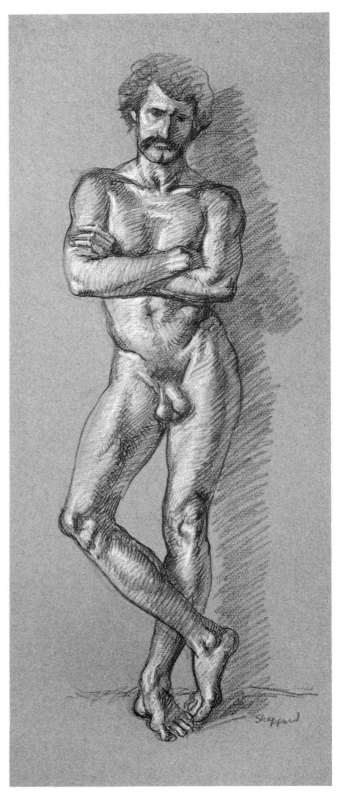

Step 3. The shadow areas are filled in and cast shadows drawn. The cast shadows are darker and sharper next to the part of the body that cast them.

Step 4. The toned paper represents the flesh tones in the light. Highlights applied with white chalk create the full volume.

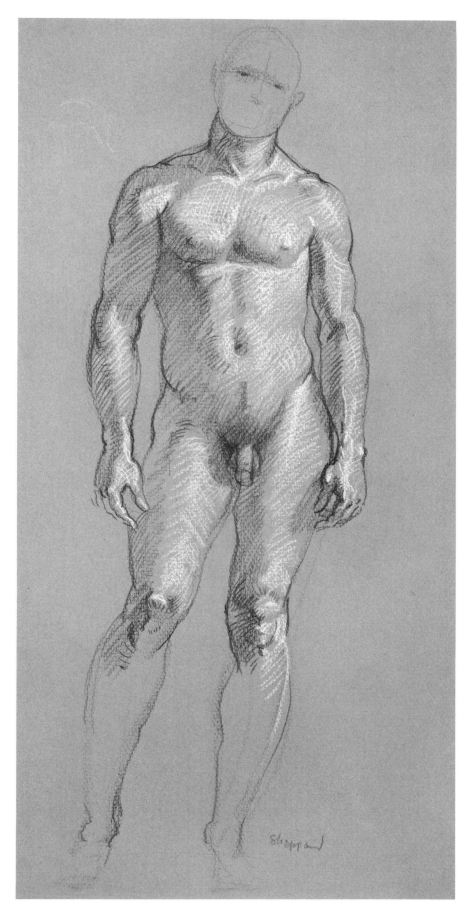

The model's weight is on his left leg and his shoulders and hips are at opposite angles. The external oblique muscles overlap the pelvic ridge and the stomach fits down into the basin of the pelvis (see diagram).

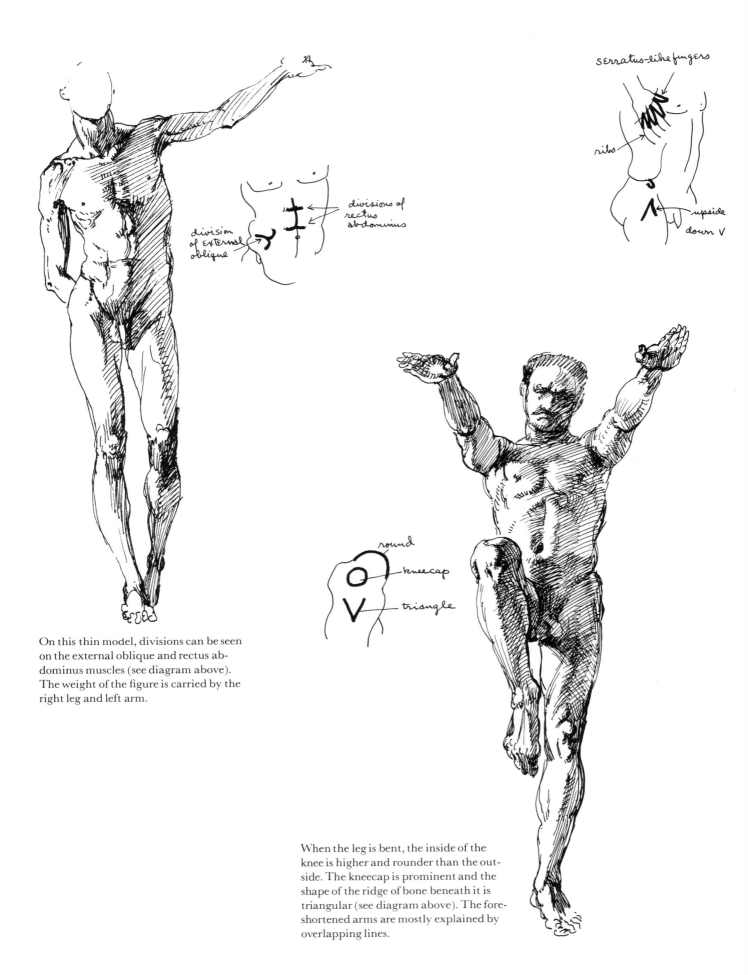

serratus-like fingers

ribs

upside
down V

divisions of
rectus
abdominus

division
of external
oblique

round

kneecap

triangle

On this thin model, divisions can be seen on the external oblique and rectus abdominus muscles (see diagram above). The weight of the figure is carried by the right leg and left arm.

When the leg is bent, the inside of the knee is higher and rounder than the outside. The kneecap is prominent and the shape of the ridge of bone beneath it is triangular (see diagram above). The foreshortened arms are mostly explained by overlapping lines.

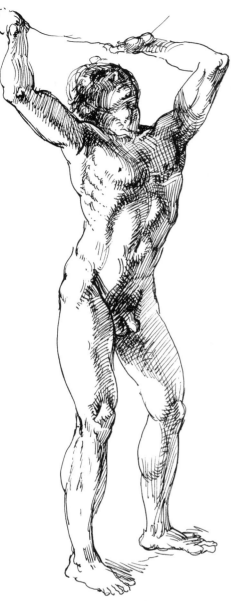

When the arms are raised, the serratus muscles show like fingers connecting to the ribs (see diagram above). Muscles attaching from the pelvis form an upside down *V* shape on the upper part of the thigh.

The shoulders and hips are parallel and the weight is evenly distributed on both legs. The small bone on the little-finger side of both wrists is prominent. The sterno-mastoid muscle starts behind the ear and inserts between the collarbone.

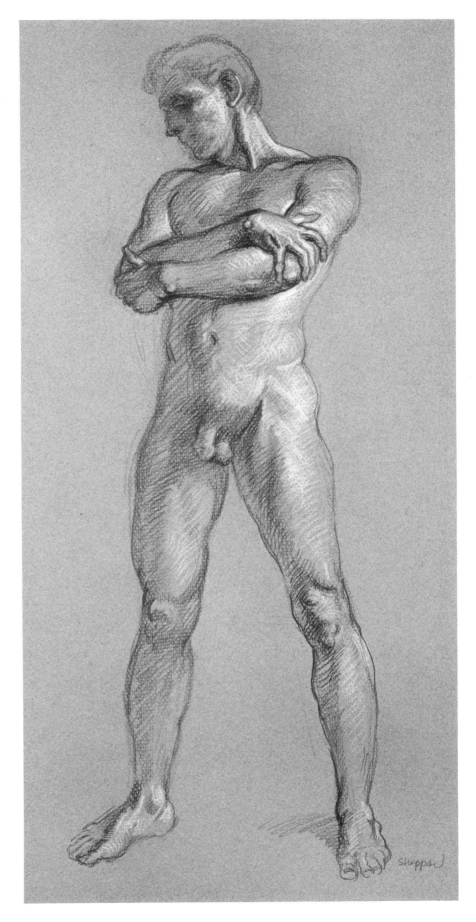

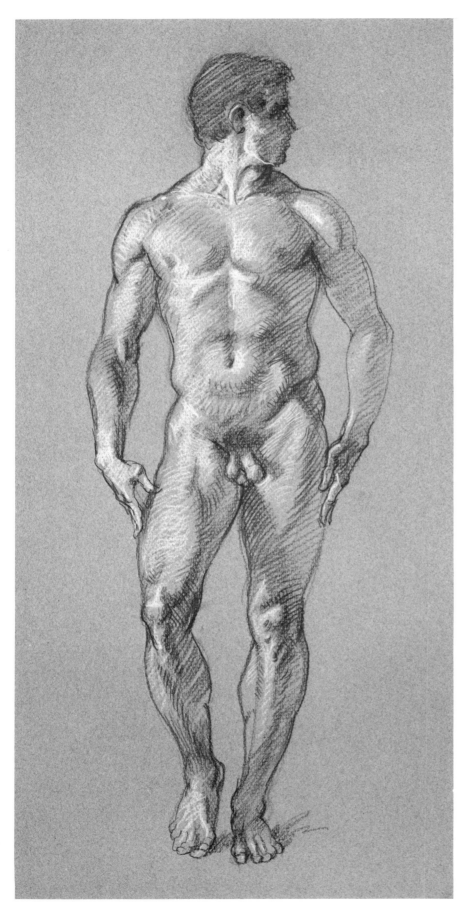

A large violin shape is created on the front of the torso by the hollow of the rib-cage and the ridge of the pelvis. The inside of the ankle is higher than the outside and at the knee the outside of the lower leg is higher than the inside (see diagrams above).

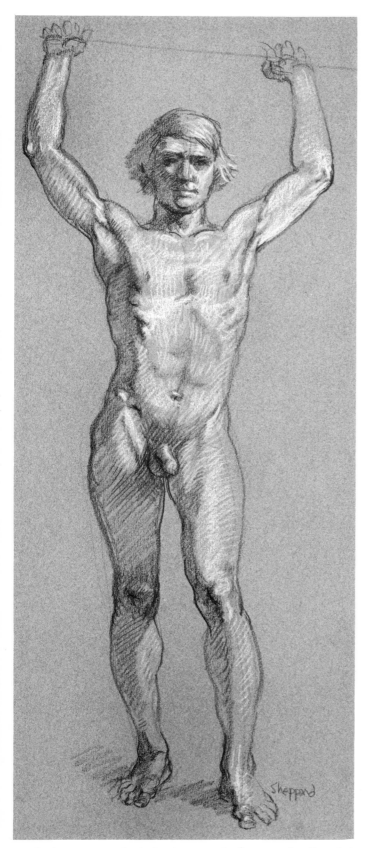

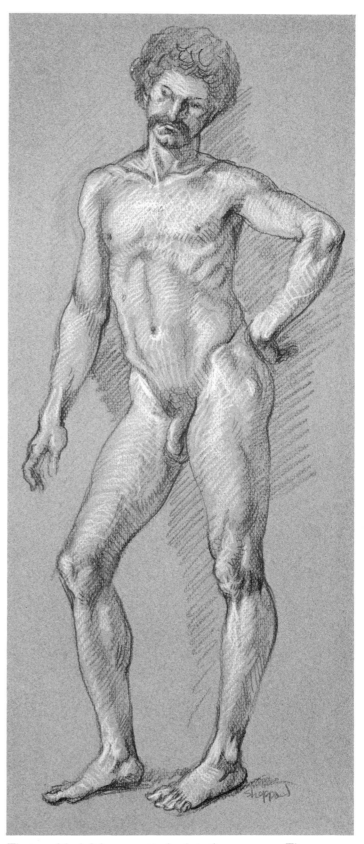

As the arms are raised, the chest muscles flatten and pull out into the arms. The biceps bulge and the ribs expand (see diagrams at left).

The top of the left forearm attaches into the upper arm. The stomach muscles are divided down the middle of the body. Two straplike tendons show on the outside of the leg behind the left kneecap.

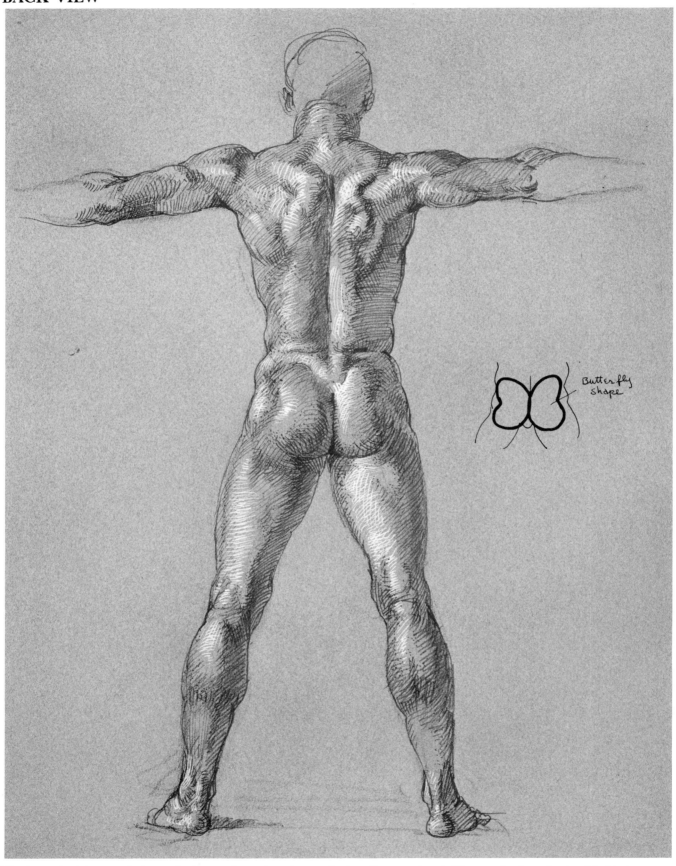

Butterfly
shape

The buttocks tighten and a butterfly shape is formed by the muscles (see diagram above). The muscles from the shoulderblades tense as they support the extended arms.

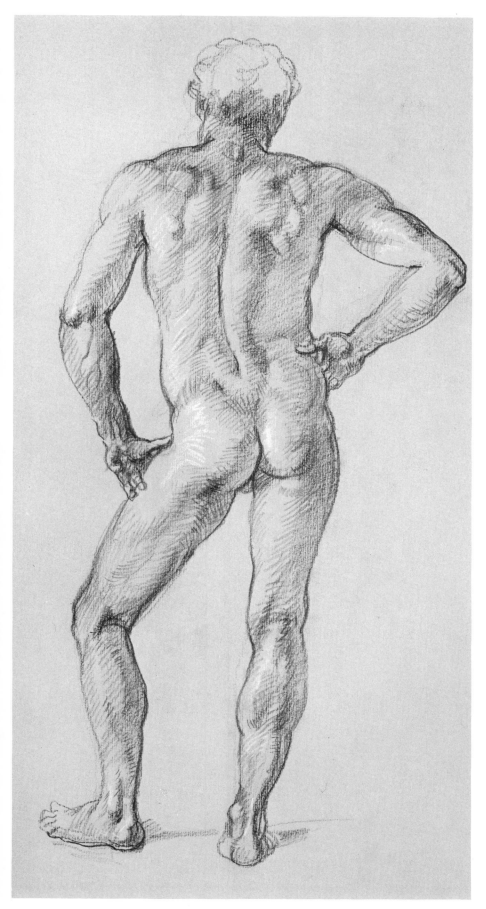

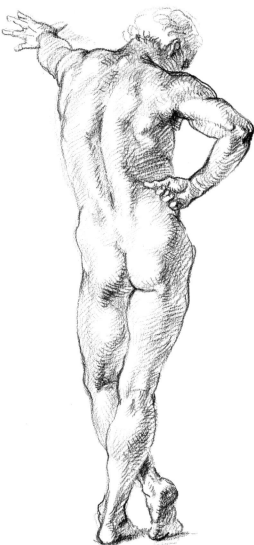

The close elbow is marked darker to bring it near. The foreshortening of the two arms is explained by overlapping outlines. An *H* shape is formed on the back of the knee by the crease and two tendons.

The hips and shoulders are at opposite angles. The weight is on the right leg that angles down under the center of the torso. The inside of the ankle is higher than the outside.

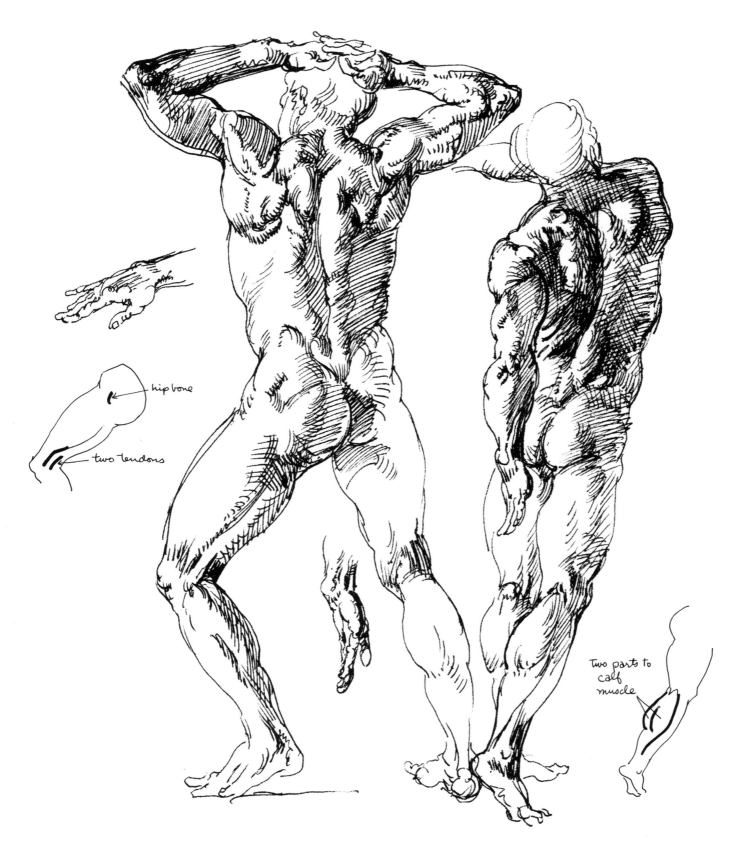

hip bone

two tendons

two parts to calf muscle

The muscles of the back and shoulders work together and are flexed in this drawing. The hipbone and the two tendons on the outside of the knee show (see diagram above).

The calf muscles divide down the middle when weight is put on the toes (see diagram above). Folds form at the waist from the twisting torso.

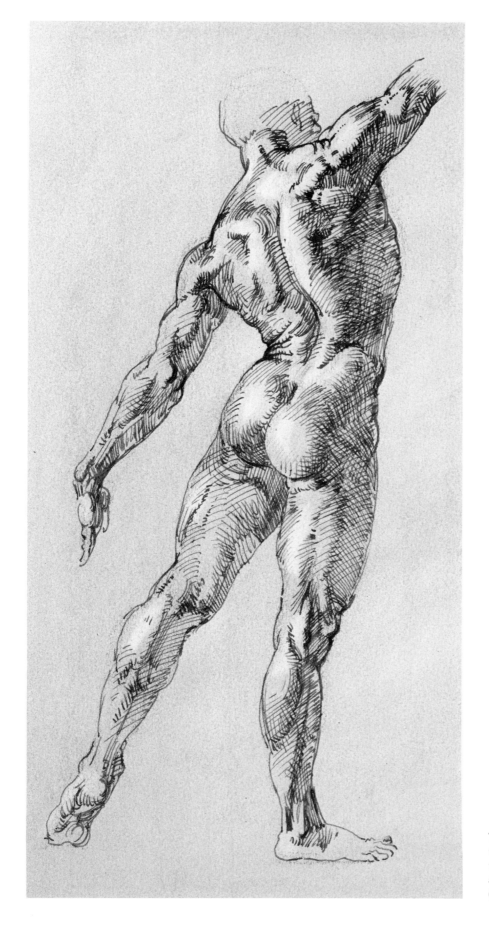

The angle of the shoulderblades follows the arms. The large trapezius muscle attaches to the top of the shoulderblades and into the base of the back of the head (see diagram).

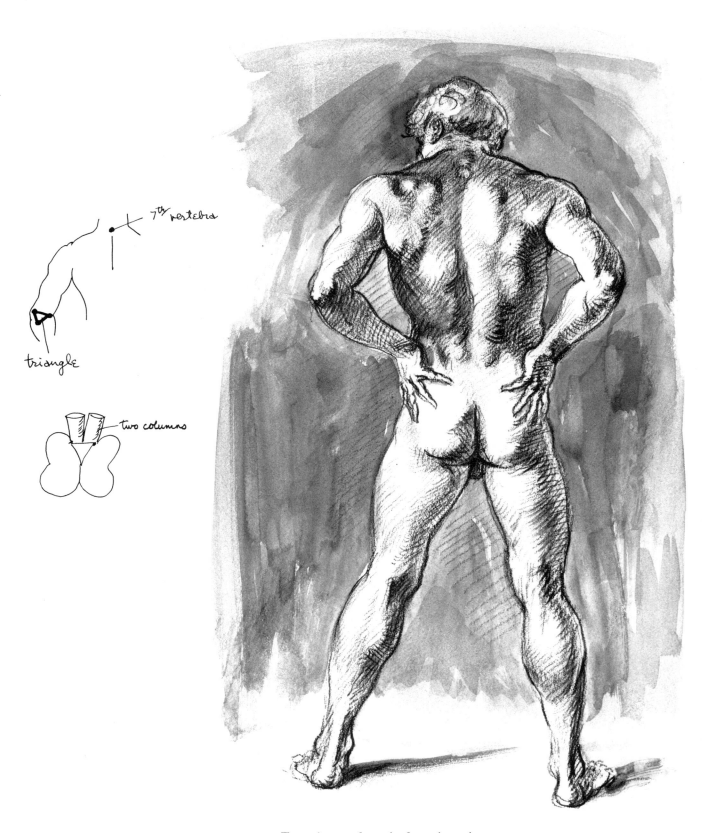

7th vertebra

triangle

two columns

Two columns of muscles form above the pelvis. The bent elbow forms a triangular shape and the seventh cervical vertebra shows on the back of the neck (see diagrams).

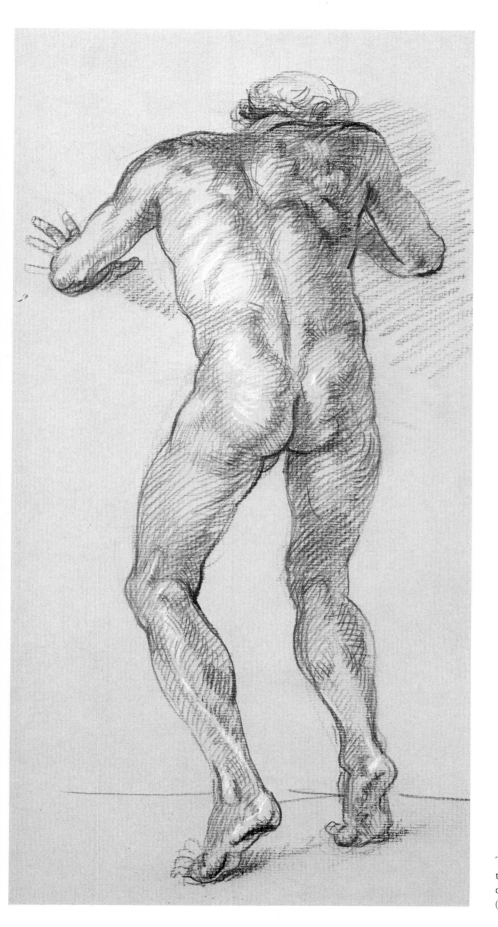

spine of pelvis dimples

The calves of the leg flex and harden as the model pushes against the wall. Two dimples form from the spines of the pelvis (see diagram).

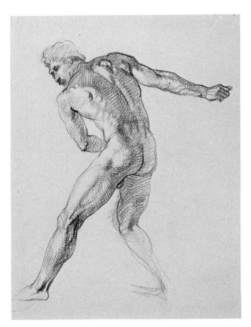

The tip of the shoulderblade makes a break in the outline of the shoulder. Its bottom protrudes and the ribs show under it, slanting downward towards the front.

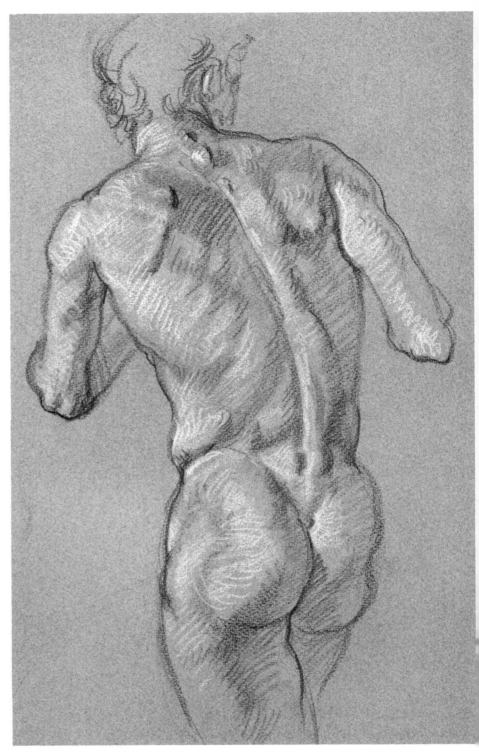

The vertebrae and shoulderblades are evident. The ribs slant downward from the back toward the front.

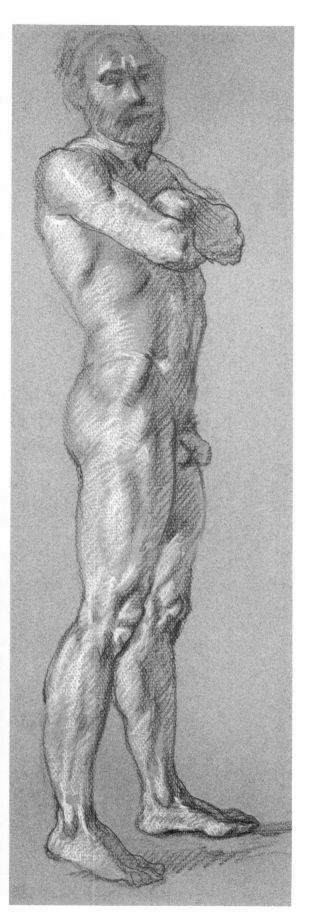

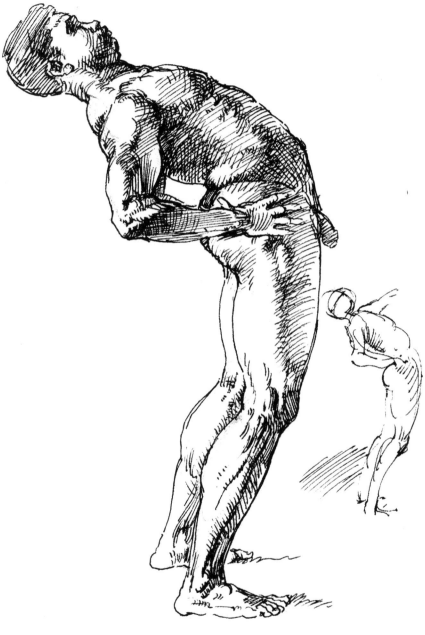

Above: The muscles in the calf strain to keep the heels down and the figure balanced. The feet point out to get greater balance.

Left: This figure is half in light and half in shadow. The accent line between them (the accent of the shadow) then becomes very important; it reveals the muscle contours and shapes in the body.

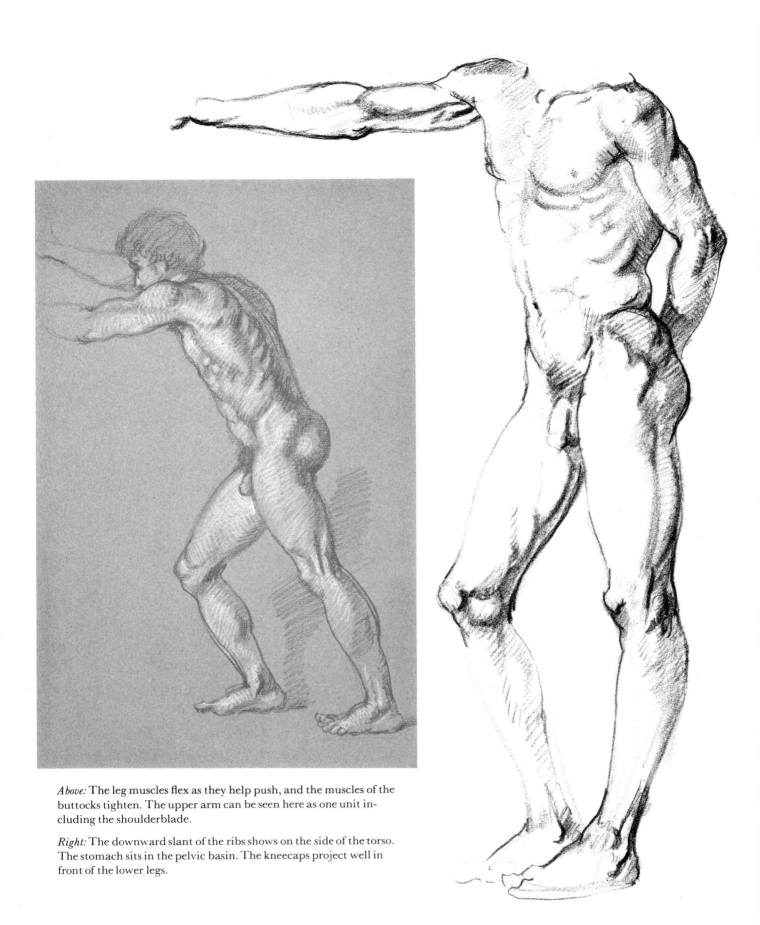

Above: The leg muscles flex as they help push, and the muscles of the buttocks tighten. The upper arm can be seen here as one unit including the shoulderblade.

Right: The downward slant of the ribs shows on the side of the torso. The stomach sits in the pelvic basin. The kneecaps project well in front of the lower legs.

The chest muscles flatten out when the arms are raised. As the model goes up on his toes the muscles in the lower part of his leg become more distinct.

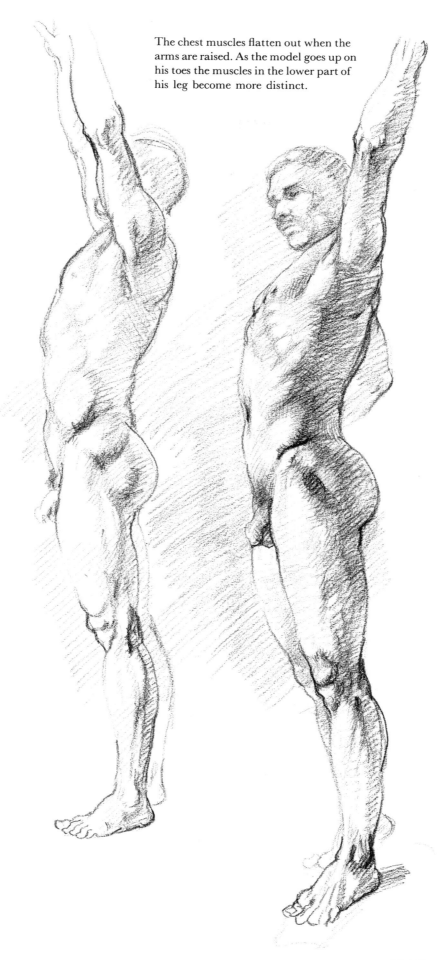

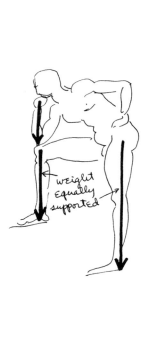

Two large muscles form the inside of the calf. The arch on the inside of the foot is evident. Body weight is evenly distributed between the left leg and a continuing line between the right forearm and right lower leg (see diagram).

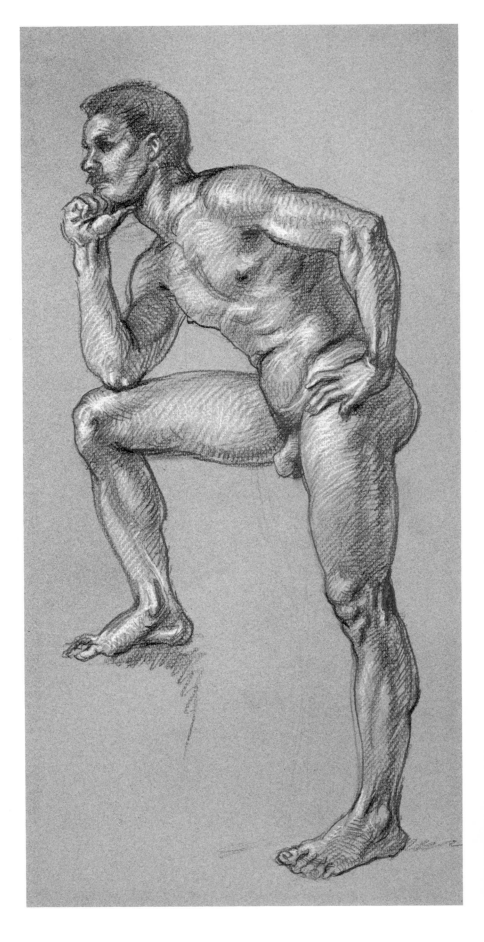

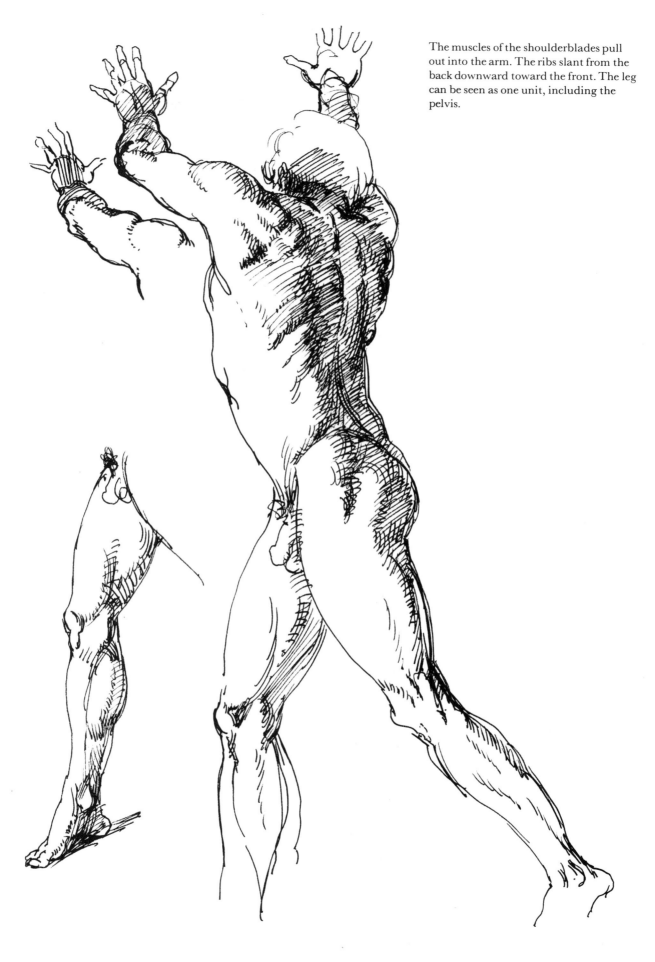

The muscles of the shoulderblades pull out into the arm. The ribs slant from the back downward toward the front. The leg can be seen as one unit, including the pelvis.

5
THE SEATED FIGURE

Most seated figures end up measuring six heads high: four for the torso and two for the part of the leg that is not foreshortened.

The weight of the figure is usually on the buttocks and thighs, flattening them out.

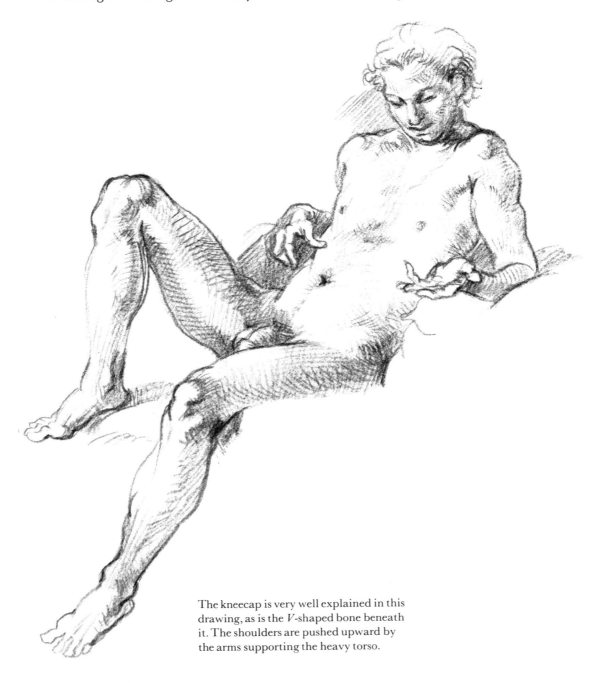

The kneecap is very well explained in this drawing, as is the *V*-shaped bone beneath it. The shoulders are pushed upward by the arms supporting the heavy torso.

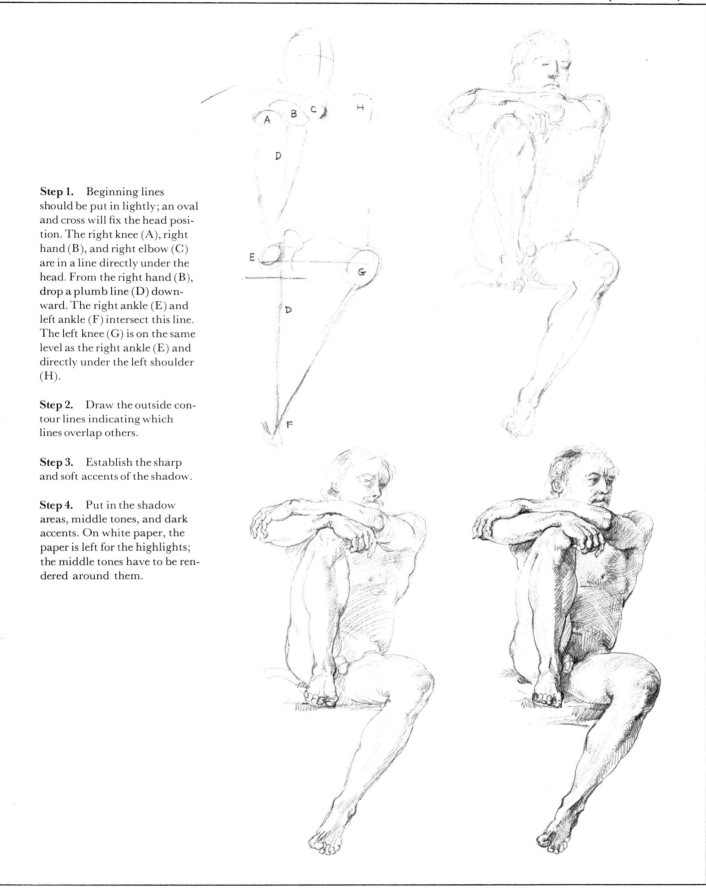

Step 1. Beginning lines should be put in lightly; an oval and cross will fix the head position. The right knee (A), right hand (B), and right elbow (C) are in a line directly under the head. From the right hand (B), drop a plumb line (D) downward. The right ankle (E) and left ankle (F) intersect this line. The left knee (G) is on the same level as the right ankle (E) and directly under the left shoulder (H).

Step 2. Draw the outside contour lines indicating which lines overlap others.

Step 3. Establish the sharp and soft accents of the shadow.

Step 4. Put in the shadow areas, middle tones, and dark accents. On white paper, the paper is left for the highlights; the middle tones have to be rendered around them.

FRONT VIEW

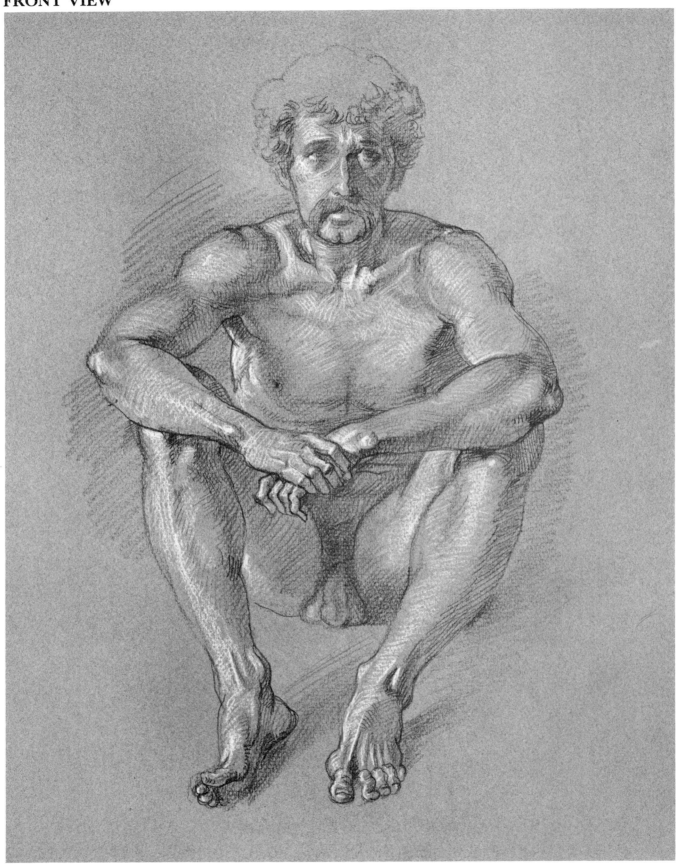

The muscles of the chest pull out into the extended arms. The forearm bone on the little finger side sits high and prominent at the wrists of both arms. The inside of the ankle is higher than the outside.

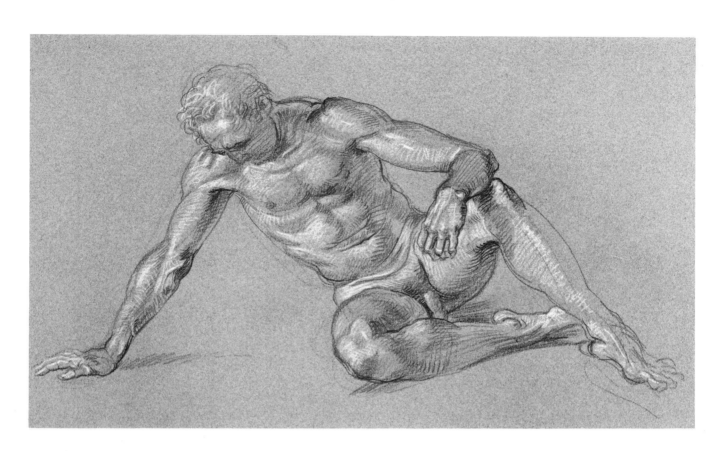

Above: As the model leans, the right chest muscle (the pectoralis) inserts under the shoulder muscle of the right arm. The folds across his belly are formed by the bent-over torso.

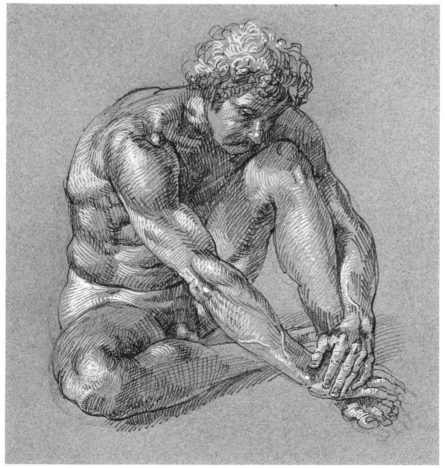

White watercolor is used for the highlights. Notice how each line follows the contour of the body.

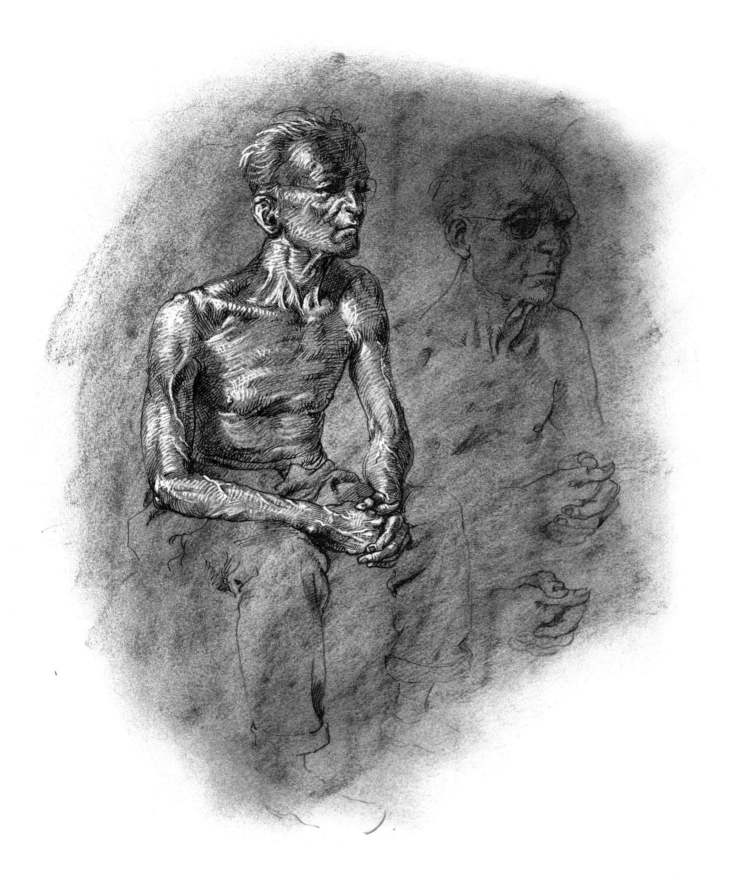

This is an old man in his eighties. Muscle tone has faded and his veins have become prominent. Fold marks have formed at the joints of his armpits and elbow.

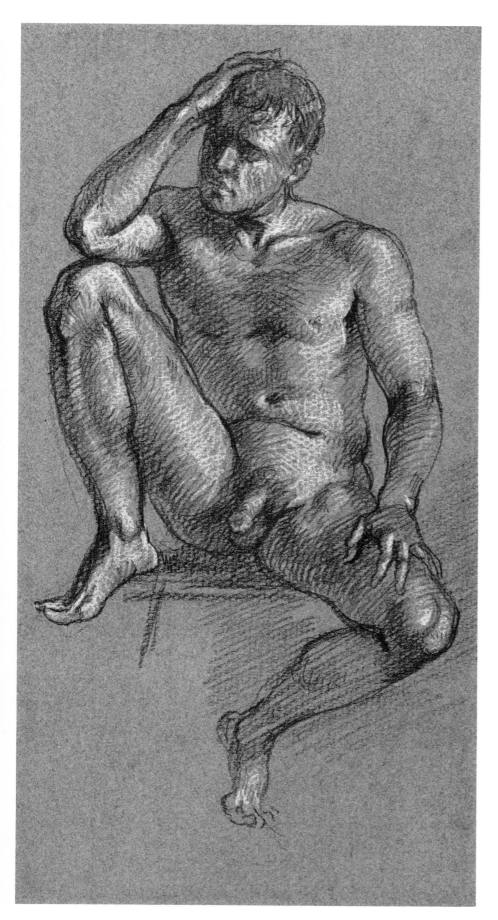

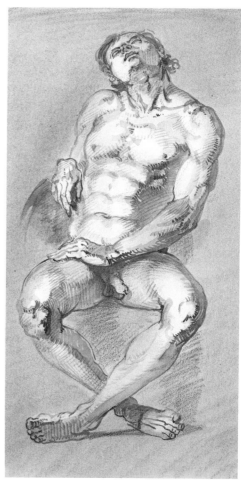

Above: This is a watercolor wash and chalk on white paper. Here the highlights have to be worked around, leaving the paper to do the job. The foreshortened legs are explained by overlapping contour lines.

A strong cast shadow on the torso from the left arm helps to push the arm forward in space. The downward curve of the shin toward the inside ankle is obvious on the right leg.

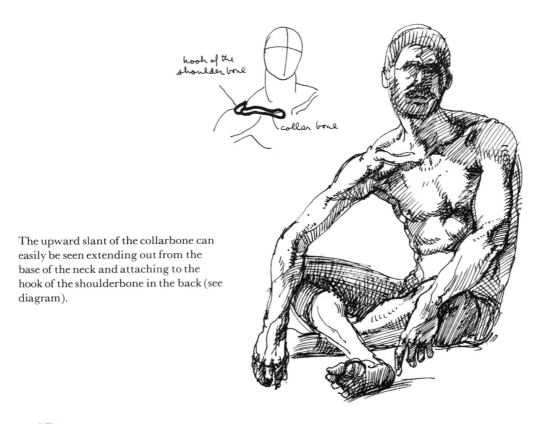

hook of the
shoulder bone

collar bone

The upward slant of the collarbone can easily be seen extending out from the base of the neck and attaching to the hook of the shoulderbone in the back (see diagram).

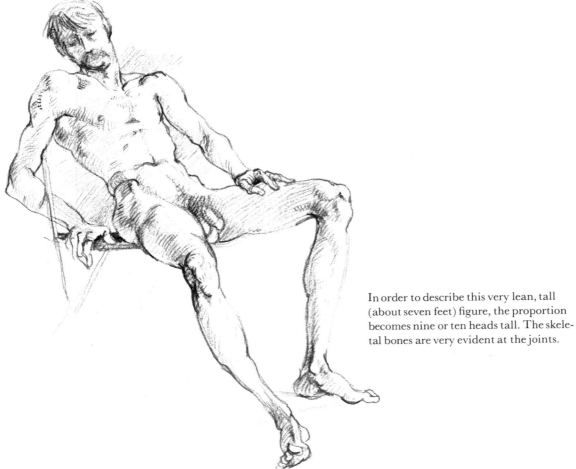

In order to describe this very lean, tall (about seven feet) figure, the proportion becomes nine or ten heads tall. The skeletal bones are very evident at the joints.

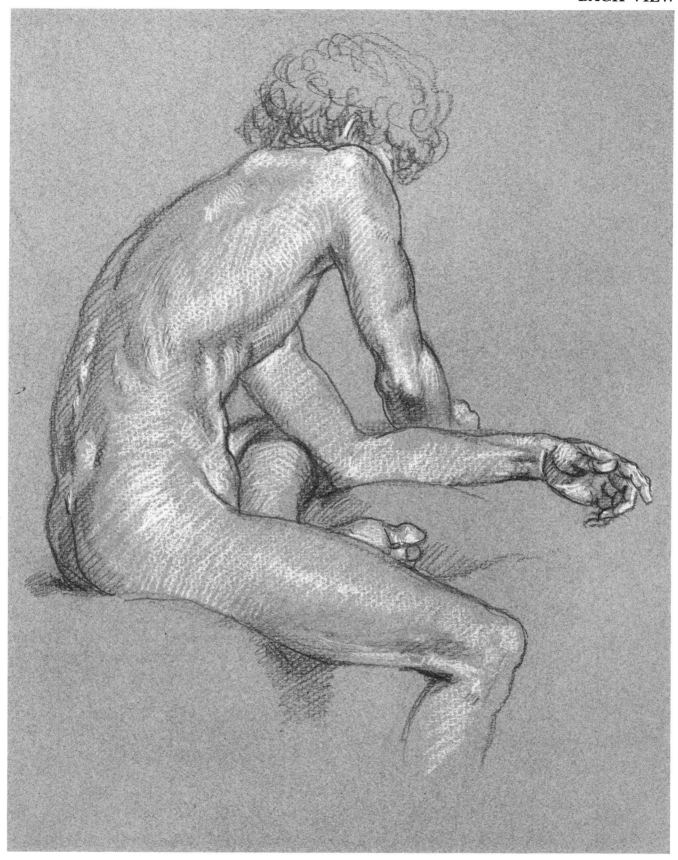

The thumb of the left hand projects forward because of the cast shadow and overlapping contour lines. The bone on the inside of the elbow is always prominent and shows on the bent right arm.

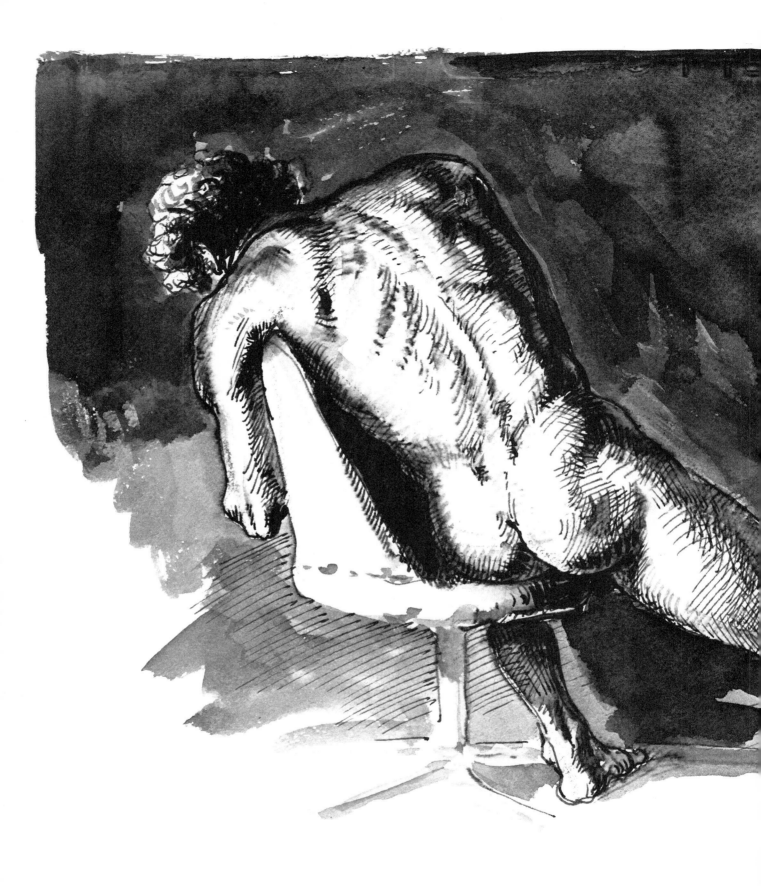

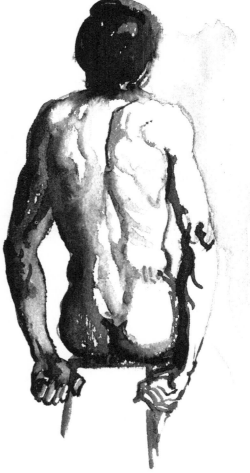

Above: The outside of the right arm is indicated by a watercolor wash over the negative background, and the paper becomes the light part of the arm. The forward, downward slant of the ribs has been indicated.

In this watercolor and ink drawing, the "butterfly" shape of the buttocks is evident. The underside of the foot reveals the inside arch and the straight outer layer of pads.

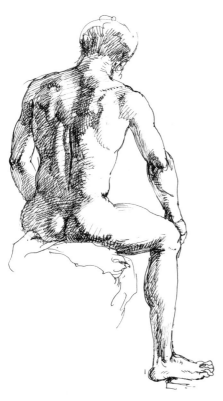

The ink lines continually follow the forms. The middle tones and highlights are treated as one tone.

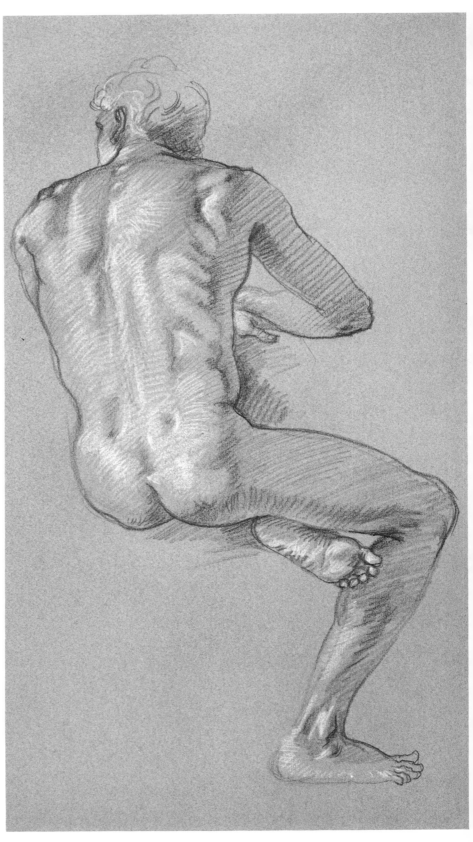

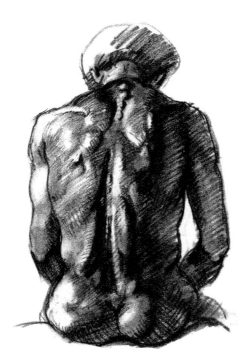

The vertebrae on the back of the neck and the shoulderbones are on the surface. The bent elbows make the bones create triangular shapes.

The two dimples at the end of the crest of the pelvis show. The ribs slant down and the shoulderbones angle outward as the arms pull forward.

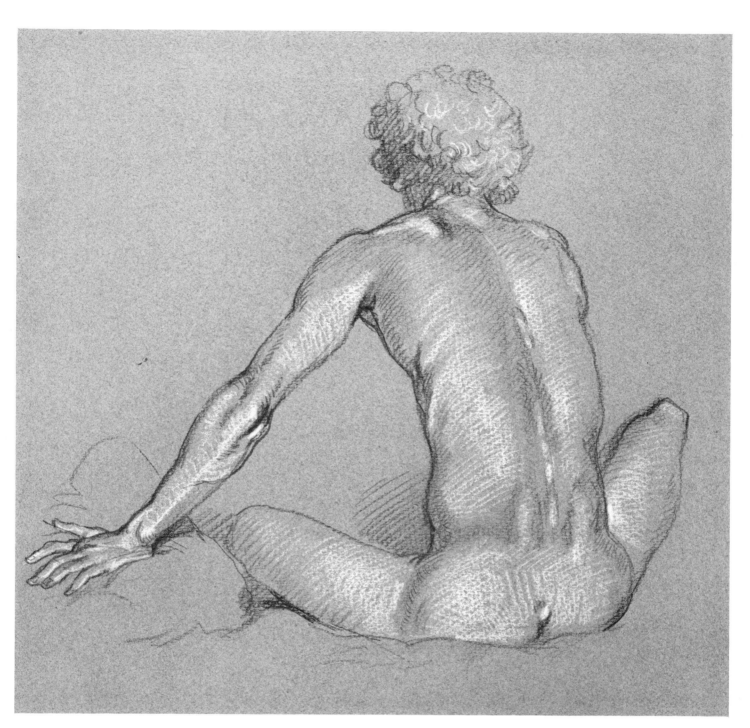

pelvis

two columns of muscles

coccyx bone

At the base of the spine, part of the pelvis called the coccyx (the beginning of the inverted human tail) protrudes. The spine pushes through the skin as the torso leans forward. Two vertical columns of muscles start at the end of the pelvis and insert up into the back along the spine (see diagram).

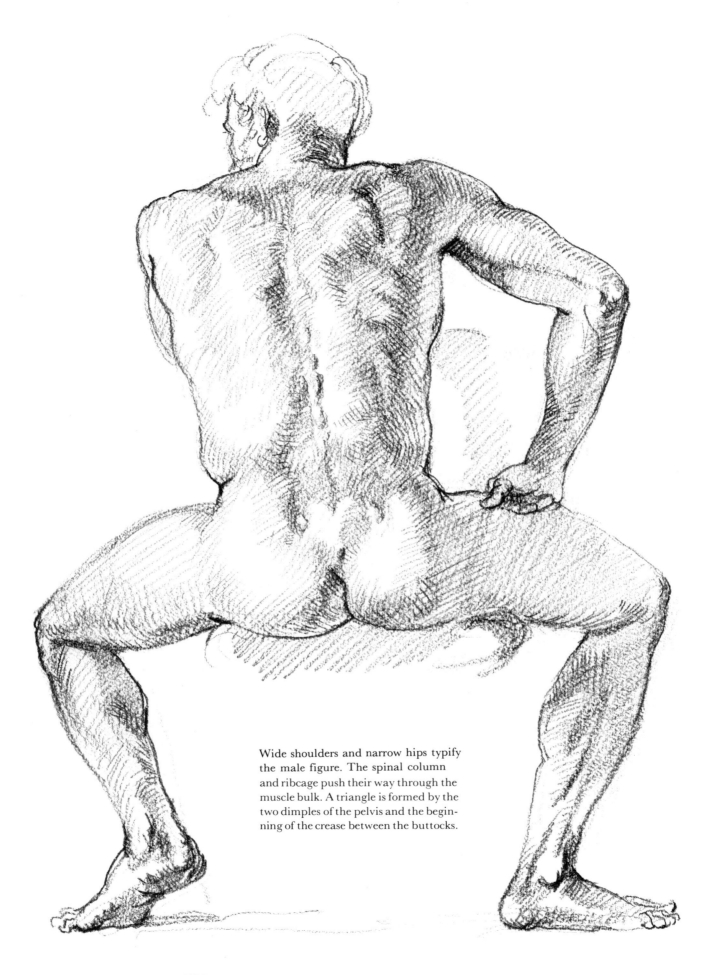

Wide shoulders and narrow hips typify the male figure. The spinal column and ribcage push their way through the muscle bulk. A triangle is formed by the two dimples of the pelvis and the beginning of the crease between the buttocks.

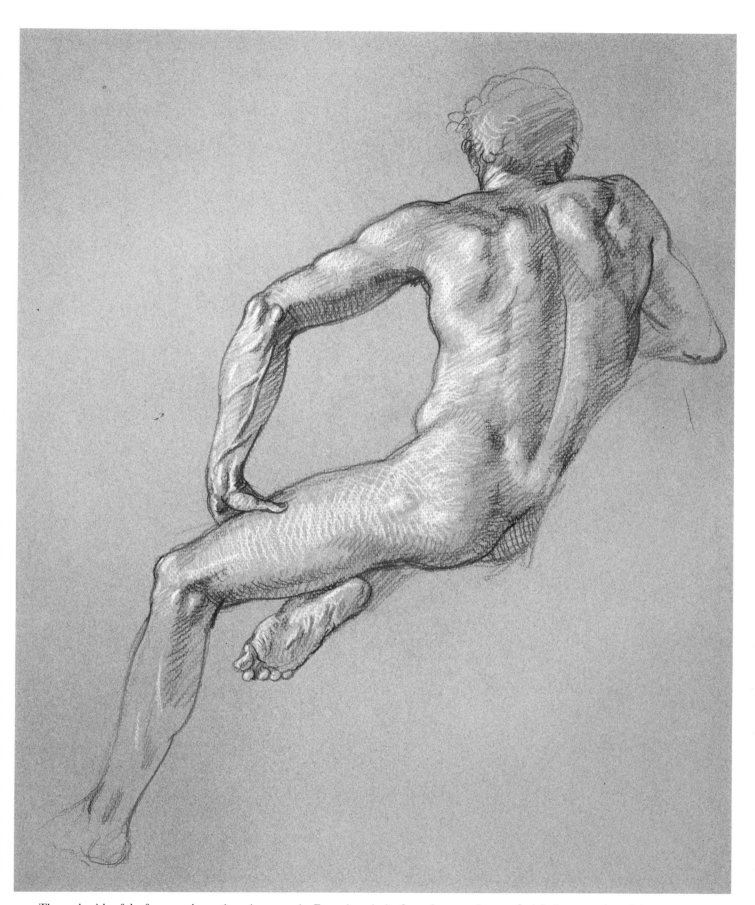

The underside of the forearm shows the veins strongly. Even though the figure has muscle tone, flesh bulges over the pelvic crest.

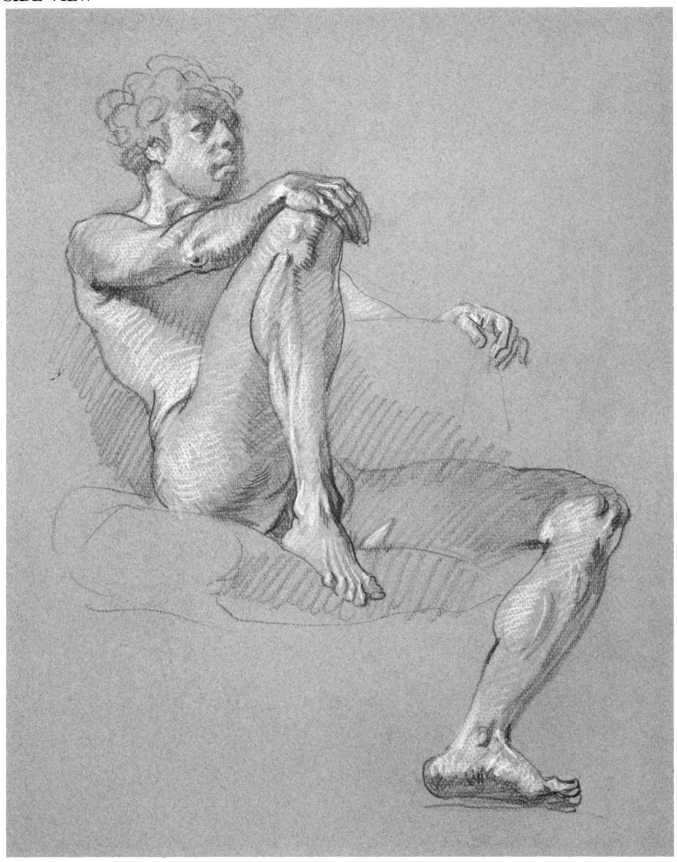

Seeing the underside of the left foot, along with the intersecting contour lines, helps make the left leg appear foreshortened. A dark accent around the right ankle pushes it to the foreground.

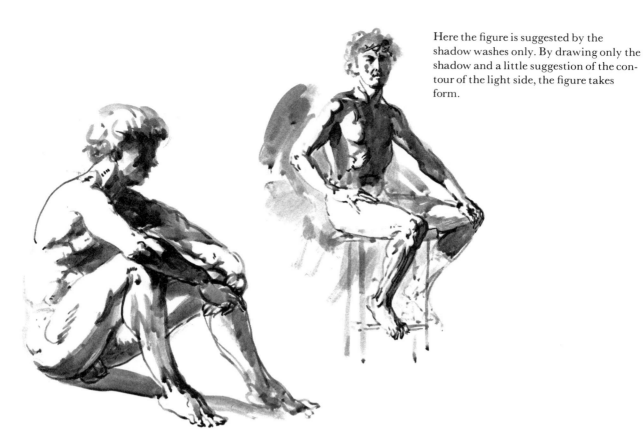

Here the figure is suggested by the shadow washes only. By drawing only the shadow and a little suggestion of the contour of the light side, the figure takes form.

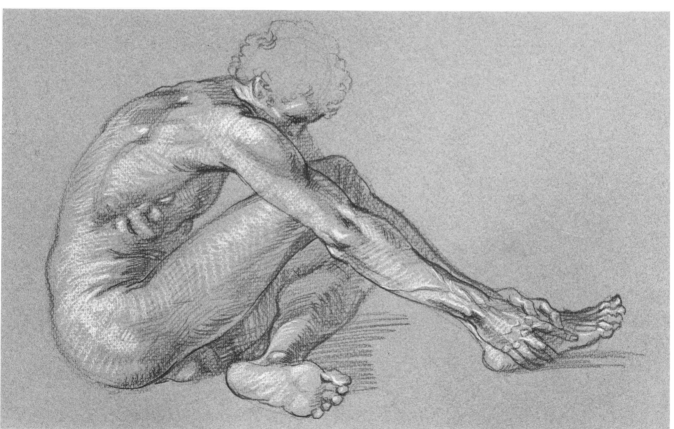

The muscles of the back extend out into the arm. The thumb side of the wrist is longer than the little finger side. There is a short flat space between the two bones of the arm and the hand at the wrist.

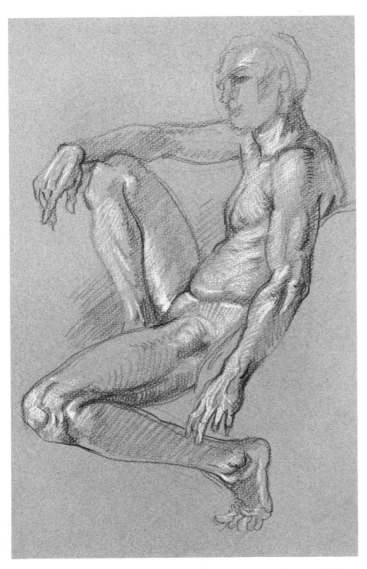

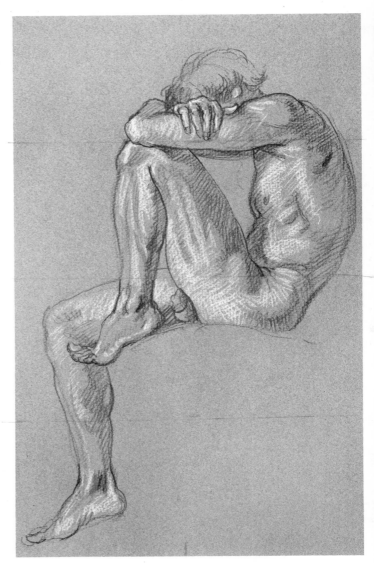

In the relaxed figure, the bones of the knee project forward. The muscles of the stomach are soft and relaxed.

The two different positions of the outside and inside of the ankle can be seen here, the outside being lower and in the middle, and the inside high and toward the front. The buttocks are flattened out by the weight of the torso.

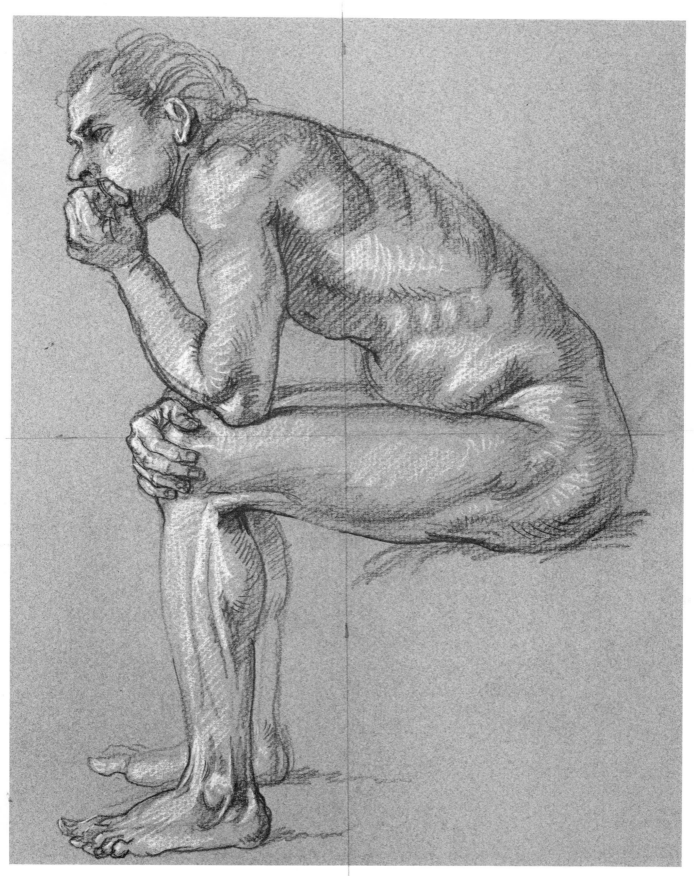

In contrast to the inside of the calf, the outside has several long, thin muscles that run down it to the foot. The belly hangs relaxed as the torso leans forward.

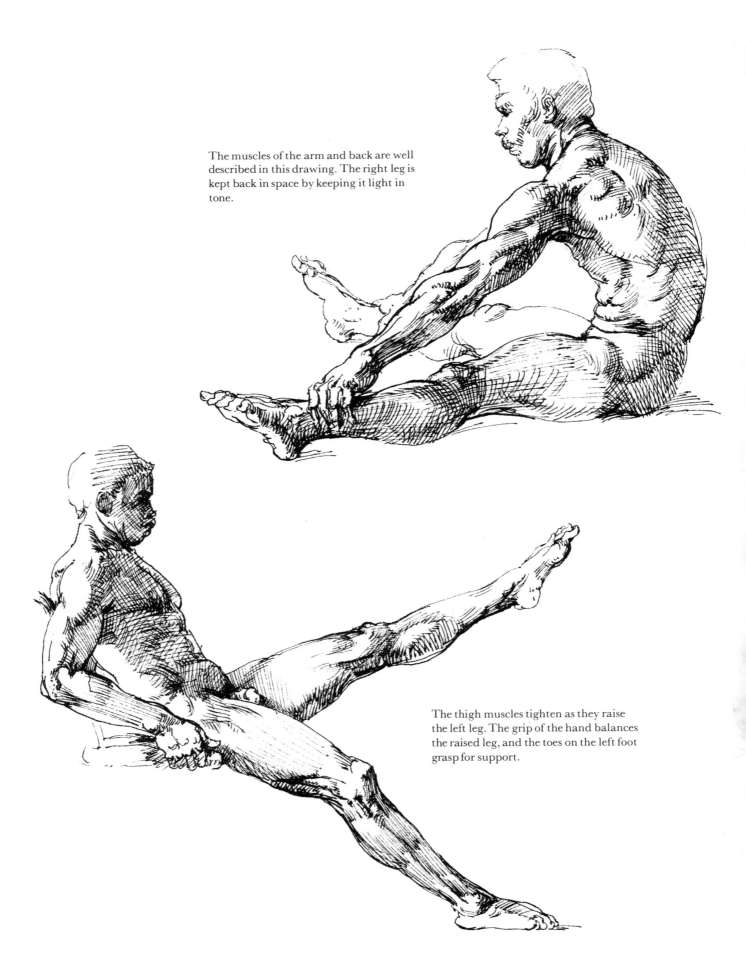

The muscles of the arm and back are well described in this drawing. The right leg is kept back in space by keeping it light in tone.

The thigh muscles tighten as they raise the left leg. The grip of the hand balances the raised leg, and the toes on the left foot grasp for support.

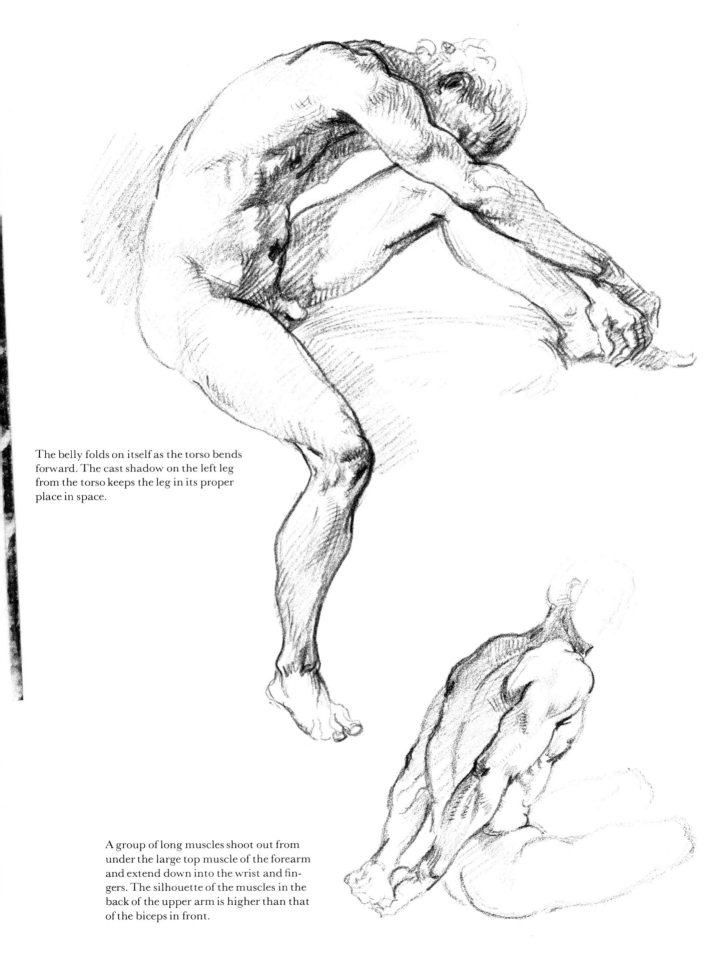

The belly folds on itself as the torso bends forward. The cast shadow on the left leg from the torso keeps the leg in its proper place in space.

A group of long muscles shoot out from under the large top muscle of the forearm and extend down into the wrist and fingers. The silhouette of the muscles in the back of the upper arm is higher than that of the biceps in front.

6
THE KNEELING FIGURE

Most of the weight of a kneeling figure is on one or both knees. A kneeling upright figure is six-heads tall, with the lower part of the leg prone to the supporting surface.

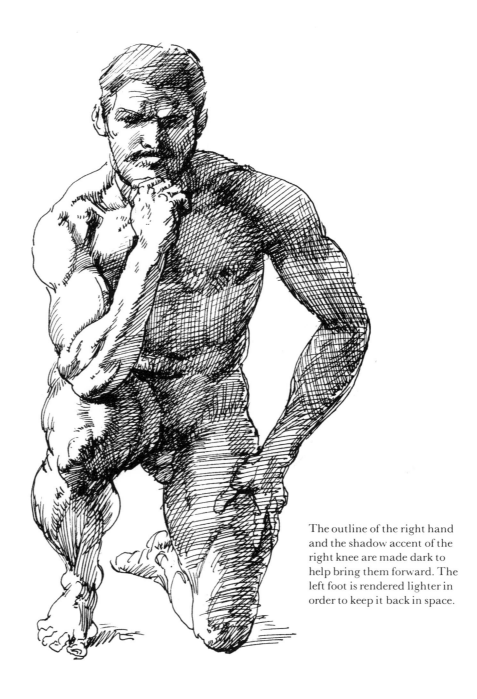

The outline of the right hand and the shadow accent of the right knee are made dark to help bring them forward. The left foot is rendered lighter in order to keep it back in space.

Step 1. A light pencil line is used to establish the attitude of the figure. The use of a pencil is recommended for the beginner. A very light wash of color is then applied to mark the shadow areas.

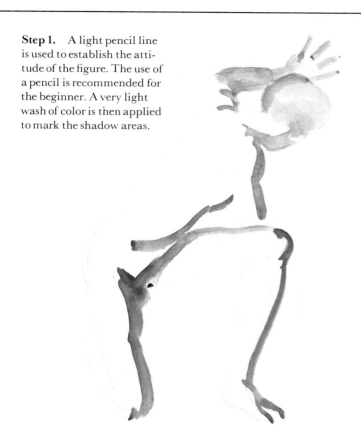

Step 2. With the same light wash, the outline is drawn more exactly and some of the inner drawing and accents of the shadows are established.

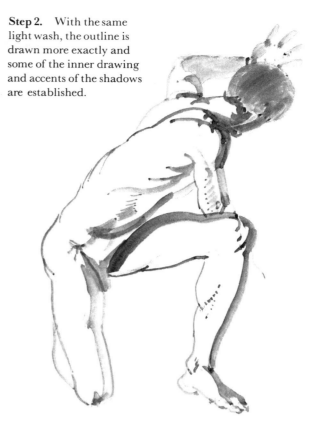

Step 3. The complete shadow area is washed in.

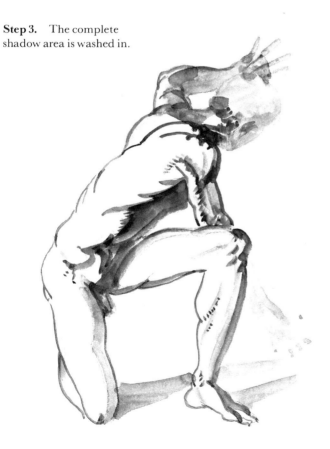

Step 4. With light washes, the modeling of the areas in the light is completed, leaving the white of the paper for highlights. Final touches of dark color are applied for the shadow accents.

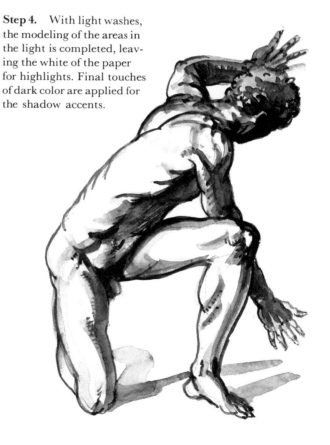

FRONT VIEW

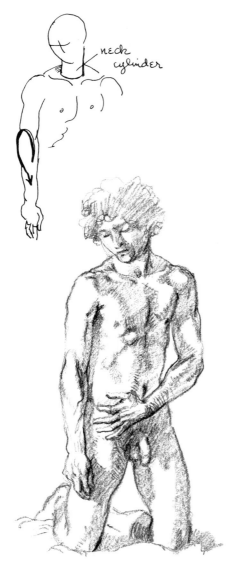

neck cylinder

Above: The muscles on the outside of the elbow start high up in the upper arm and cross over and down toward the thumb side of the wrist. The neck cylinder fits down between the back shoulder muscles and the two collarbones in front (see diagram).

The chest muscle or pectoralis pulls up into the arm and creates the front wall of the armpit. Next to the pectoralis, just above the armpit, is a small muscle called the coracobrachialis, that only shows when the arm is raised. The large muscle from the base of the neck to the back of the ear is the sternomastoid.

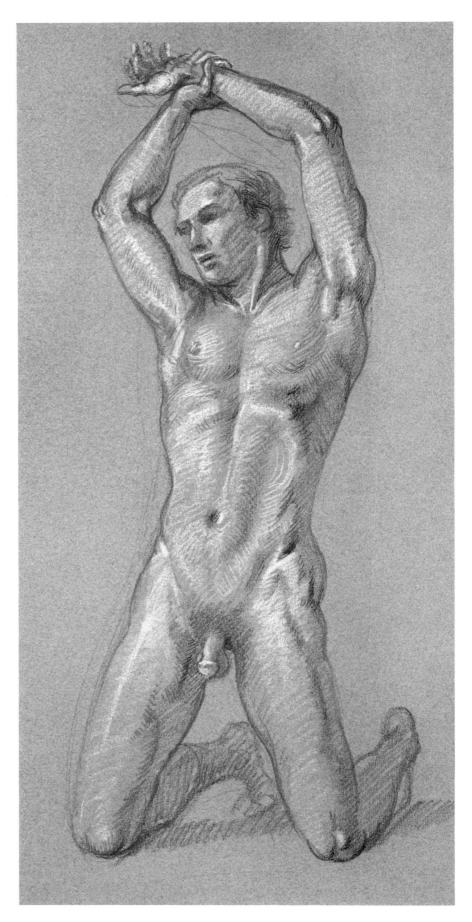

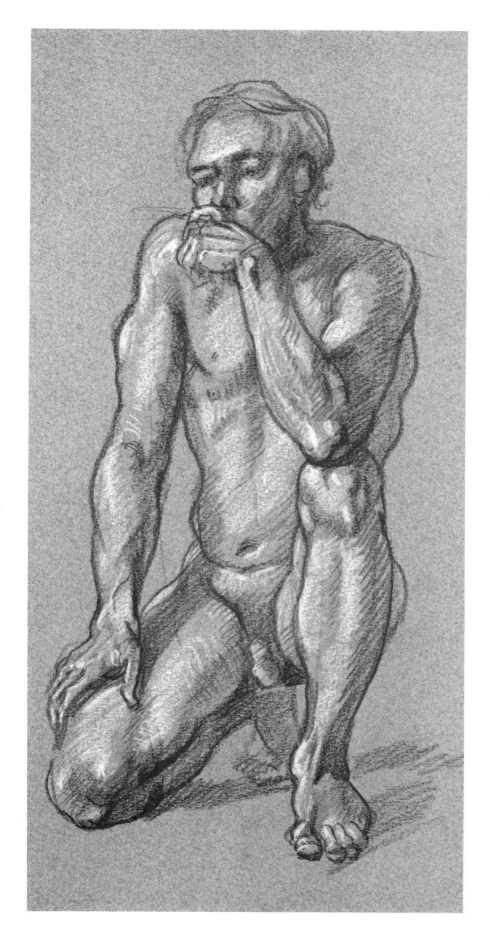

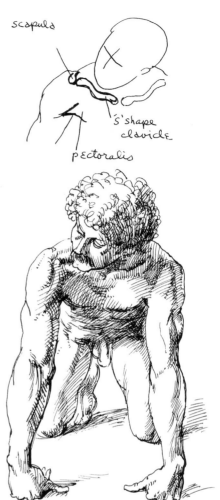

Above: The clavicles or collarbones angle back from the front of the base of the neck in an *S* shape and meet the end of the scapulas (see diagram above). The pectoralis or chest muscles insert out into the arms.

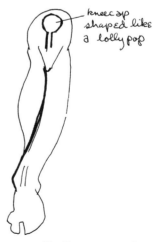

The kneecap and its ligament are shaped like a lollipop on a stick. The edge of the large bone of the lower part of the leg descends downward to the inside ankle (see diagram).

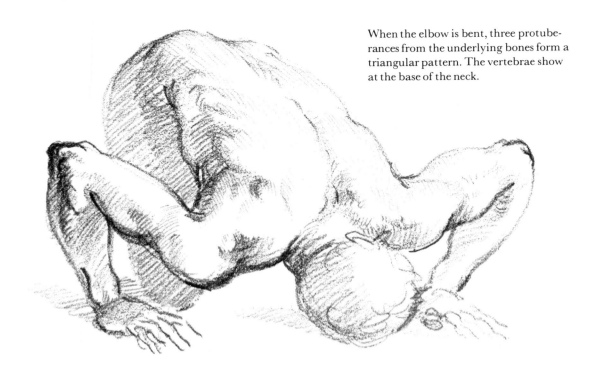

When the elbow is bent, three protuberances from the underlying bones form a triangular pattern. The vertebrae show at the base of the neck.

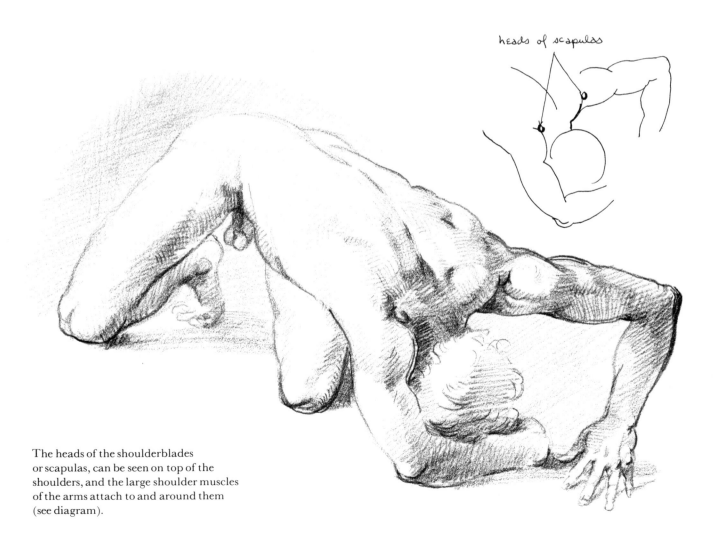

heads of scapulas

The heads of the shoulderblades or scapulas, can be seen on top of the shoulders, and the large shoulder muscles of the arms attach to and around them (see diagram).

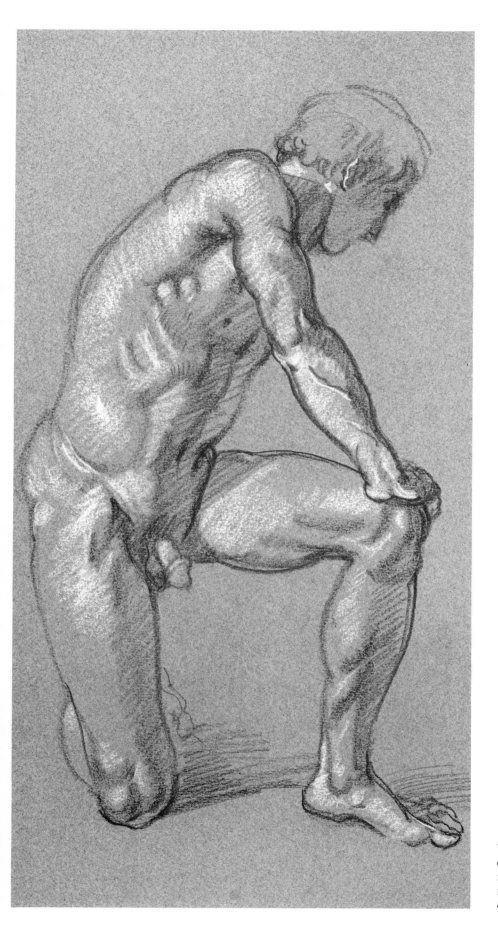

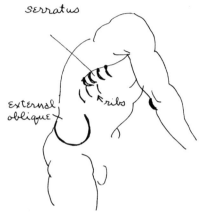

serratus

External
oblique

ribs

The full muscle above the pelvic crest is called the external oblique. The serratus muscles attach to the downward slanting ribs (see diagram). The bone on the inside of the elbow is always prominent.

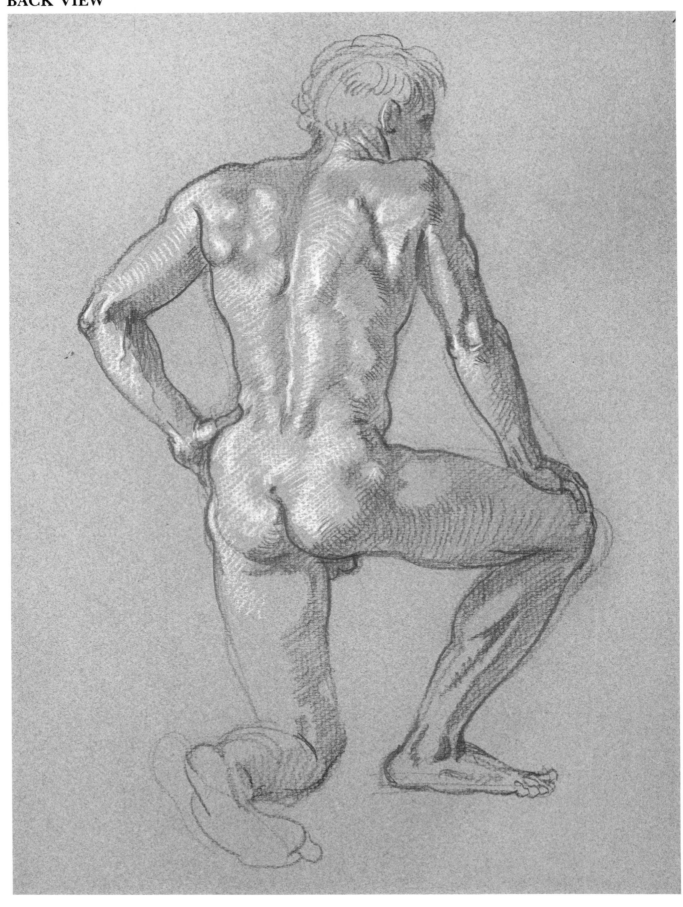

Right: As the torso twists on the pelvis and the head twists on the neck, folds are formed by the skin. The short head of the triceps is prominent on the upper part of the arm (see diagram at right).

short head of triceps

sacrospinalis

butterfly wings

Left: The inside bones of the elbows are obvious and protrude. Two cylindrical-shaped muscles, called the sacrospinalis, rise out of the pelvic region and disappear up into the back. The pelvic muscles in the back, called the gluteus maximus, form a butterfly shape (see diagram above).

The large muscle that forms the back of the shoulders is called the trapezius. It starts at the base of the skull and descends out to the tip of the scapulas forming the silhouette of the shoulders (see diagram).

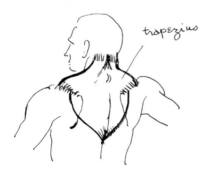

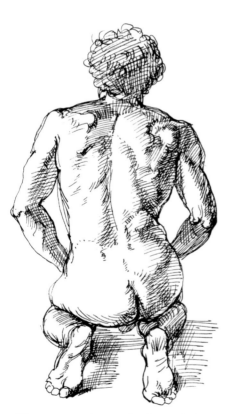

The two scapulas are clearly marked, as are the two dimples from the pelvis. The shoulders and pelvis are at opposite angles.

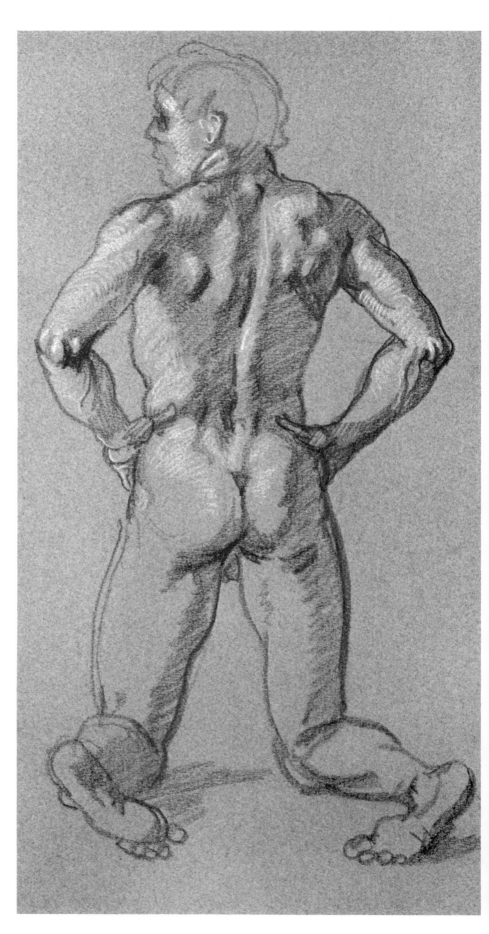

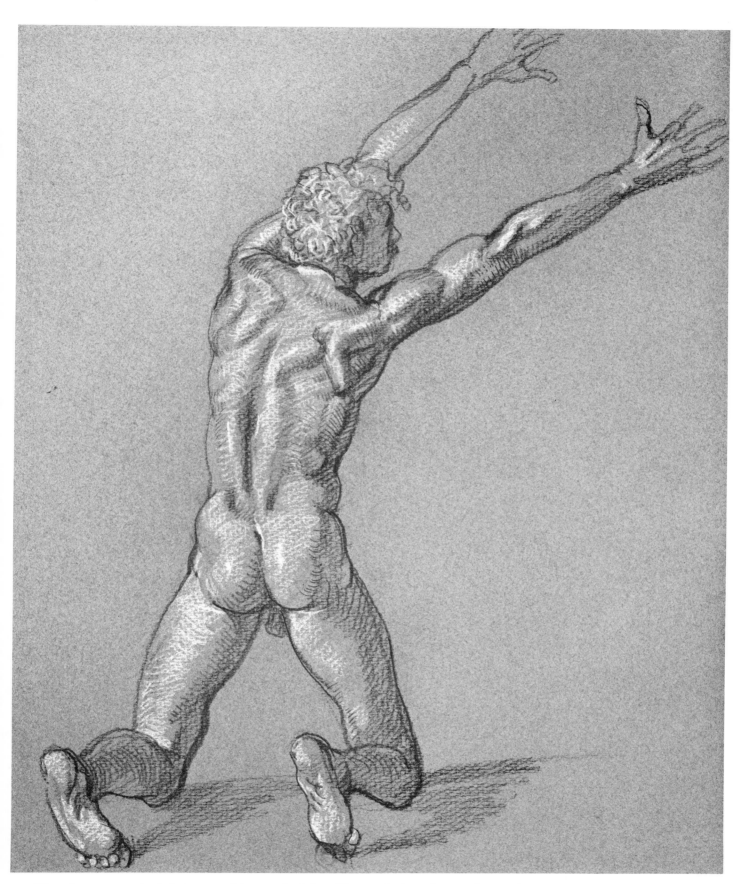

When the arms are raised, the bottom of the scapulas follow. The muscles from the scapulas attach out into the arms. They help to pull the arm back into place and rotate it.

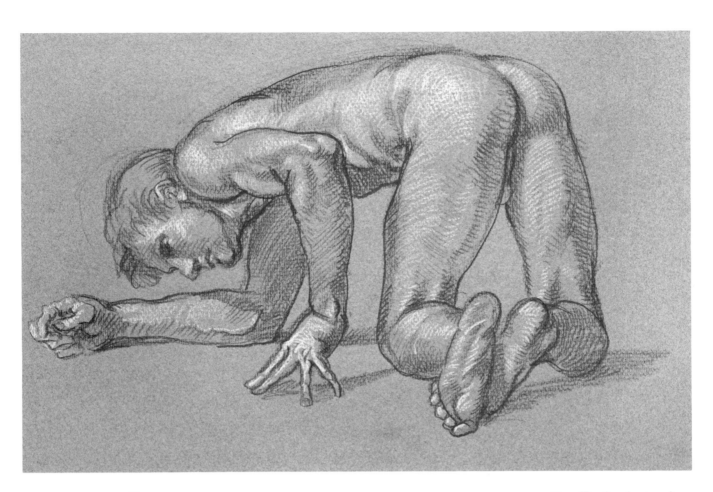

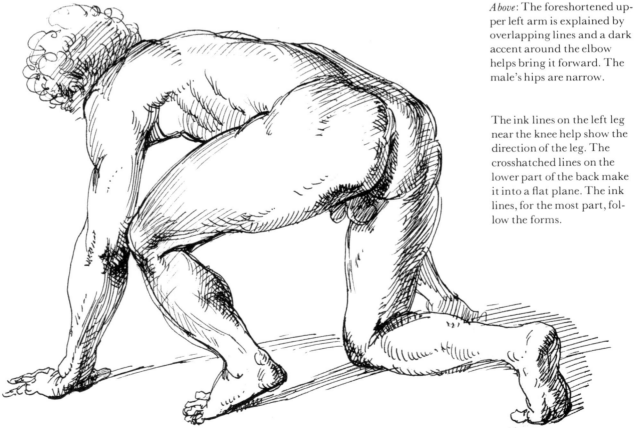

Above: The foreshortened upper left arm is explained by overlapping lines and a dark accent around the elbow helps bring it forward. The male's hips are narrow.

The ink lines on the left leg near the knee help show the direction of the leg. The crosshatched lines on the lower part of the back make it into a flat plane. The ink lines, for the most part, follow the forms.

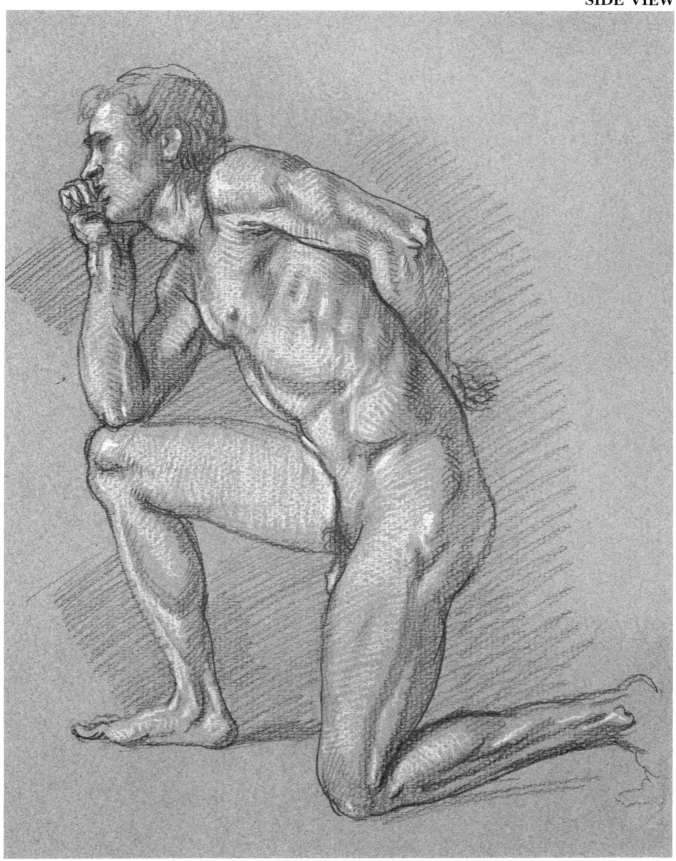

The division down the center of the body can be seen. The hipbone projects out from the pelvis and is the fourth head measurement. The two large muscles on the inside of the calf are clearly defined.

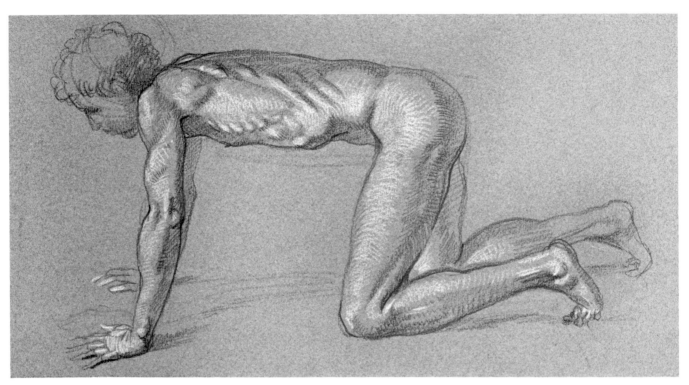

Above: The serratus muscles appear from beneath the latissimus dorsi muscle (see diagram) and attach to the ribs. The two floating ribs can be seen at the bottom of the ribcage.

A large muscle, called the latissimus dorsi, rises from the spine and pelvis and inserts out into the arm, forming the back wall of the armpit (see diagram). A band (the iliotibial band) runs down the outside of the leg from the gluteus muscles in the buttocks to the head of the large bone below the knee.

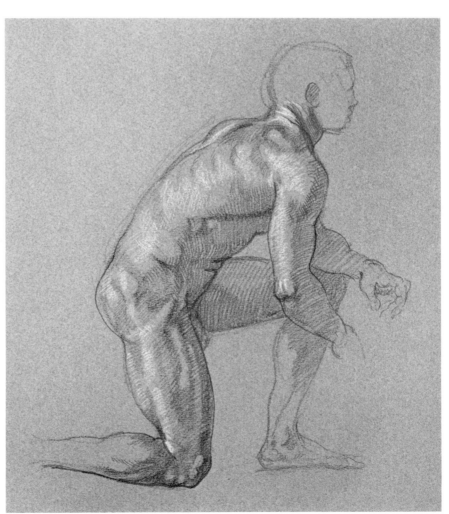

As the model twists to the left, the muscles on his right side are extended, while on the left side they fold in on each other forming large creases. The large muscle on the back of the thigh is called the biceps femoris; its two heads can be seen from the side (see diagram).

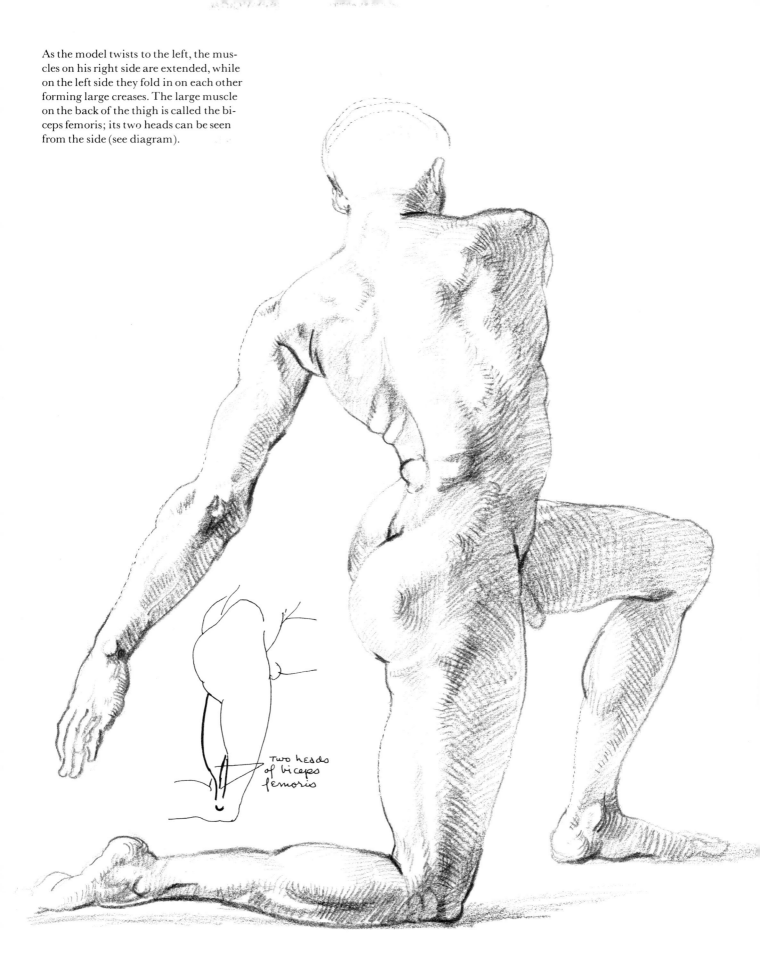

two heads of biceps femoris

These two poses are similar, except for a shift in the weight distribution. In the first drawing, the right arm, left leg, and right leg all have equal weight on them. In the second drawing, the figure creates an *A* shape, with the weight equally divided between two points.

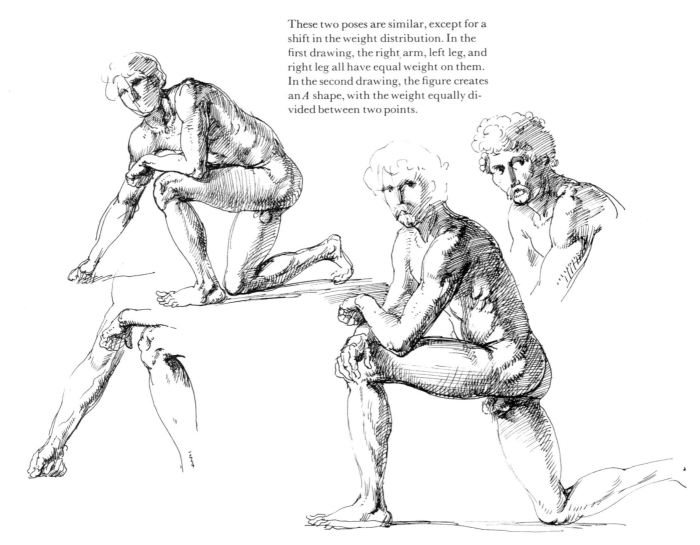

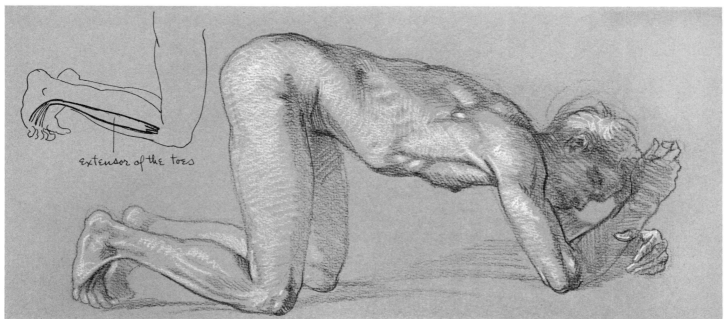

extensor of the toes

The tendons of the toes extend from a long muscle on the outside of the lower part of the leg called the extensor of the toes. The ribcage creates the main shape of the torso (see diagram).

Right: The left arm is locked, supporting the weight of the torso. When the knee is bent, the skin draws tight over the bones, exposing their shapes.

Below: The spinal column rises out of the pelvis and can be seen up to the base of the neck. The ribs can be seen on the back angling downward toward the front of the body.

7
THE CROUCHING FIGURE

Except for a few flat-footed positions, the crouching figure gives the feeling of expectant action or an action just completed. The weight distribution is temporary. Foreshortened arms and legs become a drawing problem.

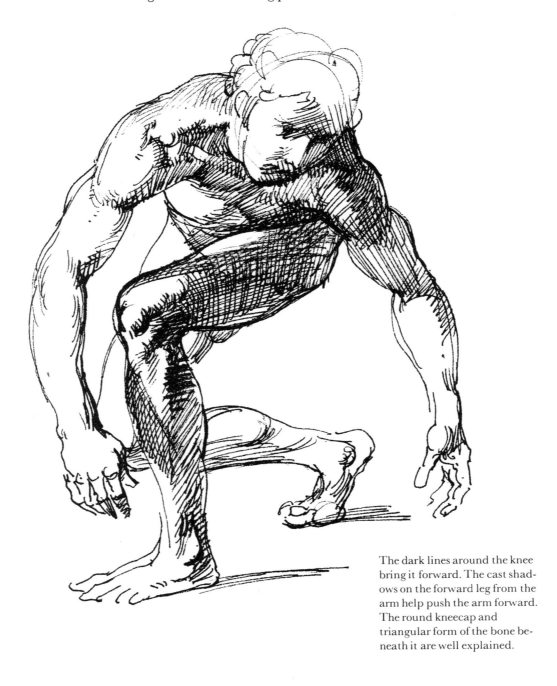

The dark lines around the knee bring it forward. The cast shadows on the forward leg from the arm help push the arm forward. The round kneecap and triangular form of the bone beneath it are well explained.

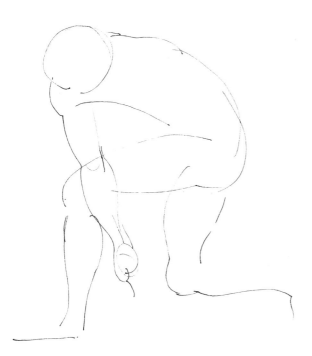

Step 1. A quick light outline is put down with pen suggesting the attitude and proportion. It is important to keep the drawing fluid and as loose as possible.

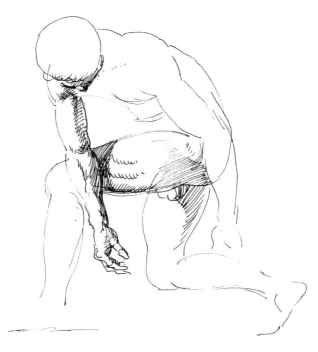

Step 2. The shadow and accents are indicated in a few areas. Because the ink has certain permanent qualities, it is not important to work all over at once. The ink lines follow the forms they depict.

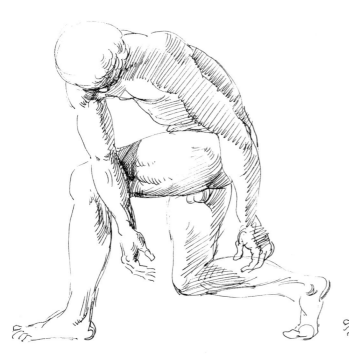

Step 3. The outline is redrawn more carefully, reserving the darks for later. The full mass of shadow is put in.

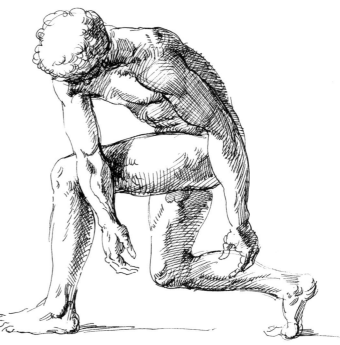

Step 4. With the addition of crosshatching and darker accents, the rest of the figure is rendered. The darks are used to push or pull one section in front of another.

FRONT VIEW

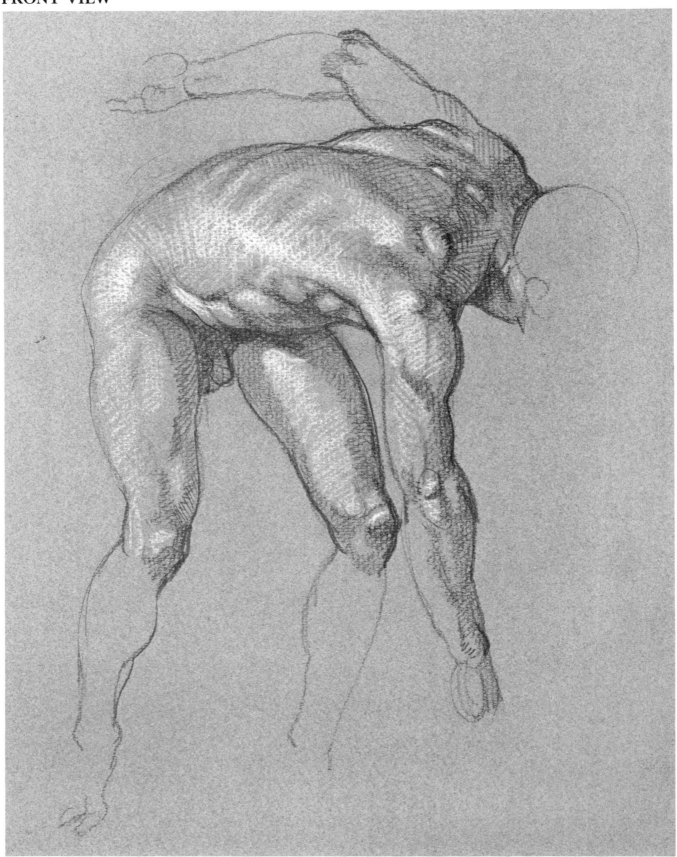

The latissimus dorsi muscle stretches out into the arm and the ribs of the back show through it. The serratus muscles pull out from under it and attach to the ribs on the side.

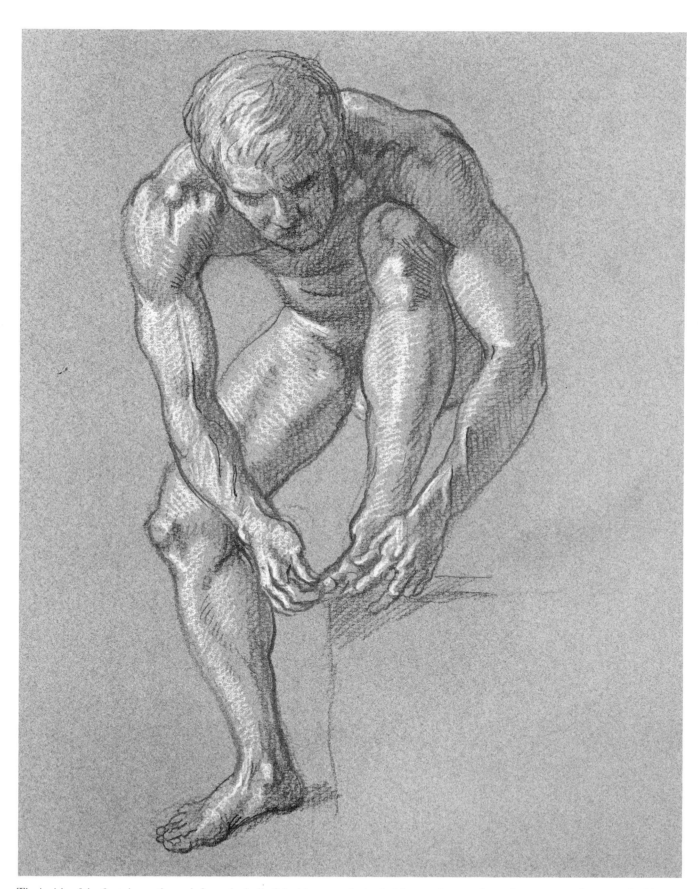

The inside of the foot shows the arch from the ball of the big toe to the heel. A large vein runs down the upper arm between the biceps and triceps and breaks up into smaller tributaries on the inside of the forearm.

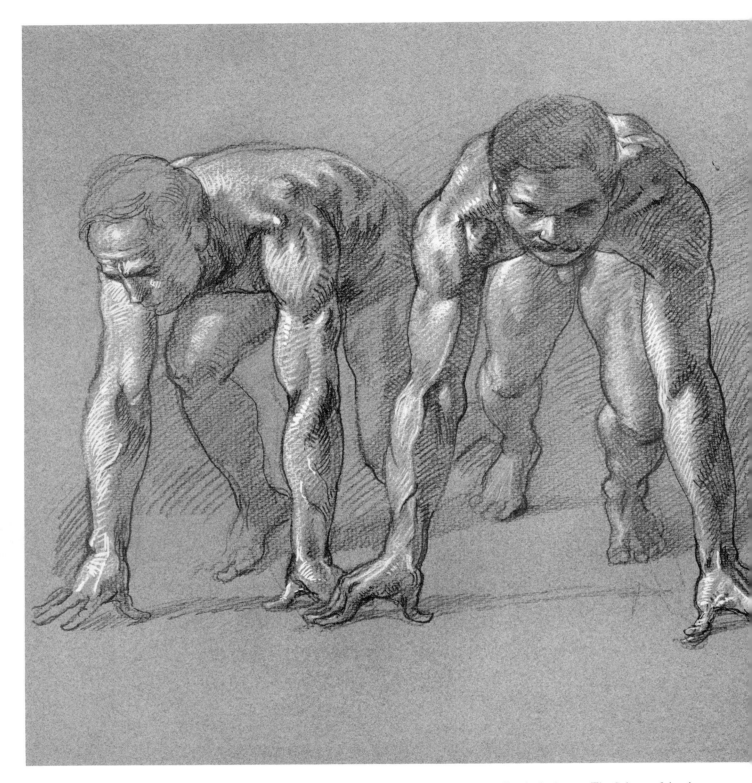

The weight of the torsos is held by the extending locked arms. The *S* shape of the clavicles or collarbones can be easily seen. The divisions of the deltoid muscles or shoulder muscles of the arm are defined (see diagram).

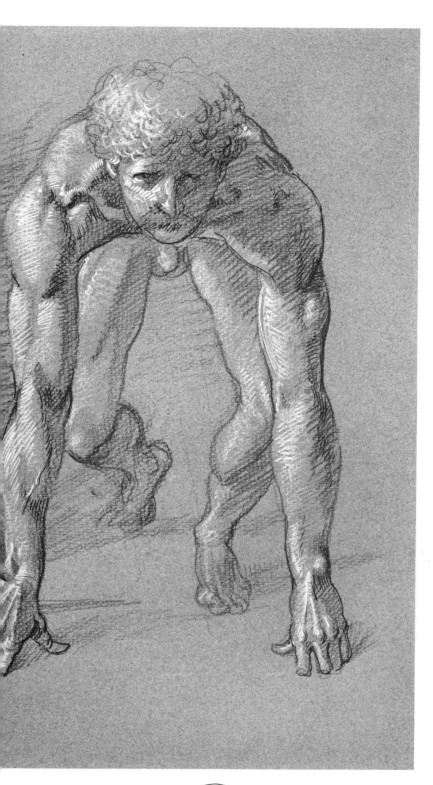

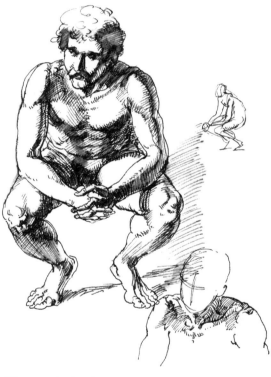

The cast shadow from the right arm on the leg and torso helps make them recede. The drawing was rendered in a water-soluble ink, and was then washed over with a brush and clear water.

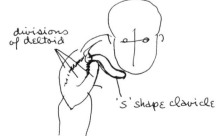

divisions
of deltoid

'S' shape clavicle

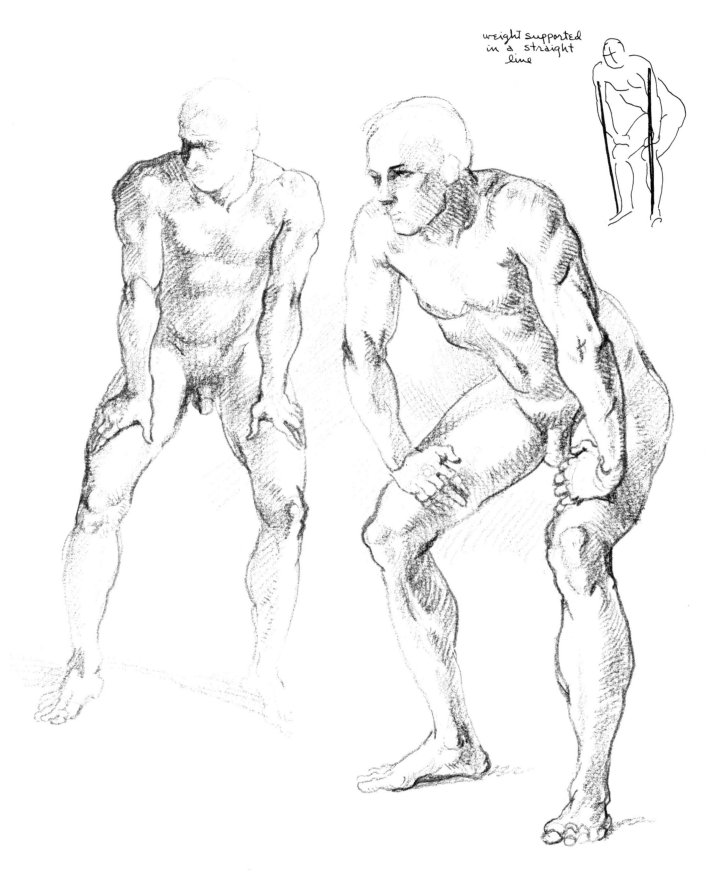

weight supported
in a straight
line

The figures are posed in similar positions except that the hands point in on one and to the outside on the other. The torso weight is carried in a straight line from the lower leg through the length of the arm to the shoulder (see diagram). The locked arm flexes the triceps.

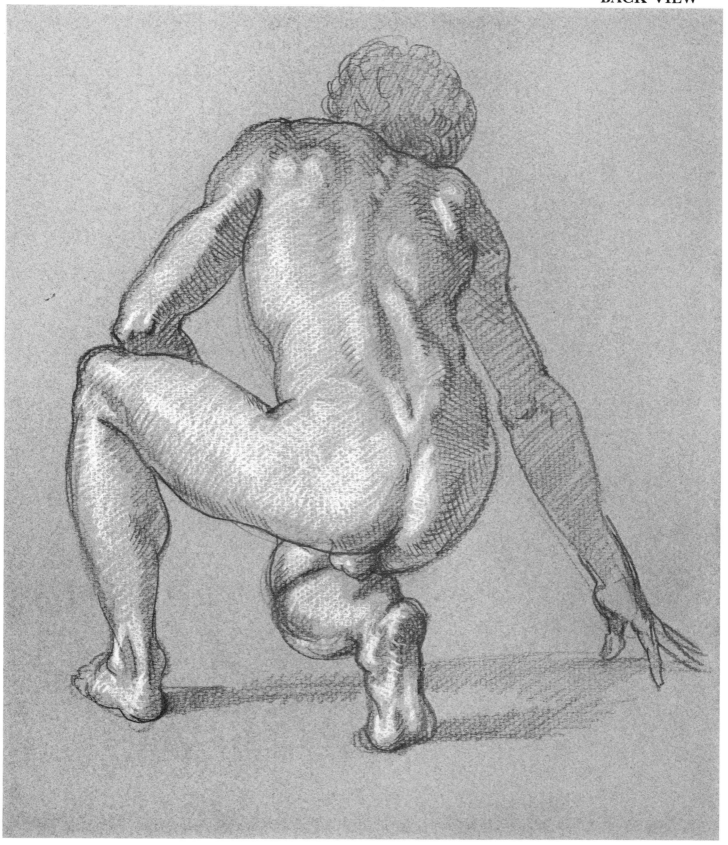

The backbone twists and the shoulders slant with it. The different shapes of the bent and straight elbow can be seen. The flat *V* shape of the bottom of the spine is evident between the buttock muscles.

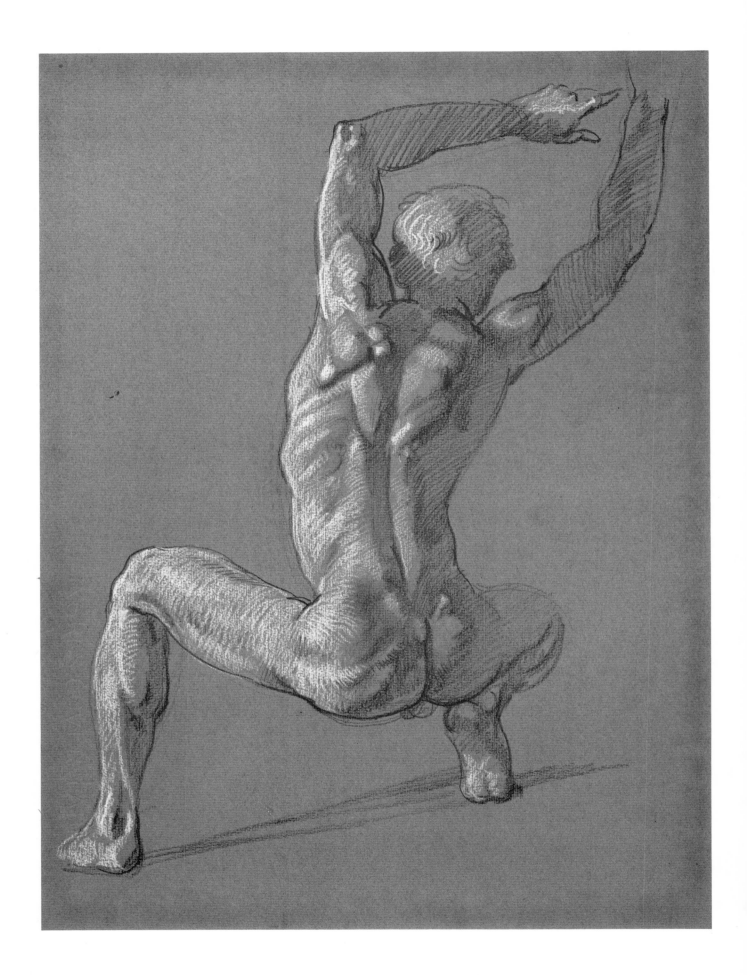

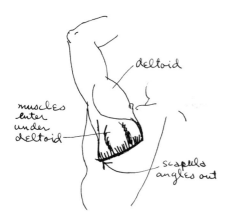

muscles
enter
under
deltoid

deltoid

scapula
angles out

Left: The scapulas angle out as they follow the direction of the raised arms. The muscles from the scapula enter into the upper arm underneath the deltoid (see diagram).

Below: The cast shadow from the left arm on the leg explains the rounded form of the leg. The large calf muscle can be seen covering the lower back of the right leg, and attaching to the foot at the heel. On the right foot, the arch on the big-toe side and the straight pad on the outside of the foot show as the sole is exposed.

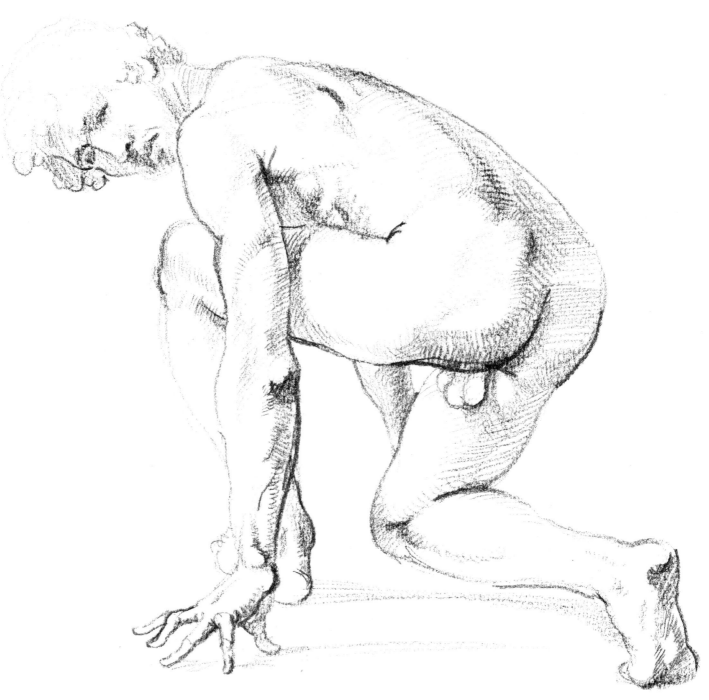

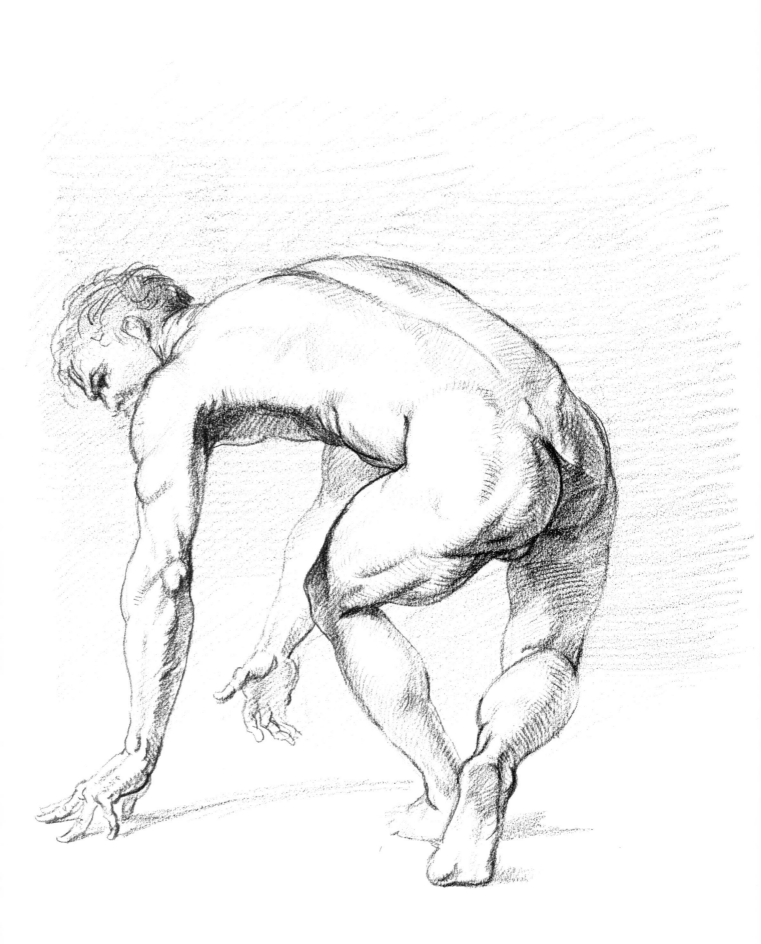

Left: The cast shadow from the left arm and overlapping forms helps explain the foreshortening on the left leg. The pelvic ridge on the side and back can easily be seen.

Below: The large areas of light and shadow help explain the twisted position of the figure. Dark accents help push one form in front of the other. Tendons show on the back of the knee.

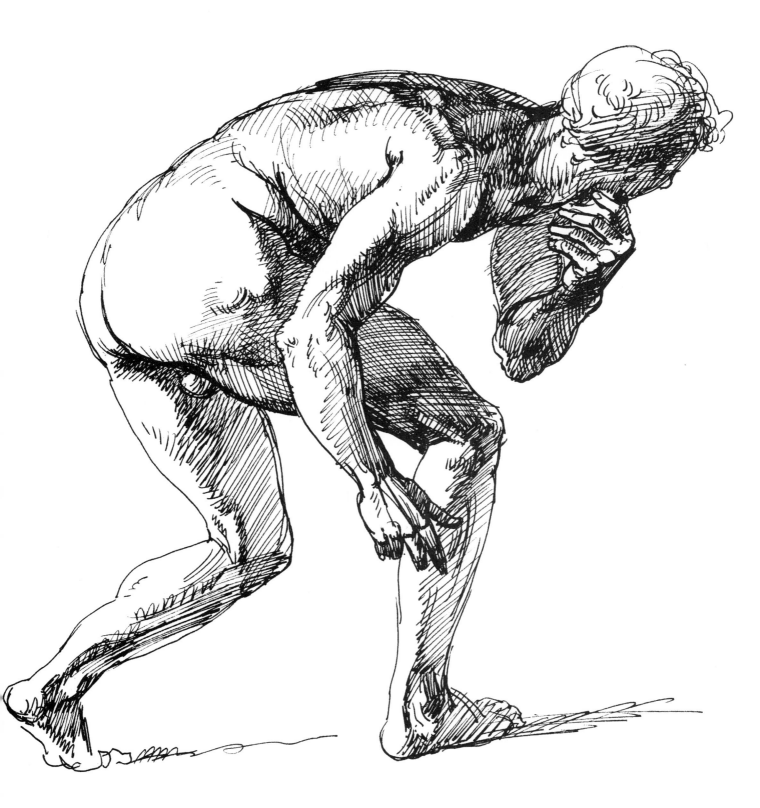

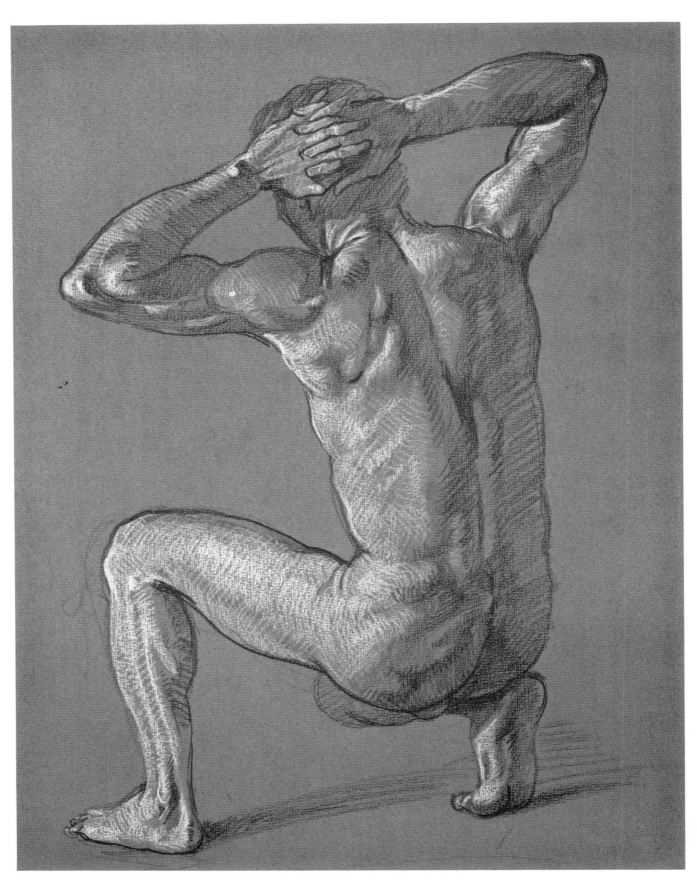

The large latissimus dorsi muscle enters the arm and forms the back wall of the armpit. The separations of the various fibers of the gluteus muscle or buttocks can be seen. In the upper left arm, light hits two of the three tricep heads.

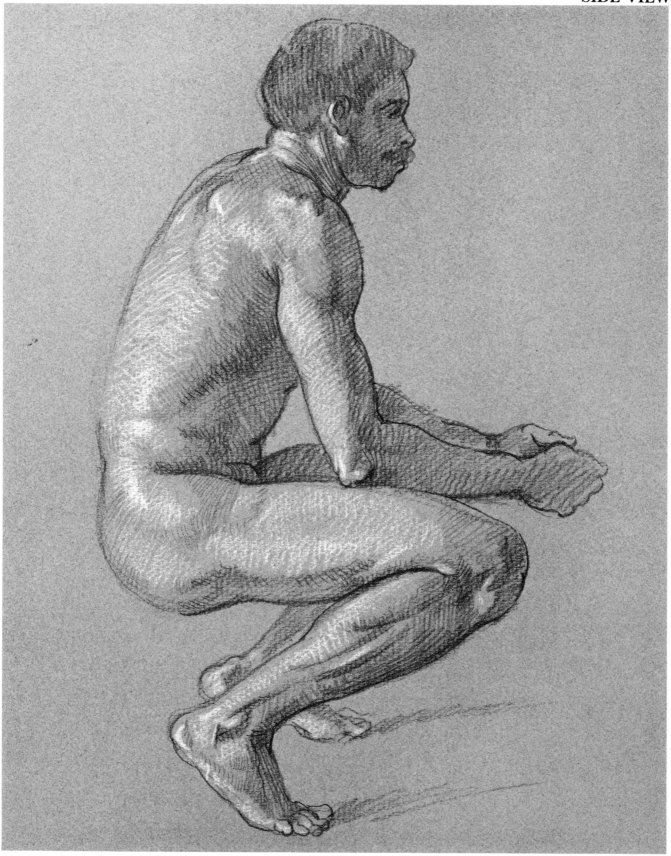

On the relaxed back, the shoulderblade sticks out prominently. The hands and arms counter the weight of the torso, balancing the model as he supports himself on his toes.

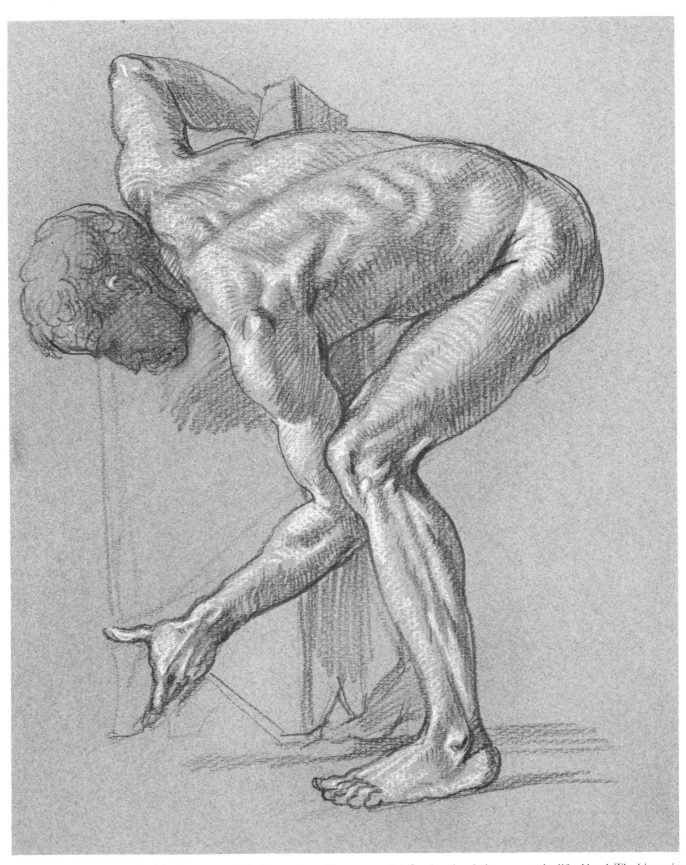

The muscles on the outside of the lower part of the leg strain and become well defined as they help support the lifted load. The biceps in front of the upper arm swell as they help lift the object.

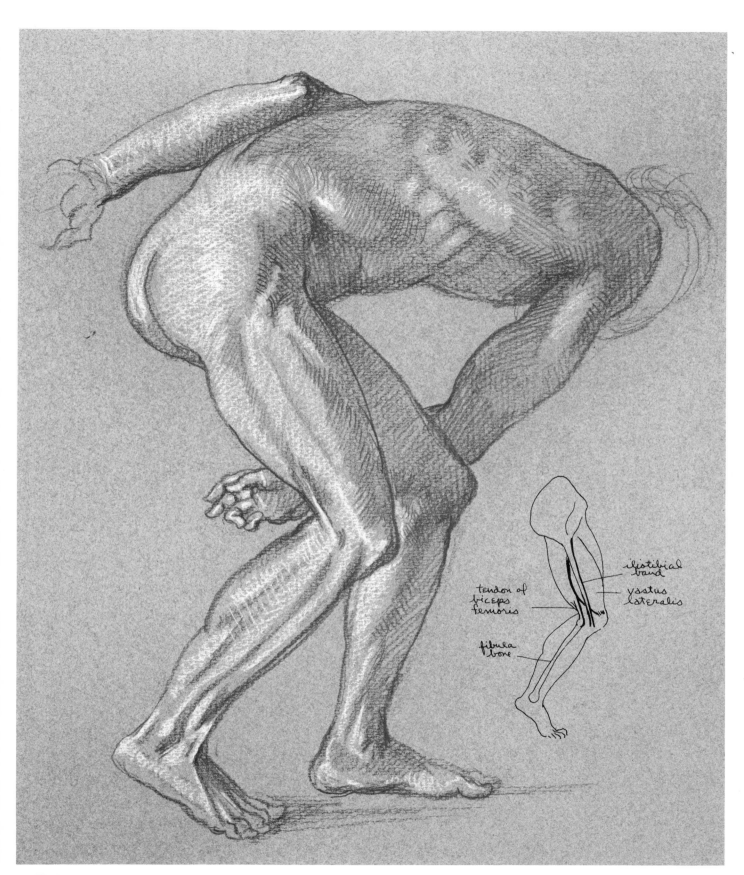

The iliotibial band and the biceps femoris show as two tendons on the outside of the knee. The large muscle under the iliotibial band is called the vastus lateralis. The tendon of the biceps femoris attaches to the fibula or outside bone of the lower part of the leg. The fibula can always be seen at the ankle and outside of the knee (see diagram).

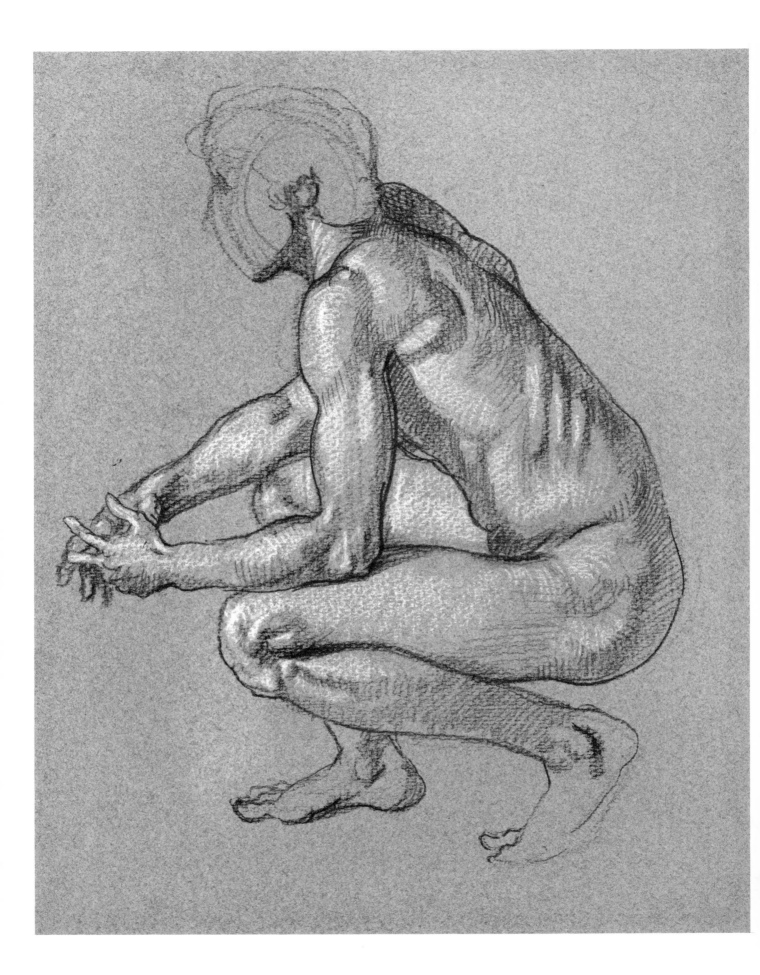

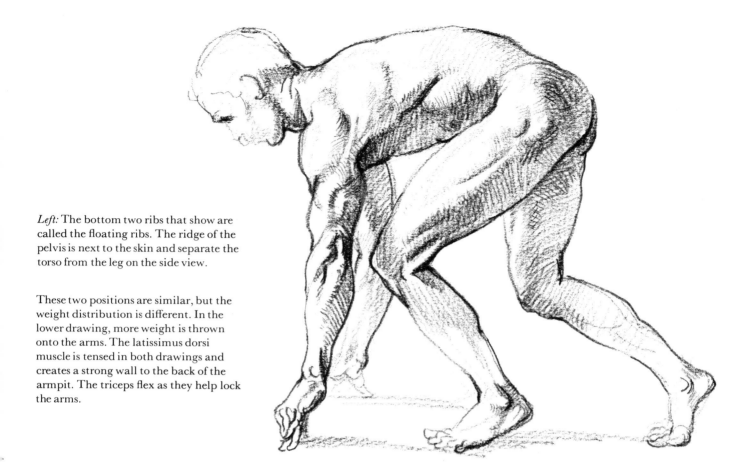

Left: The bottom two ribs that show are called the floating ribs. The ridge of the pelvis is next to the skin and separate the torso from the leg on the side view.

These two positions are similar, but the weight distribution is different. In the lower drawing, more weight is thrown onto the arms. The latissimus dorsi muscle is tensed in both drawings and creates a strong wall to the back of the armpit. The triceps flex as they help lock the arms.

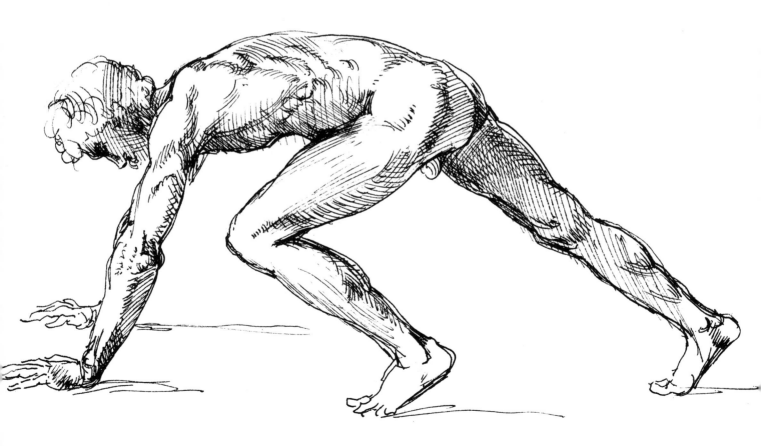

As the arm stretches out, the three heads of the triceps appear in the back of the arm. When the leg is bent, the tendon of the biceps femoris appears (see diagram).

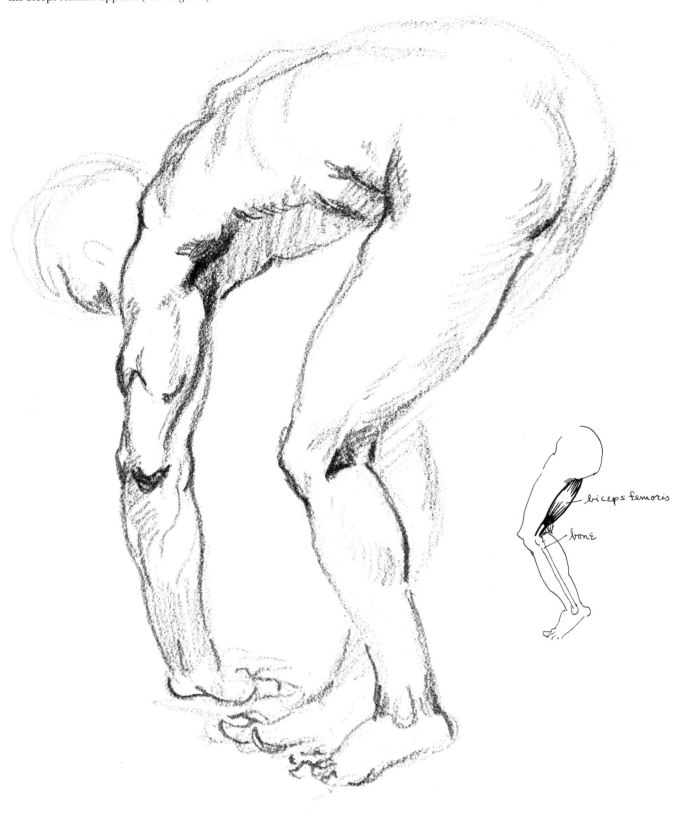

biceps femoris

bone

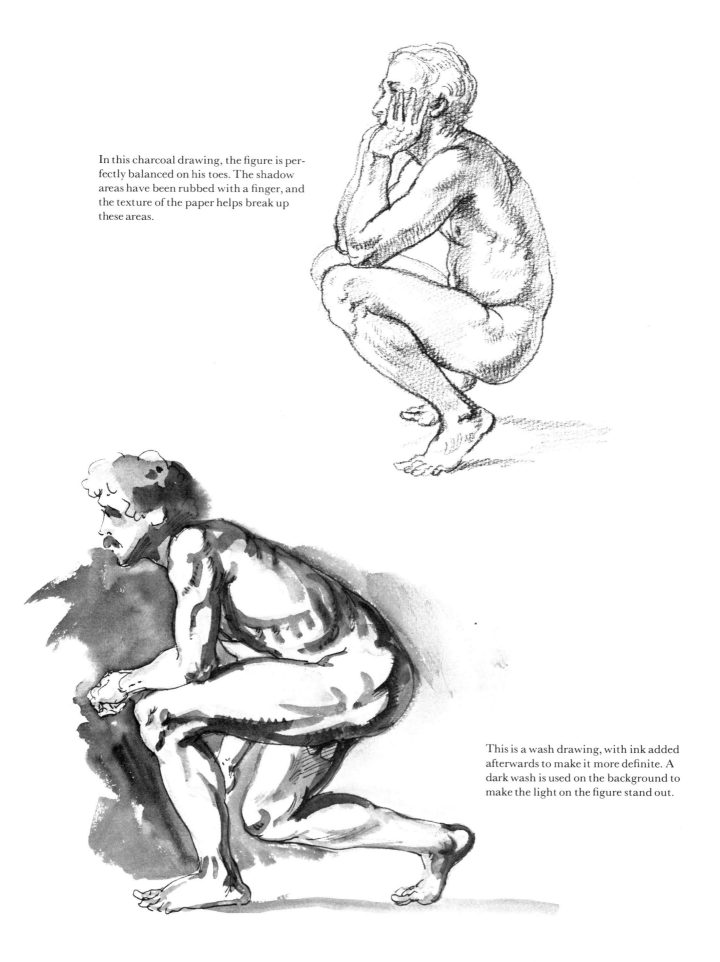

In this charcoal drawing, the figure is perfectly balanced on his toes. The shadow areas have been rubbed with a finger, and the texture of the paper helps break up these areas.

This is a wash drawing, with ink added afterwards to make it more definite. A dark wash is used on the background to make the light on the figure stand out.

8
THE RECLINING FIGURE

Foreshortened limbs and difficult angles make the reclining figure seem more difficult to draw. Proportion becomes the biggest problem. The upright figure is more familiar to the eye and therefore easier to conceive than the reclining one. The eight-head-length measurement is hard to use if there is any foreshortening. Probably the easiest way to measure is to divide the length of the figure in half and then in quarters, finding a new point of reference for measurement.

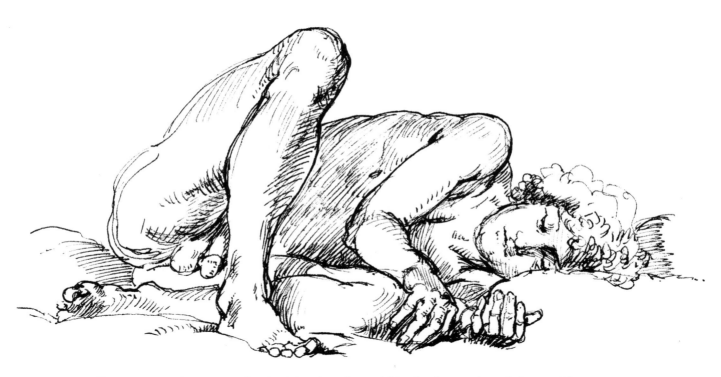

The right leg and arm are outlined to bring them forward. The foreshortened arm is drawn with overlapping lines. The arch of the knuckles can be seen, the middle knuckle being the highest point in the arch.

Step 1. First cover the entire white paper with charcoal, rubbing it with your hand until it is a single gray tone. Then draw the figure with charcoal, making certain that the attitude and contour lines are established.

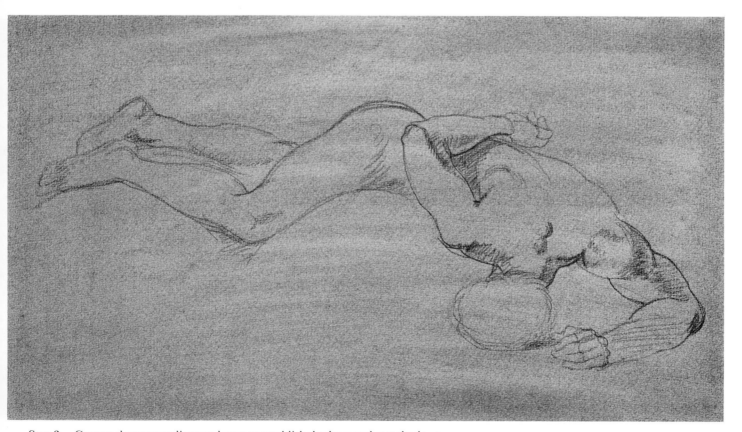

Step 2. Correct the contour lines and start to establish shadows and cast shadows.

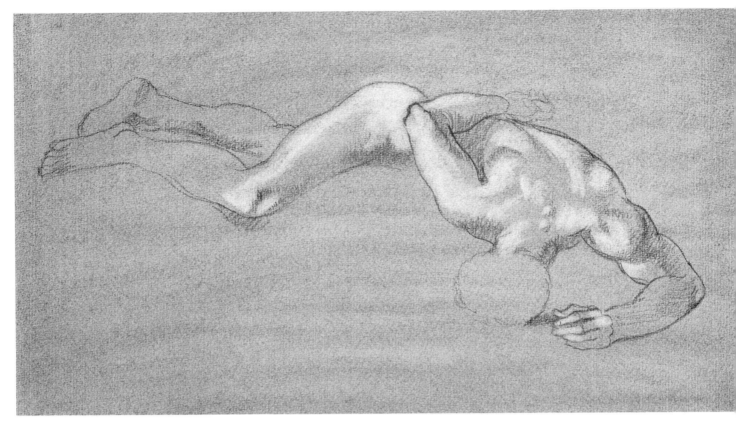

Step 3. Pick out highlights with a kneaded eraser, letting the white paper stand for the highlights. Tones can be controlled easily by rubbing with your finger or erasing. This technique is very versatile and allows easy corrections.

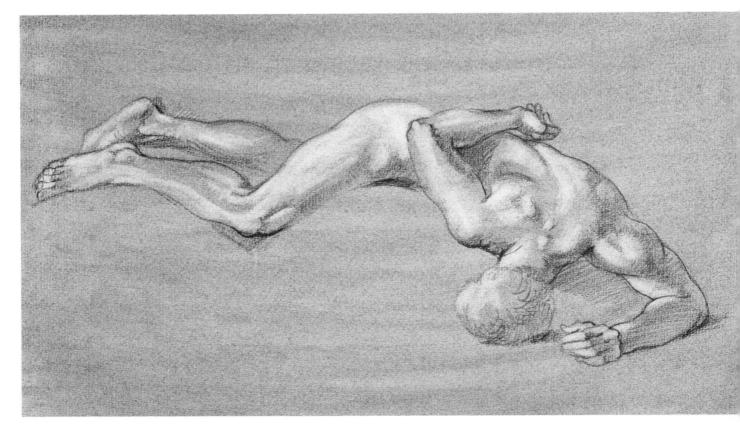

Step 4. Bring the drawing to a finish, working simultaneously in both light and shadow areas.

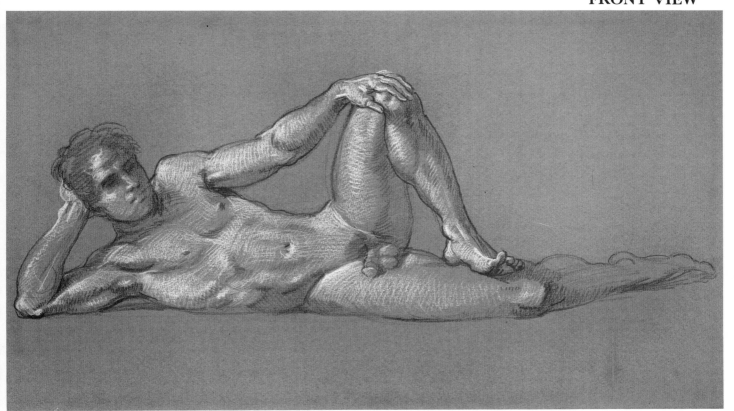

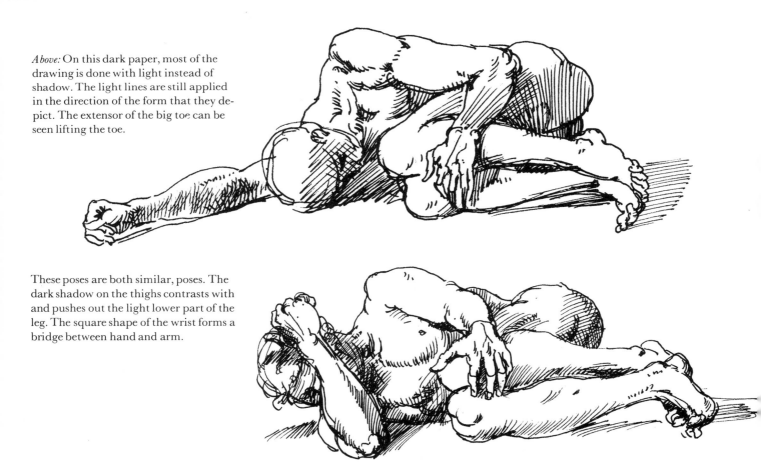

Above: On this dark paper, most of the drawing is done with light instead of shadow. The light lines are still applied in the direction of the form that they depict. The extensor of the big toe can be seen lifting the toe.

These poses are both similar, poses. The dark shadow on the thighs contrasts with and pushes out the light lower part of the leg. The square shape of the wrist forms a bridge between hand and arm.

Dark accents and cast shadows
are used to explain the place-
ment of one form in front of an-
other in this pencil drawing.
Notice that the shadow areas
are scribbled in.

Below: The cavity of the ribcage
is obvious here. The stomach is
pulled down by its weight. Ten-
dons insert into the top of the
foot from the leg.

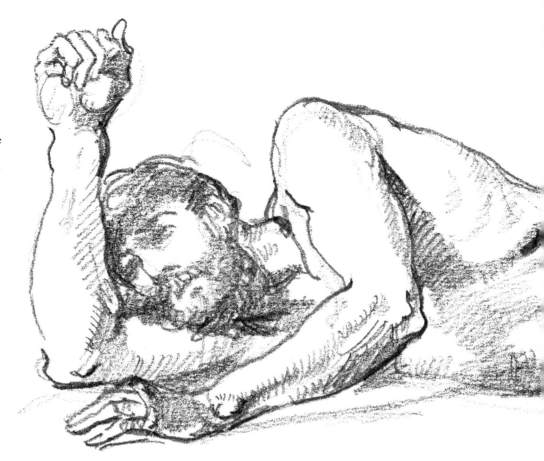

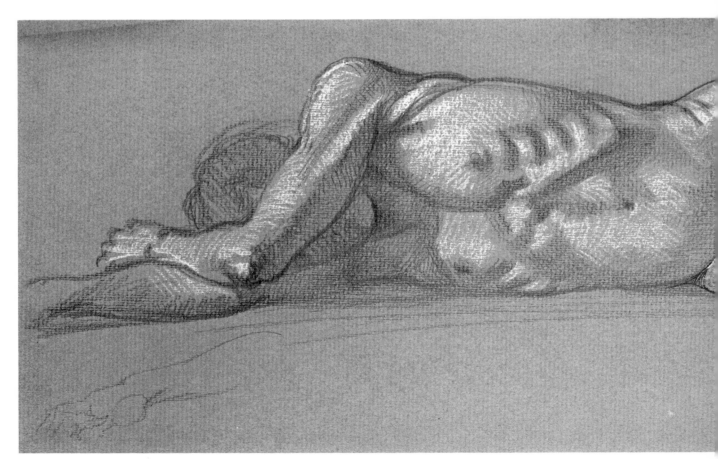

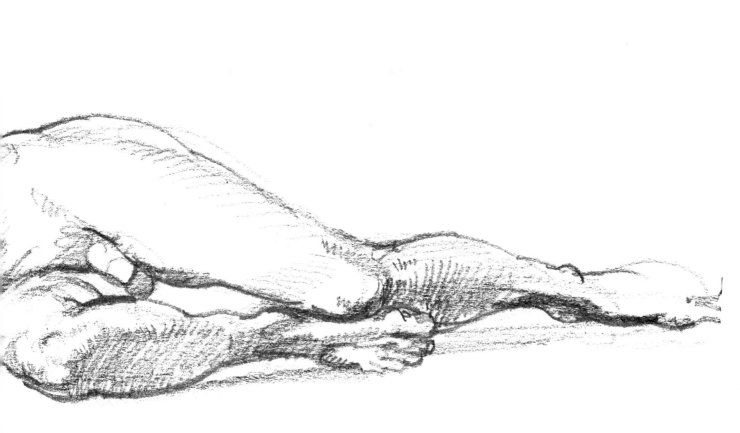

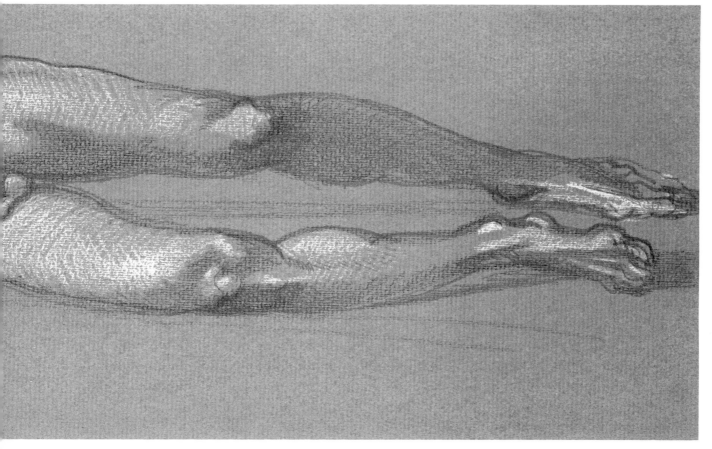

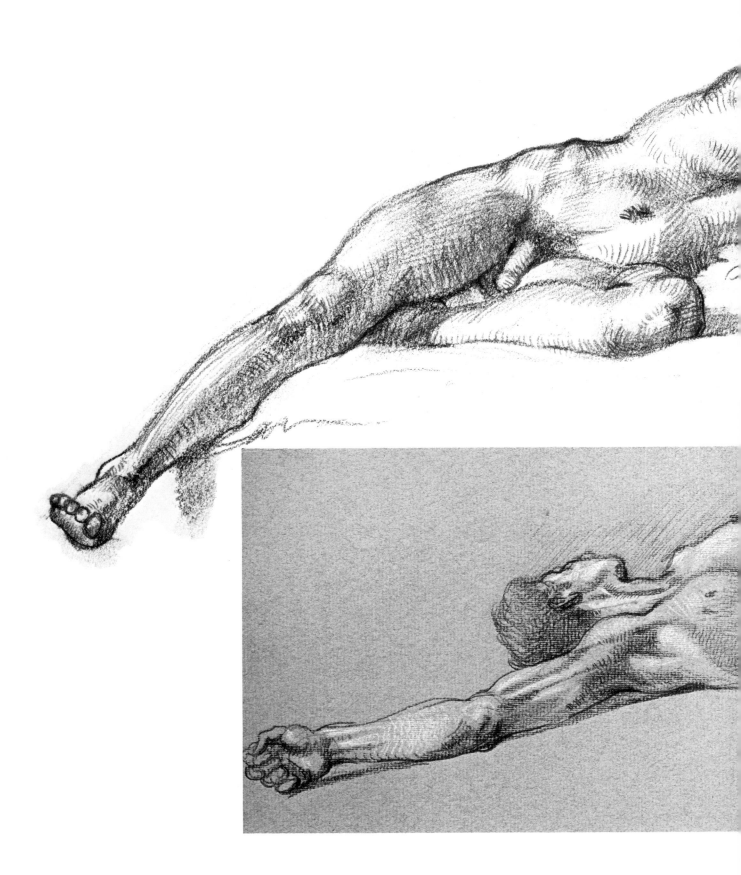

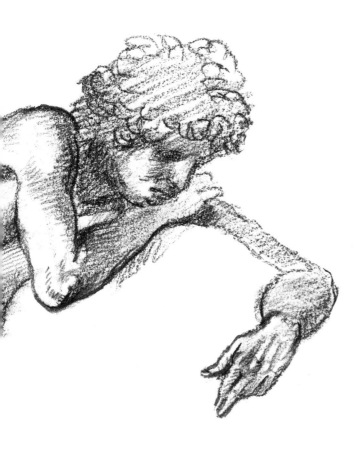

The ribcage and pelvic crest help shape the top silhouette of the torso. The weight of the stomach is pulled down by gravity.

Below: Careful attention is given to drawing the closer hand and foot so as not to draw them too large. They are drawn the same size as normal, keeping their proportions accurate. Yet the foreshortening works, and they project forward.

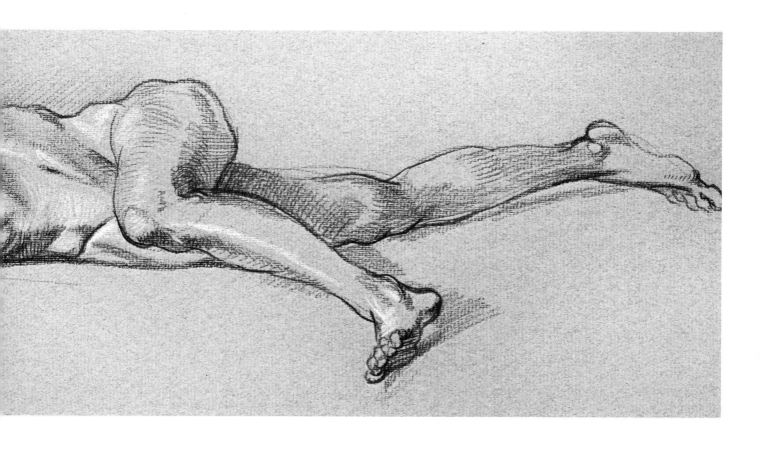

BACK VIEW

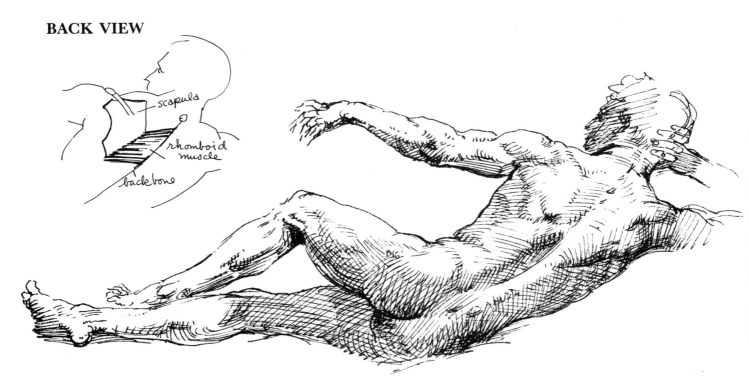

A flat plane is formed by the rhomboid muscle, which appears along the bottom edge of the shoulderblade to the backbone (see diagram). The shape of the shoulderblade can be seen on the back.

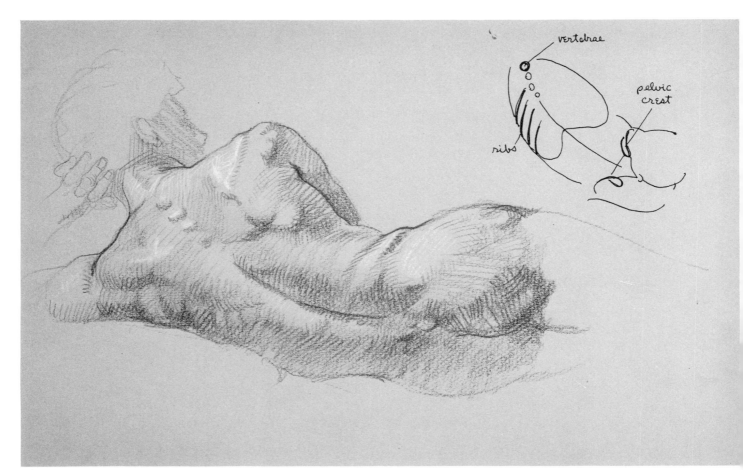

The vertebrae are very pronounced on the back of the neck. The ribs slant down and show from under the trapezius muscle in the center of the back, and the two ends of the pelvic crest can be seen (see diagram).

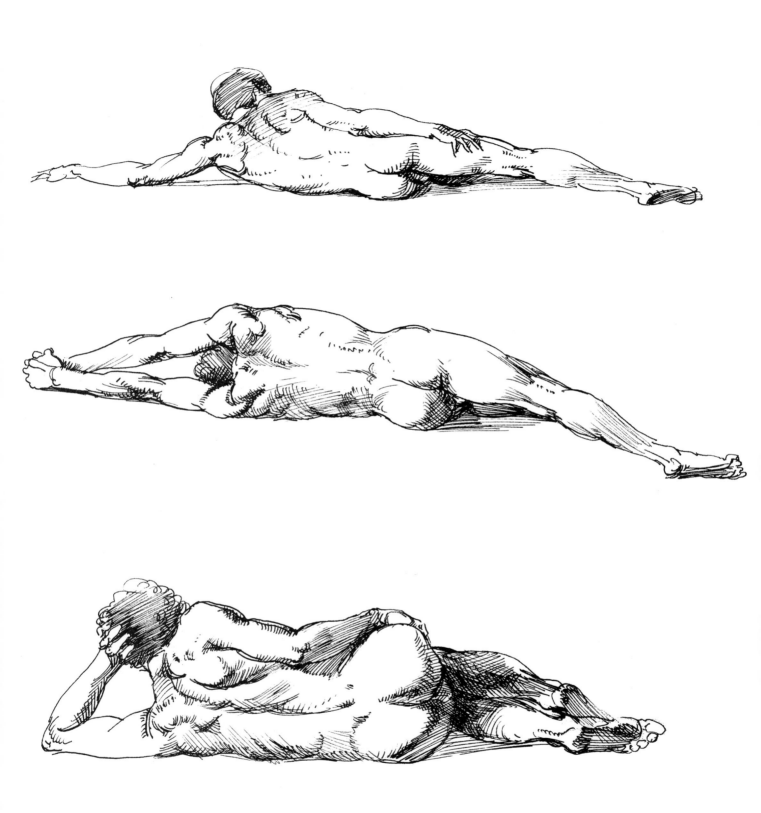

As the position of the arms changes, the shapes of the muscles of the upper back change. The leg positions change the muscles in the lower back to a lesser degree.

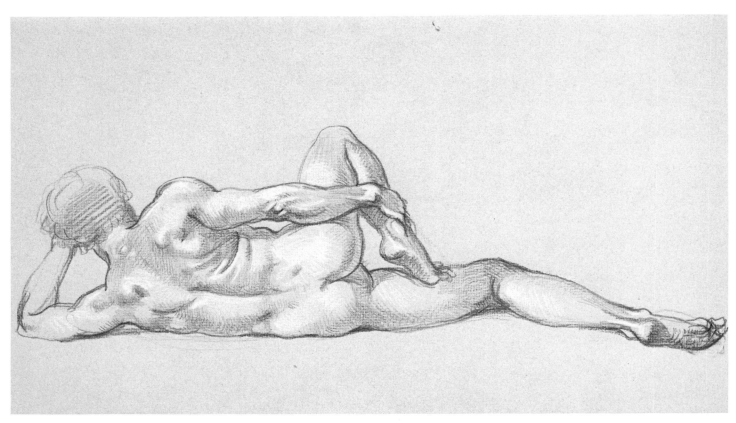

Creases are formed on the torso when the leg is raised and the arm is pulled back. The hips and shoulders are at opposite angles.

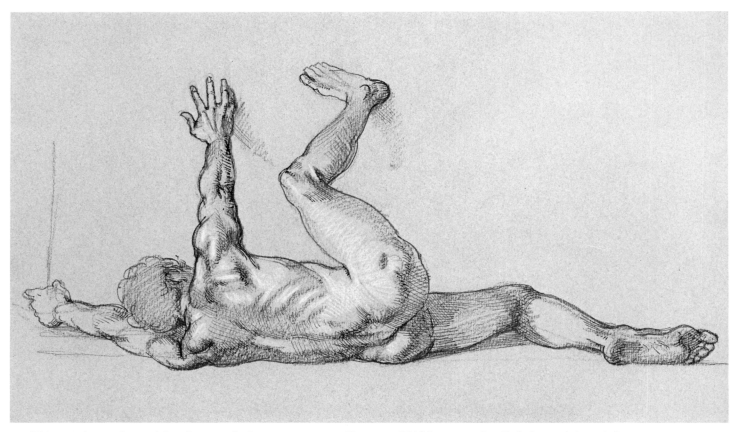

This technique—charcoal drawing reworked with ink—was used by many Old Masters, and really helps explain each form.

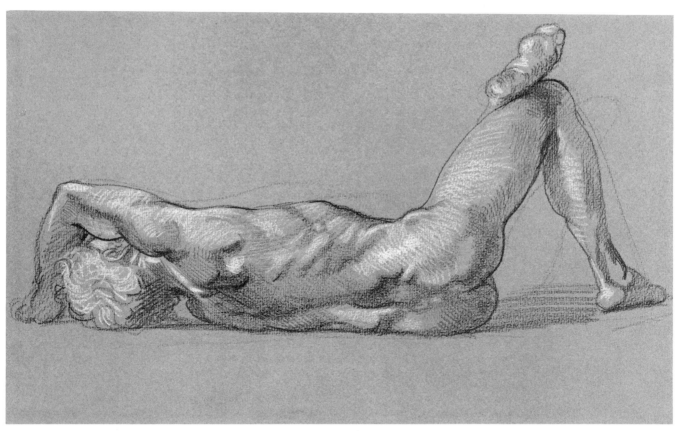

The shape of the ribcage becomes apparent as the body twists. The raised arm pulls the skin taut over the ribs and the muscles.

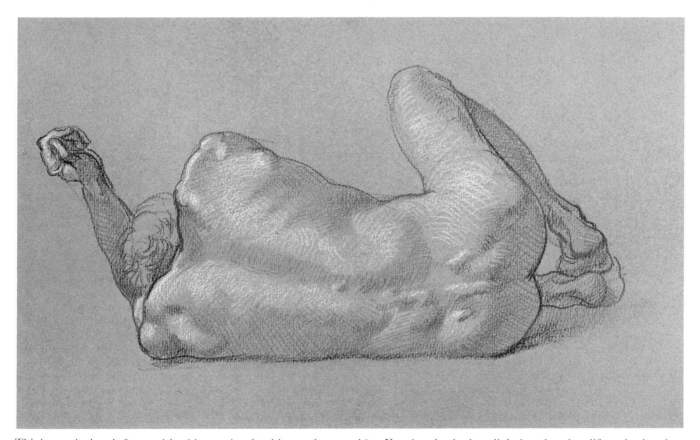

This is a typical male form, with wide massive shoulders and narrow hips. Keeping the shadows light in value gives life to the drawing.

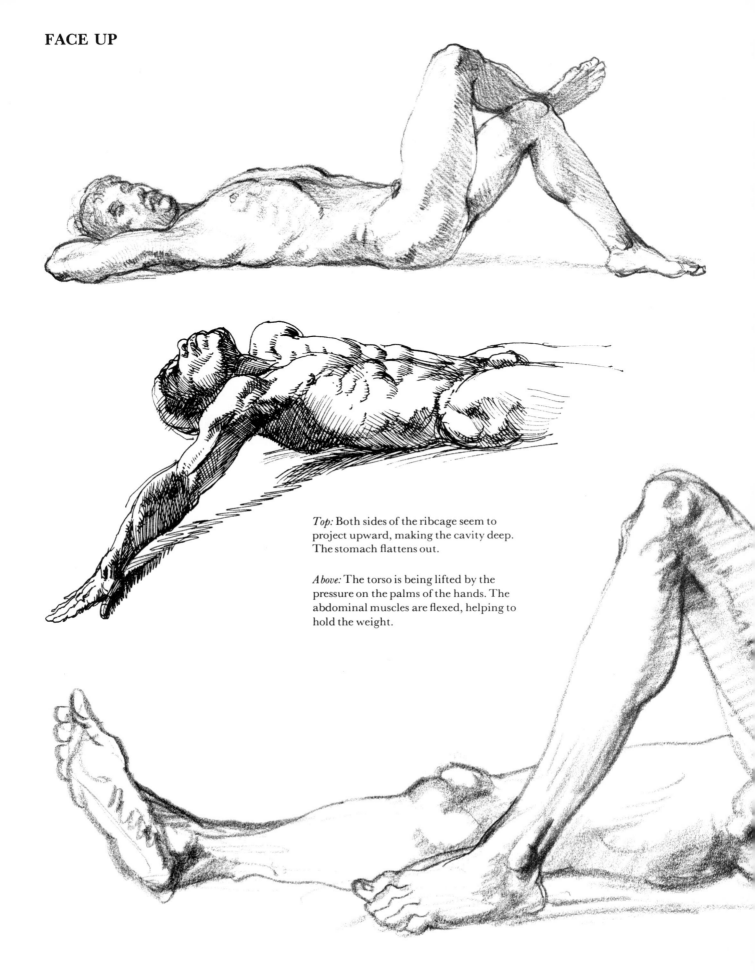

Top: Both sides of the ribcage seem to project upward, making the cavity deep. The stomach flattens out.

Above: The torso is being lifted by the pressure on the palms of the hands. The abdominal muscles are flexed, helping to hold the weight.

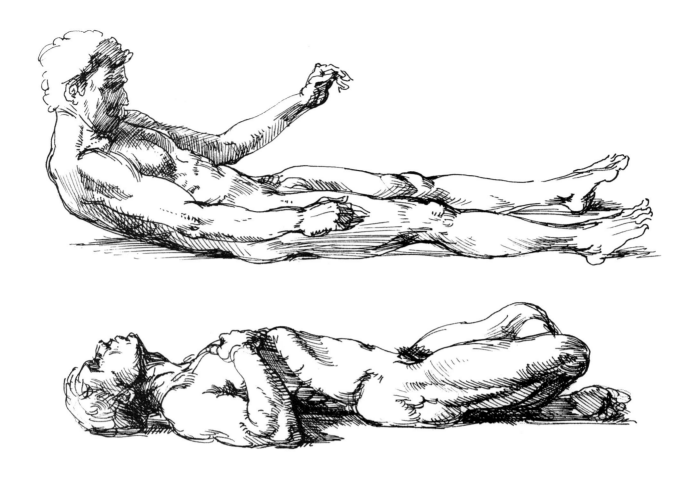

Top: The muscles on the front of the torso and neck strain to lift the body. The tendons of the toes extend, trying to hold the feet down as a balance.

Above: As the chin is lifted, the Adam's apple protrudes on the neck. The sternomastoid muscle runs from behind the ear to the base of the throat.

Below: In this five-minute sketch, the shadow areas were scribbled in after the contour lines were drawn. The dark accents were put in last.

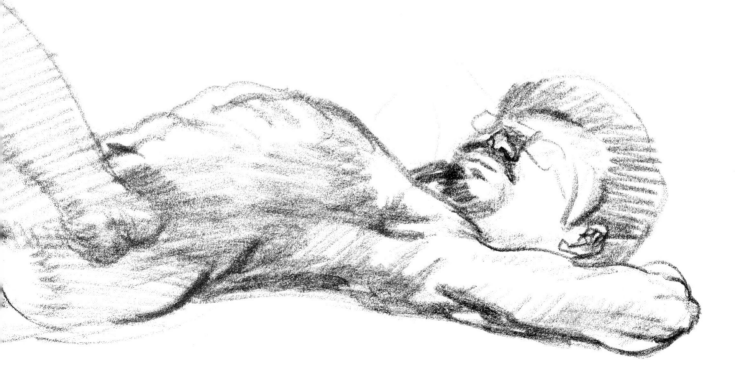

This was a twenty-minute ink sketch over a rough pencil drawing. With the pencil drawing in, the ink drawing can be made more carefully.

Below: the division down the middle of the belly is caused by two long muscles running parallel to each other from the ribcage to the pubic area. When the model lies on his back, the stomach is depressed.

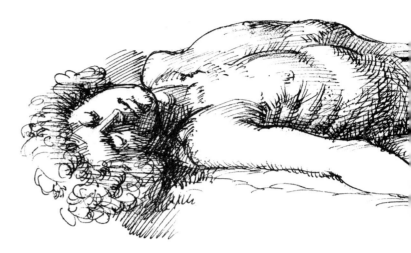

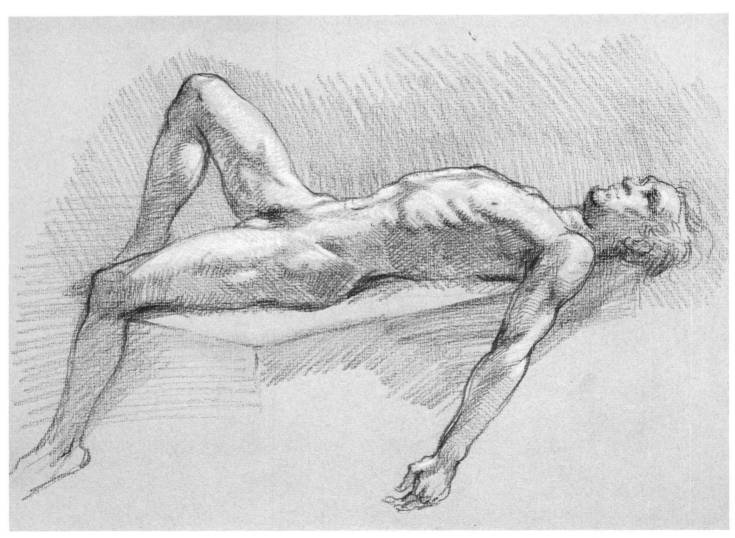

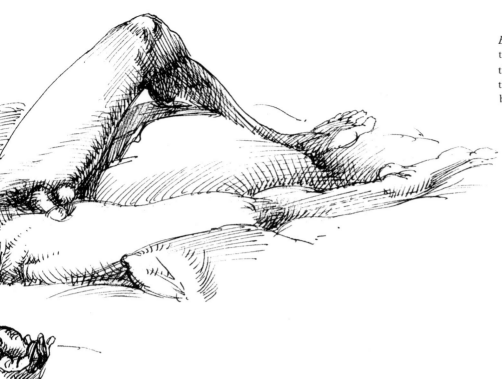

Below : After establishing the torso and arms, it is important to draw the hands and feet together. Then draw the legs connecting the feet with the buttocks:

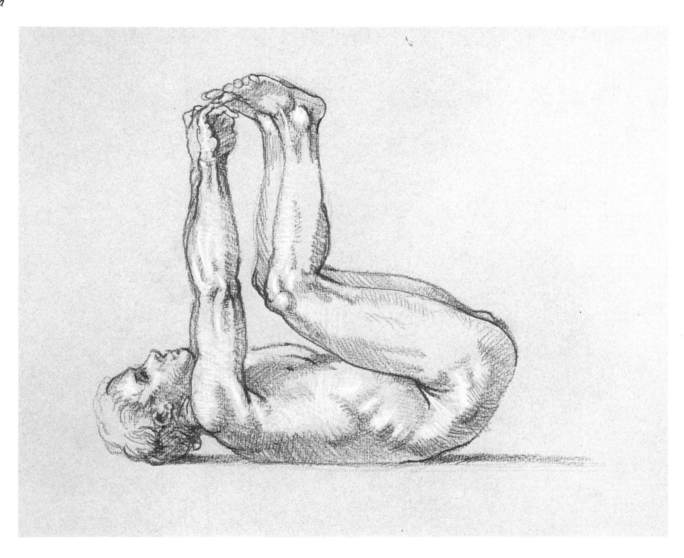

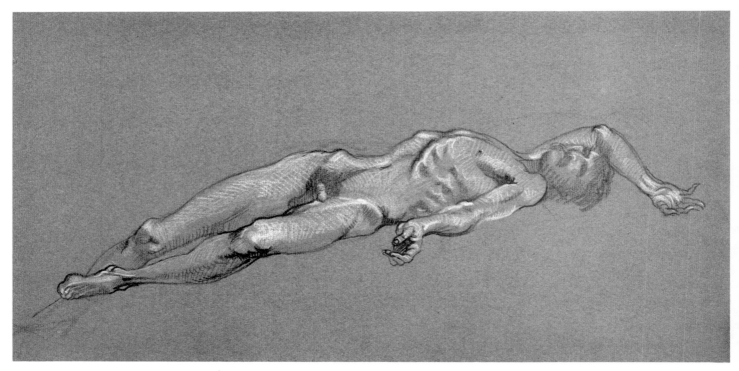

On this tall, thin model, the ribcage and pelvis have little flesh on them and become prominent. The bones at the elbow and knee also seem large.

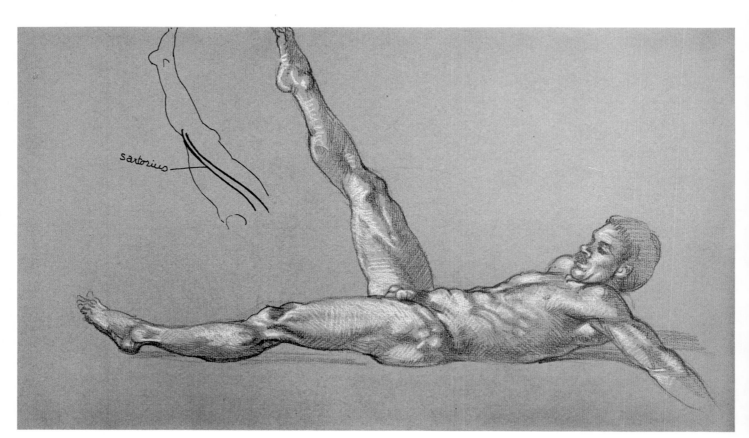

sartorius

The longest muscle in the body is the sartorius. Its diagonal direction across the thigh shows as the right leg is raised (see diagram).

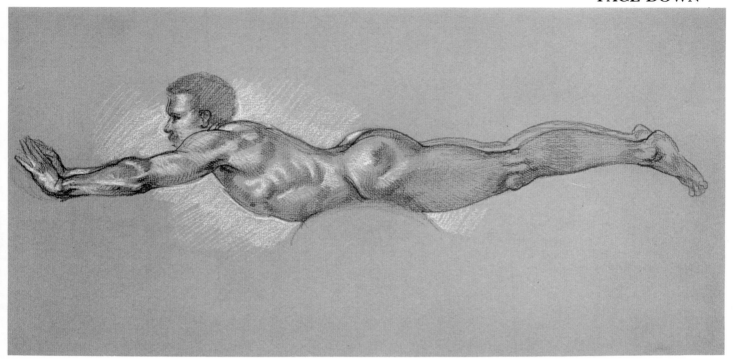

The model is posed in a diving position. The back is arched, and his toes and fingers are extended. The weight is supported in the midsection of the body. This is one way to draw figures suspended in mid air.

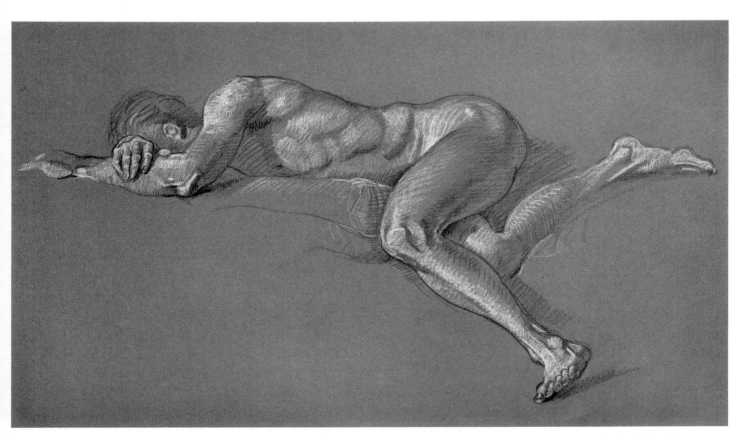

Among the tendons in front of the ankle, two show prominently: one to the big toe, and one to the other four toes. On the left ankle, both can be seen making a ramp shape between the leg and foot. These "extensors," as they are called, raise and point the toes. Other tendons come behind the ankle and insert into the sole of the foot. On the right ankle, another extensor can be seen.

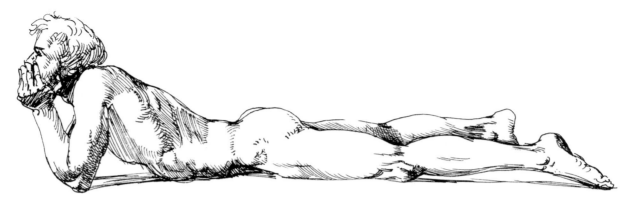

Above: The abdomen and thighs flatten out against the supporting surface from the weight of the body. The buttocks are flexed because of the extended toes.

Above, opposite page: The torso is raised and supported by the arms, making the backbone arch.

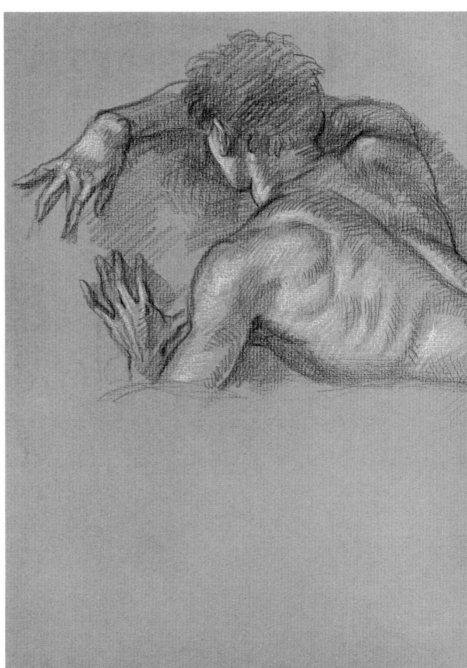

A diffused edge is kept between the figure and the soft supporting surface. The back is arched and the left buttock tightens as it helps to extend the left leg. The left knee is locked, supporting the lower part of the left leg.

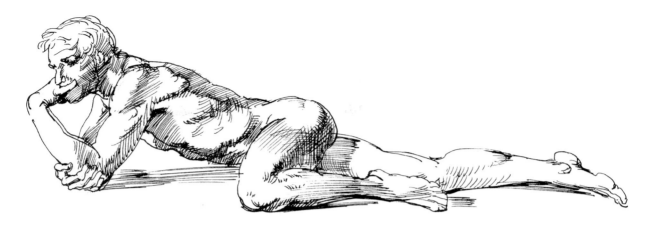

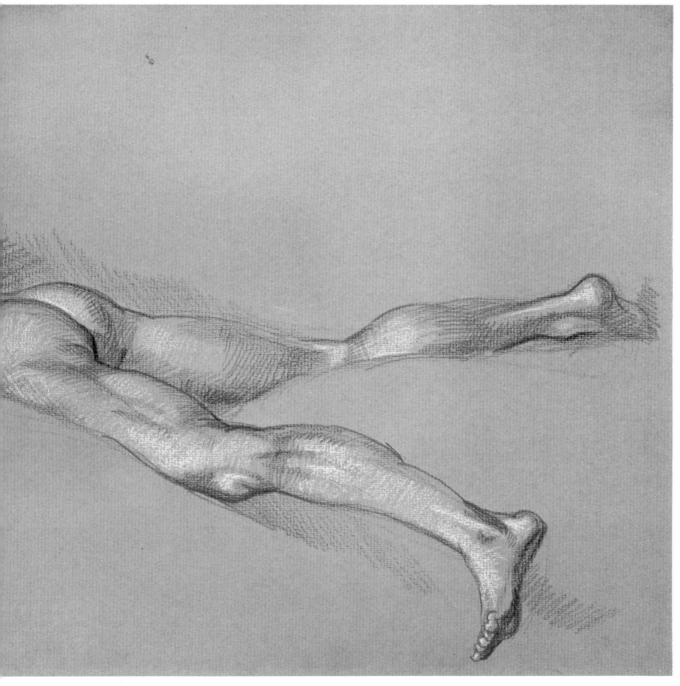

9
THE FORESHORTENED FIGURE

It is important to observe the subject from a distance when drawing the foreshortened figure. Being too close creates a camera-like distortion where the nearest objects appear too large. It is also a good habit to first draw the two extremities of a foreshortened form and then connect them. Starting at one point and drawing out to the other usually ends in a disaster. Establishing the cast shadows becomes extremely important because they push one form in front of another.

Drawing the bottom of the left foot helps explain the direction of the left leg. The strong cast shadow on the arm pushes the right leg forward.

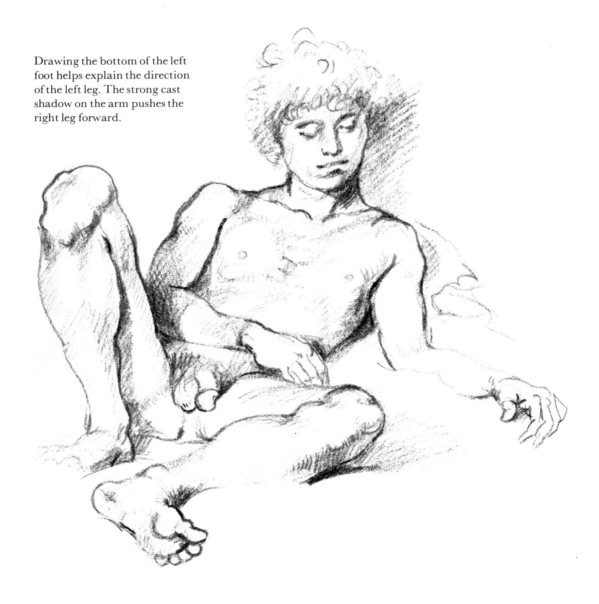

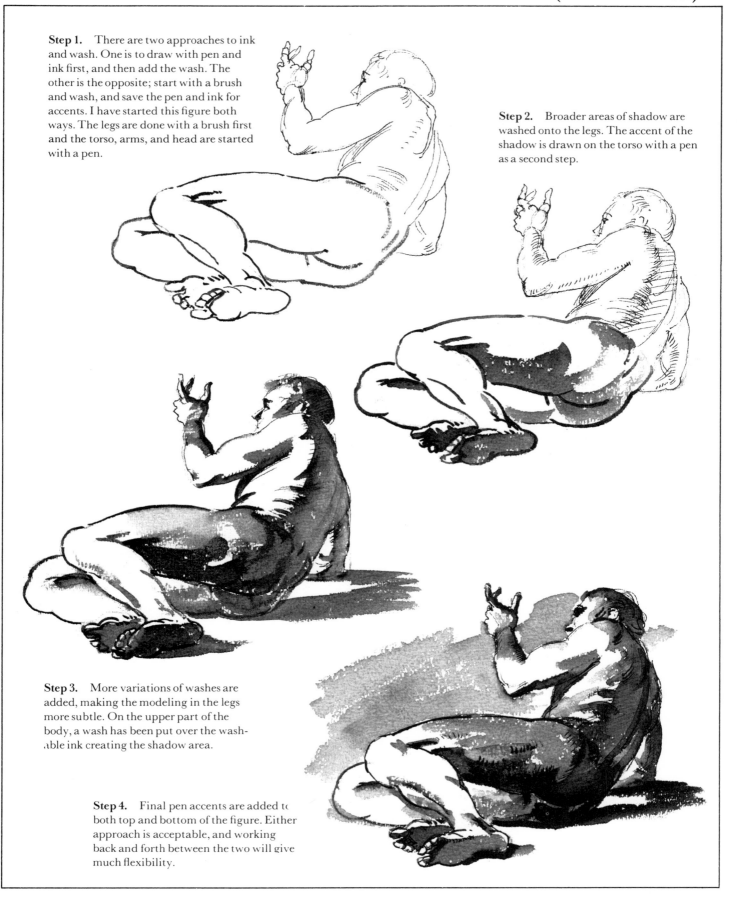

Step 1. There are two approaches to ink and wash. One is to draw with pen and ink first, and then add the wash. The other is the opposite; start with a brush and wash, and save the pen and ink for accents. I have started this figure both ways. The legs are done with a brush first and the torso, arms, and head are started with a pen.

Step 2. Broader areas of shadow are washed onto the legs. The accent of the shadow is drawn on the torso with a pen as a second step.

Step 3. More variations of washes are added, making the modeling in the legs more subtle. On the upper part of the body, a wash has been put over the washable ink creating the shadow area.

Step 4. Final pen accents are added to both top and bottom of the figure. Either approach is acceptable, and working back and forth between the two will give much flexibility.

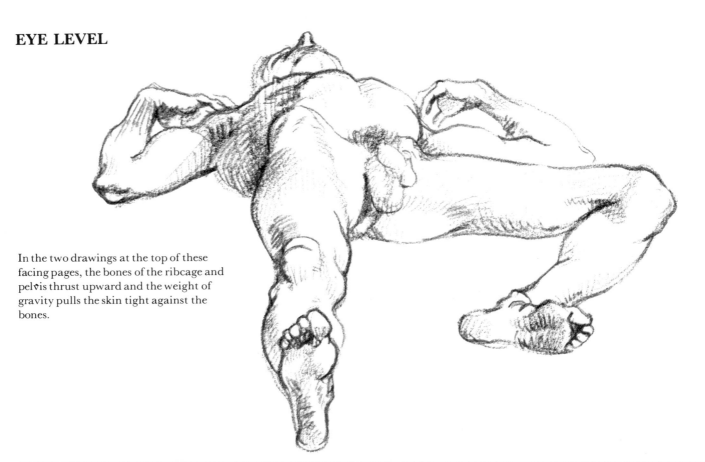

In the two drawings at the top of these facing pages, the bones of the ribcage and pelvis thrust upward and the weight of gravity pulls the skin tight against the bones.

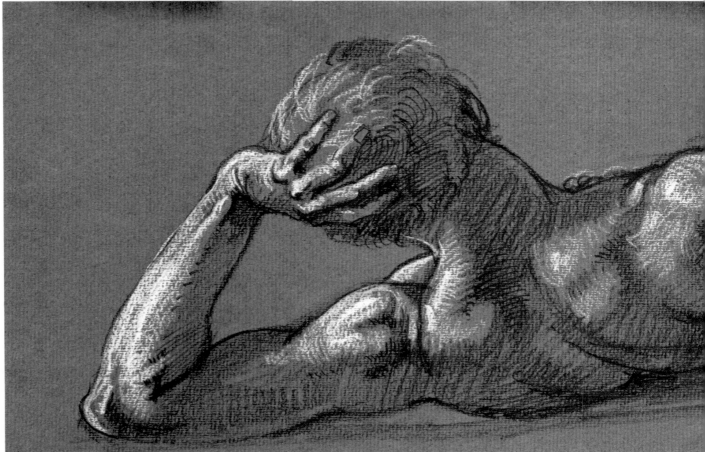

A strong side light helps explain one form in front of another, creating contrasts of dark against light and light against dark.

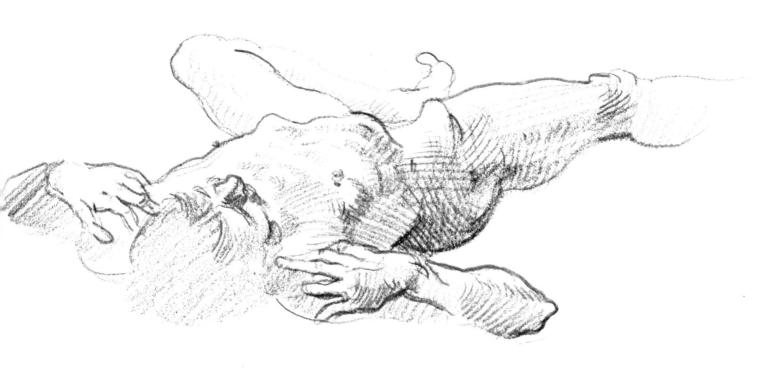

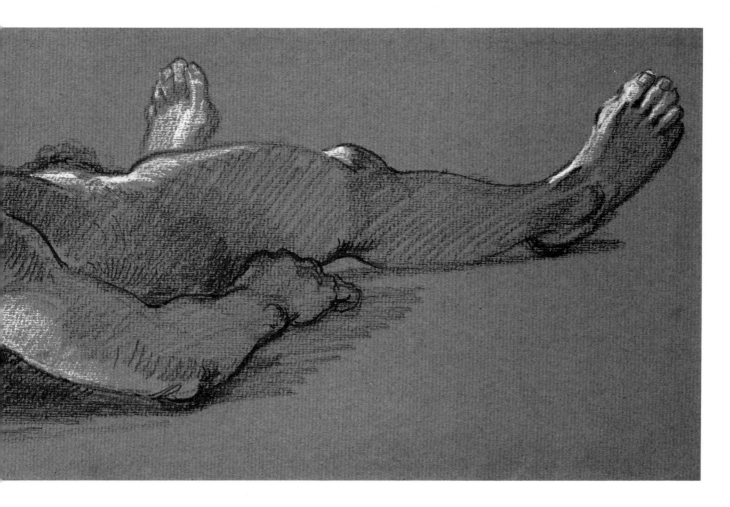

This was a five-minute sketch. The three points of the bent elbow show and the kneecap is evident on both knees. The underside of the left foot reveals the arch on the big-toe side.

Below: Overlapping shapes in the torso put the buttocks well behind the shoulders, creating a telescopic effect because of the sharp perspective (see diagram).

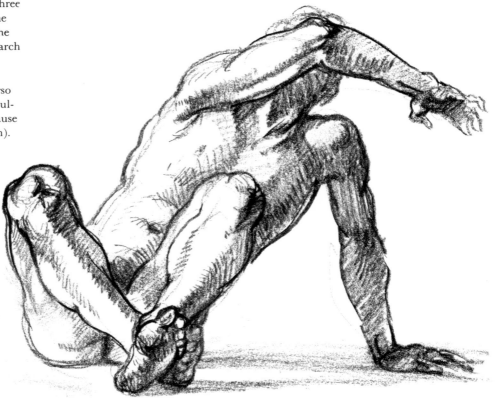

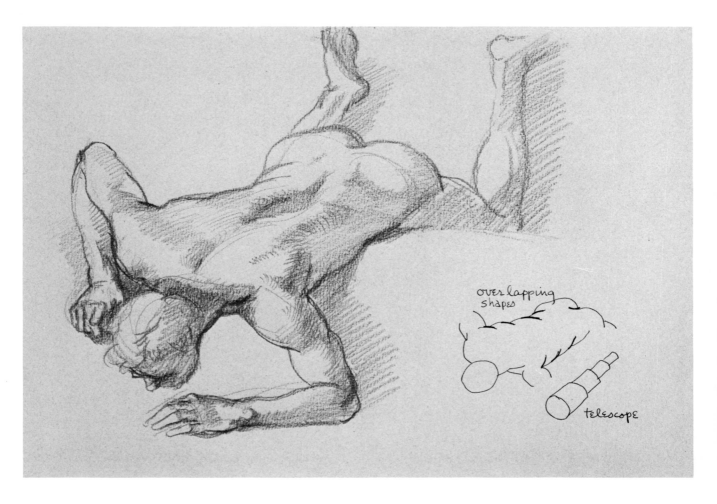

over lapping
shapes

telescope

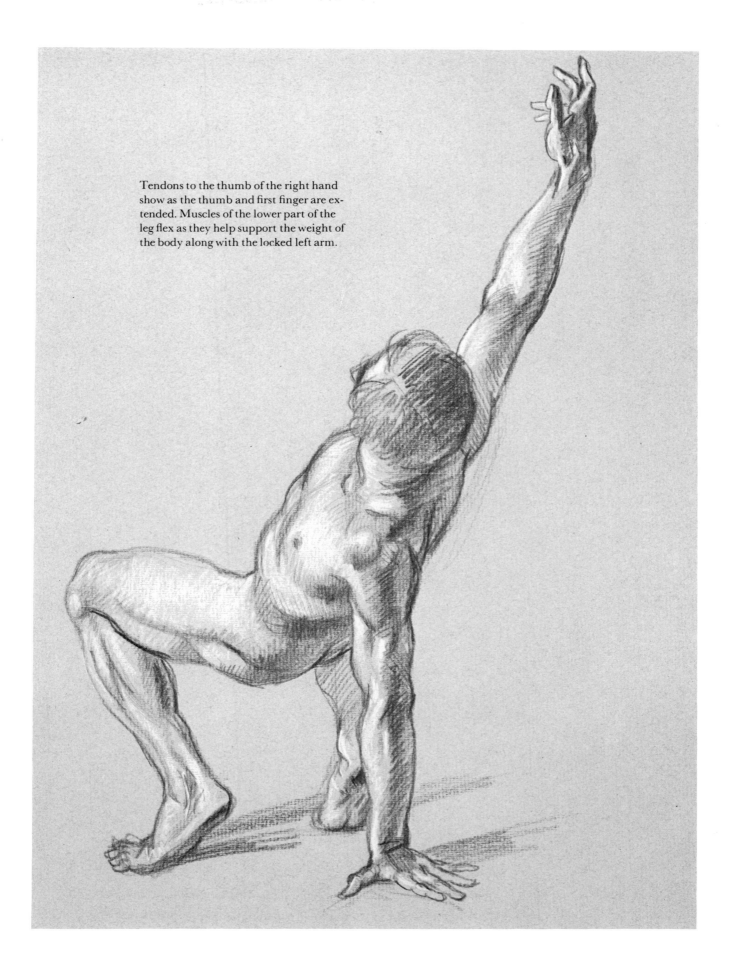

Tendons to the thumb of the right hand show as the thumb and first finger are extended. Muscles of the lower part of the leg flex as they help support the weight of the body along with the locked left arm.

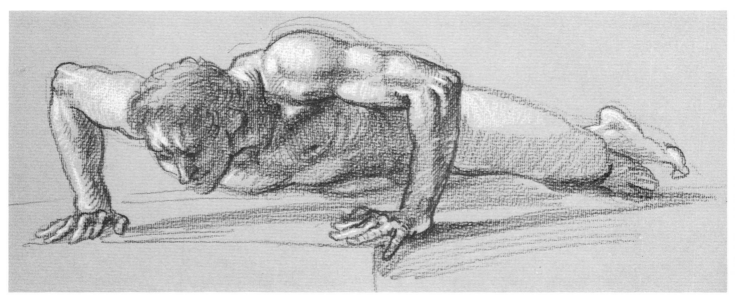

The muscles in the arm flex as they support the body. The head and arms are rendered with more contrast and stronger accents than the legs to bring them into the foreground.

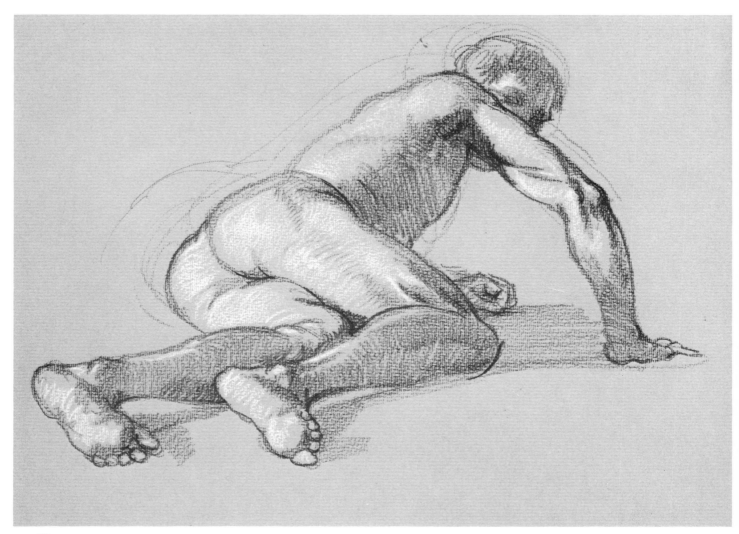

The bottom of the spine can be seen as a small flat plane between the two buttocks. The upper part of the supporting arm shows clearly the triceps on top and its attachment into the elbow and the biceps on the underside.

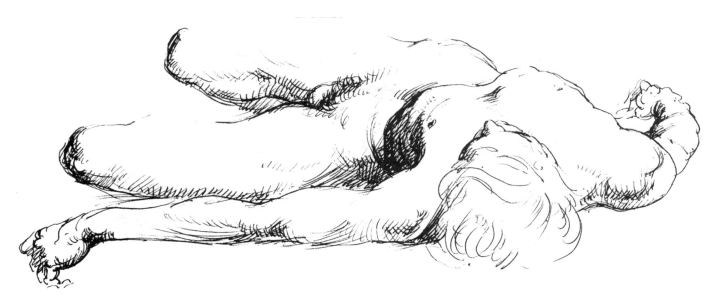

A top view of the ribcage reveals its shape in the foreshortened torso. The pectoralis muscles of the chest attach out into the arms.

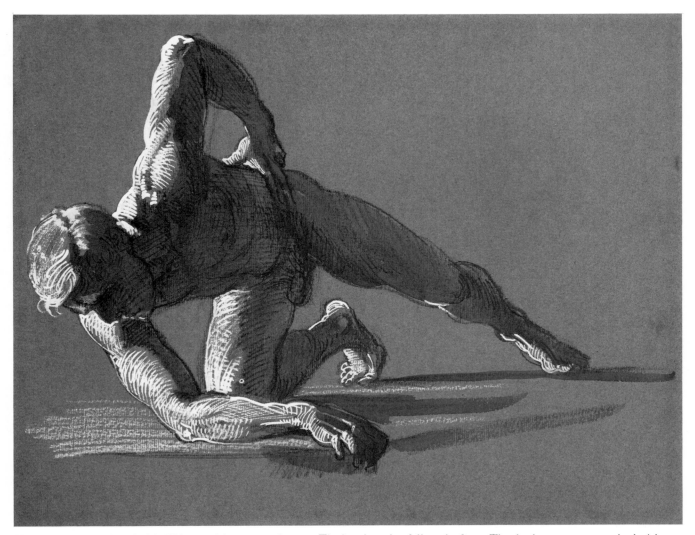

Highlights were painted with Chinese white on toned paper. The brushstrokes follow the form. The shadow area was washed with one tone. Dark accents were added with a pen and ink.

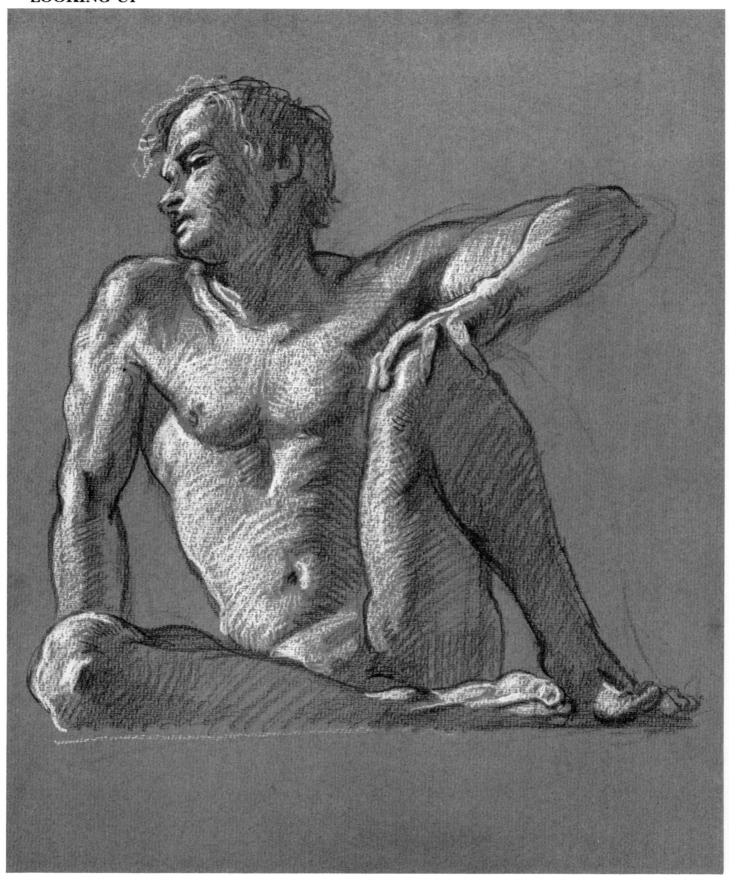

A constant awareness of looking up and under each form is necessary because of the tendency to draw everything at eye level.

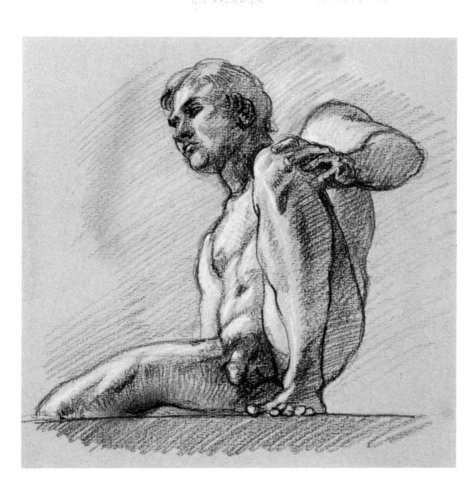

The *V* shape shows under the left kneecap and the curved shinbone. When the light comes from above, all the underplanes are in shadow.

Below: The relaxed stomach bulges in the seated position. The serratus muscles on the top of the ribs show under the latissimus dorsi as it rises up the side of the torso and attaches into the arm. (See diagram on page 88 for the location of the latissimus dorsi.)

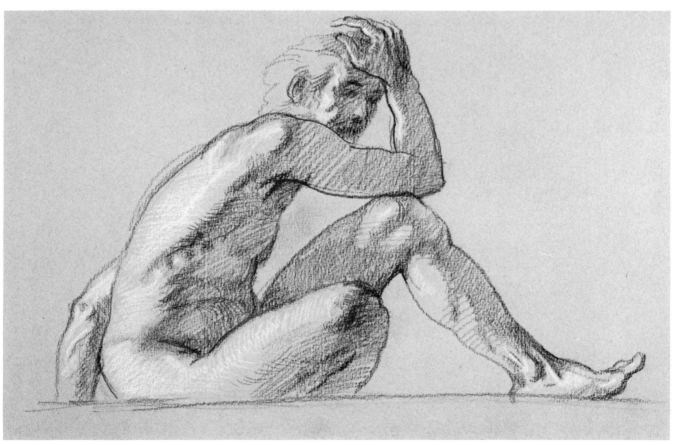

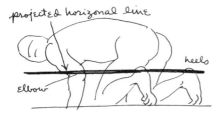

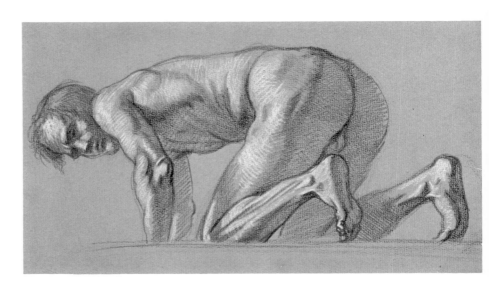

Any kind of head measurement is impossible in the foreshortened figure. Finding forms that intersect horizontal or vertical lines can help. For instance, the elbow and both heels are on the same line (see diagram).

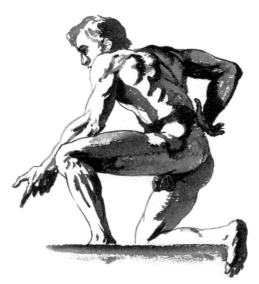

This is a wash drawing with a brush. The figure was first drawn in with light tones. The dark accents were added after the initial wash was dry.

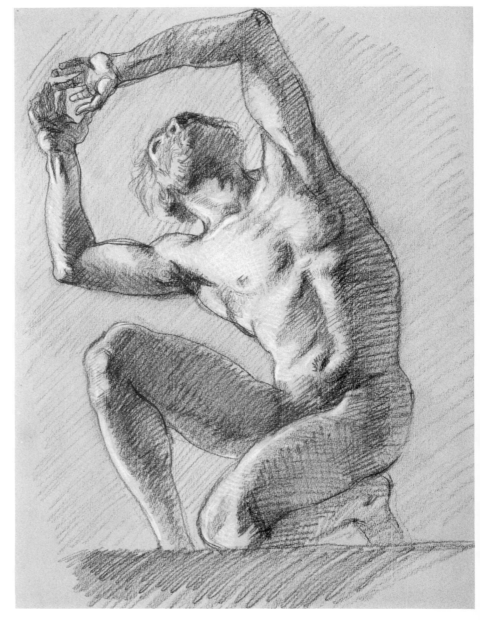

The cavity of the ribcage is explained by a dark shadow. The rib attachments on the chest are evident and the clavicles angle back. On the right knee, the outline of the top inside bone is round and high, the outside bone of the left knee is sharper. The kneecap sits in between these two bones.

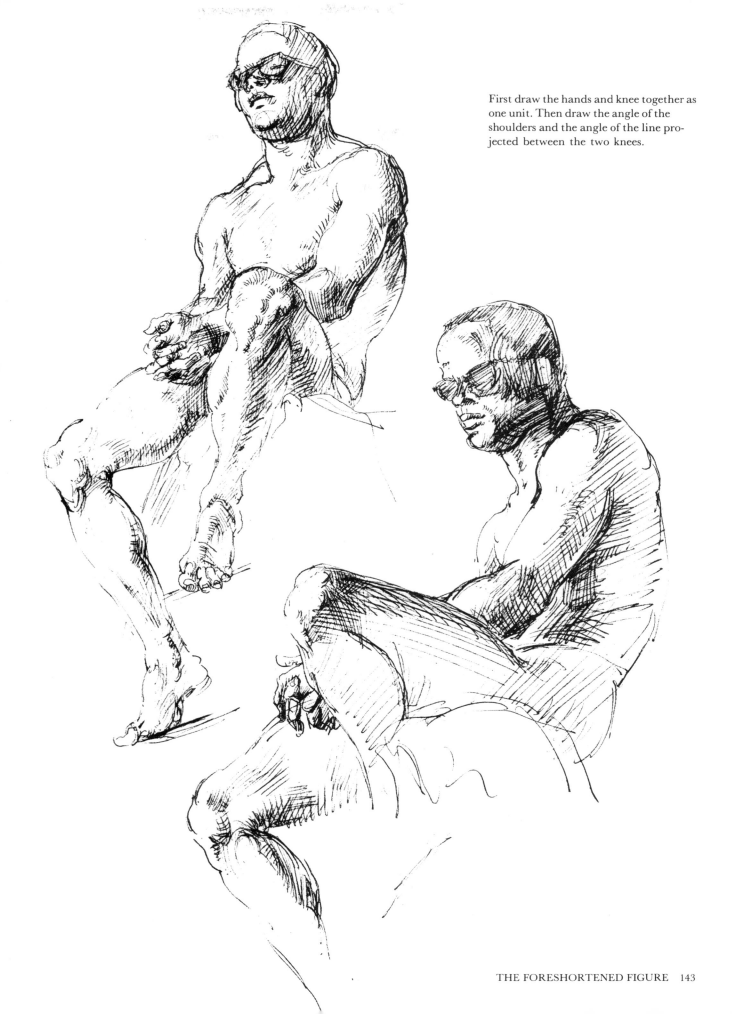

First draw the hands and knee together as one unit. Then draw the angle of the shoulders and the angle of the line projected between the two knees.

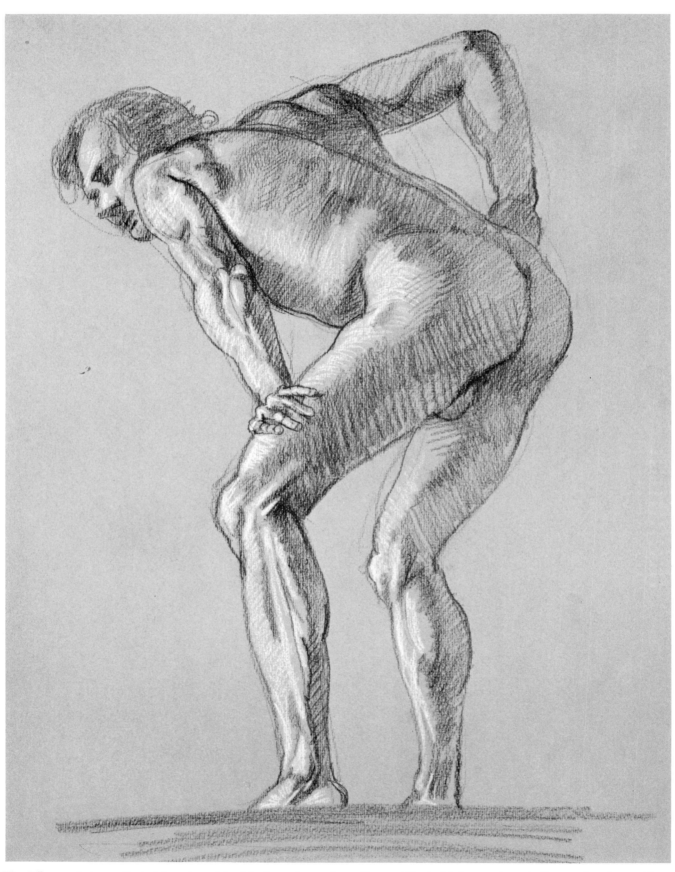

The difference between the inside and outside of the lower leg can be easily seen. The inside has two large bulky muscles, the outside has long stringy muscles that go from the knee down to the foot, separating around the ankle.

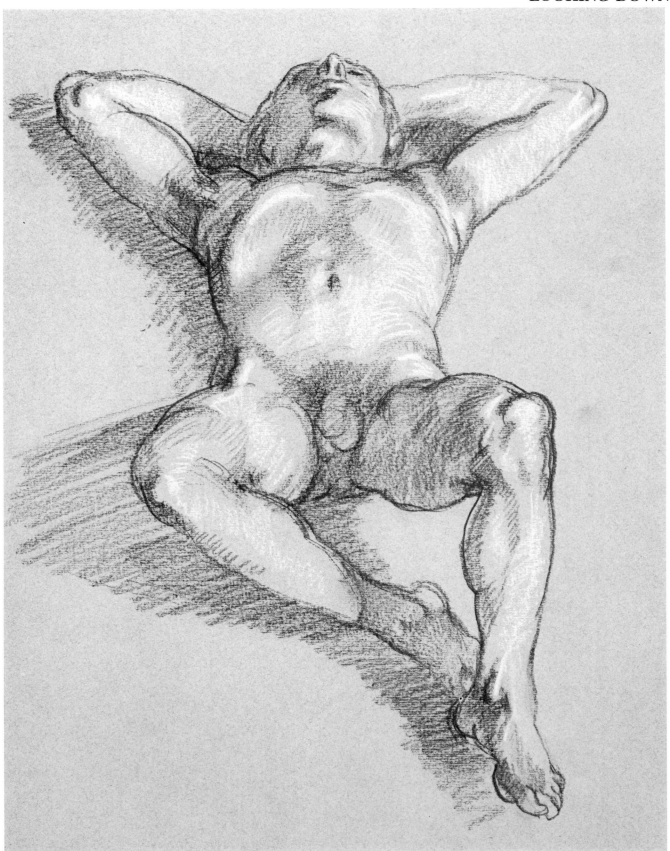

Drawing the figure from above or from below is much the same problem. The cast shadow suggests that the figure is lying on his back.

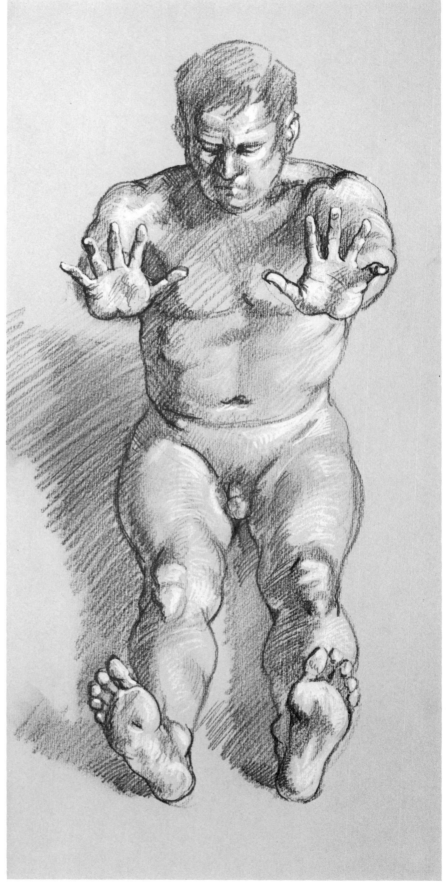

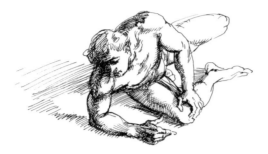

Again, cast shadows and overlapping lines are the two most useful tools in drawing a foreshortened figure.

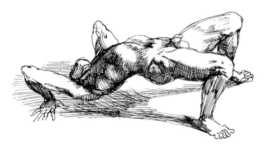

The viewpoint here is looking down on a contorted pose. The torso is suspended by the two hands and head as well as the feet. The back is arched and legs are spread to keep balance.

Right: The soles of the feet show the arch on the inside and straight outside. The figure, viewed from above, is in a seated position with arms and legs extended forward.

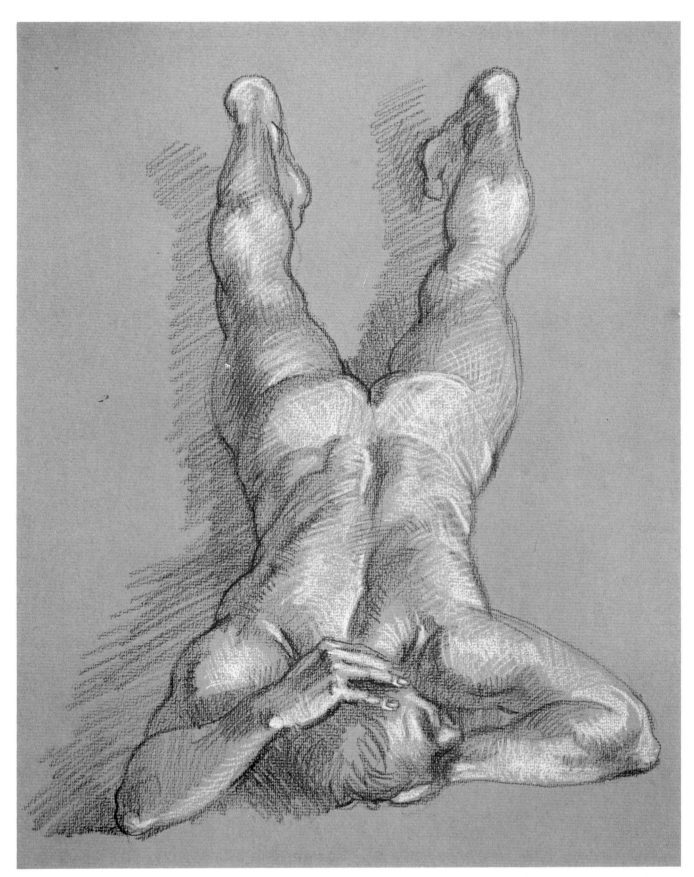

Two columns of muscles, the sacrospinalis, rise out of the base of the spine and insert up into the back. Creases form on the shoulders when the arms are raised.

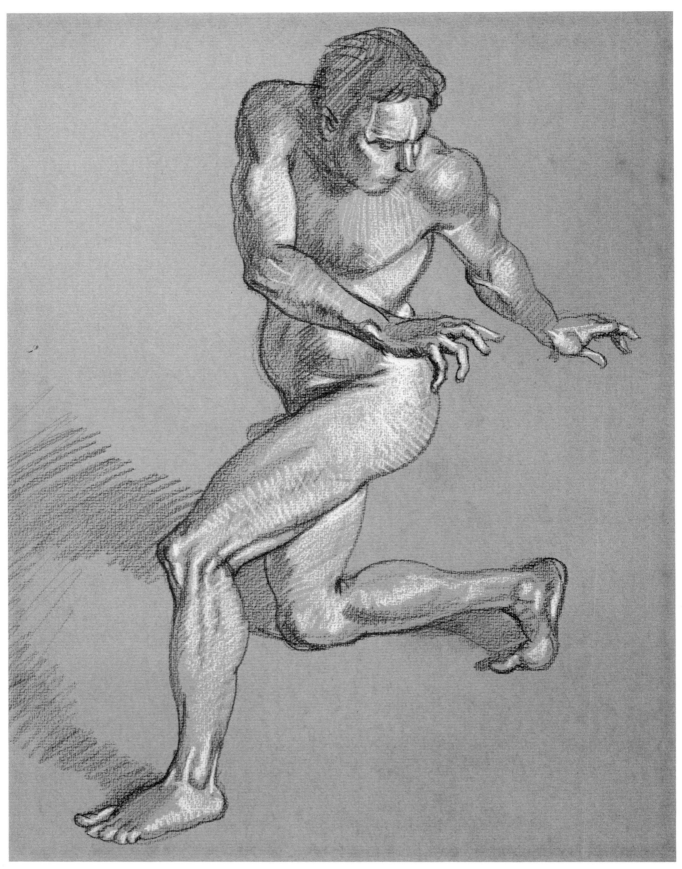

The hand is brought forward by the strong contrast of light and dark. The hips and shoulders twist in opposite directions as well as slant at opposite angles.

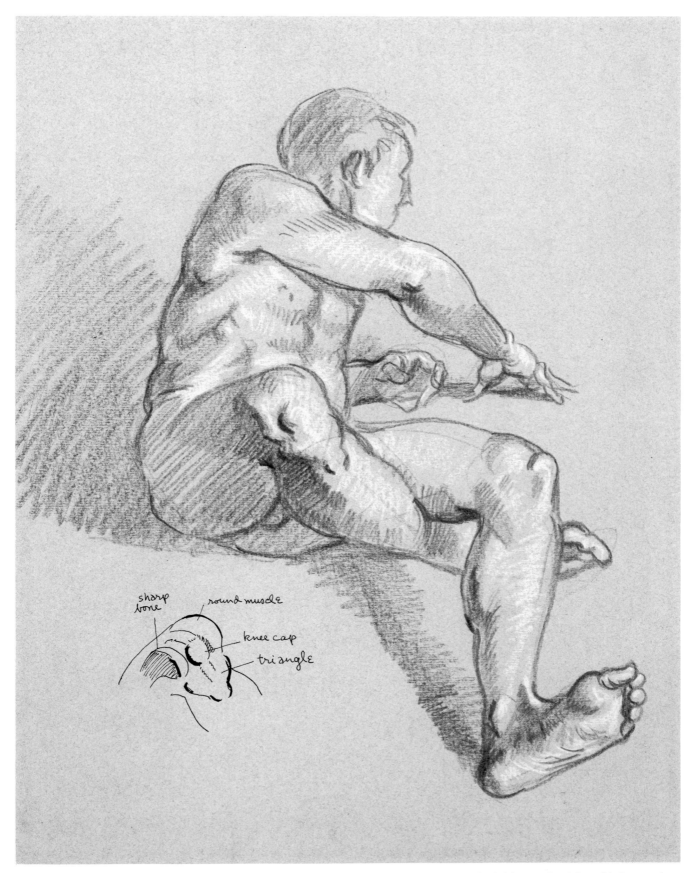

The shapes of the knee are well explained in this drawing (see diagram). The shadow cast by the left leg on the right ankle locates the left leg in space and shows where the two legs cross.

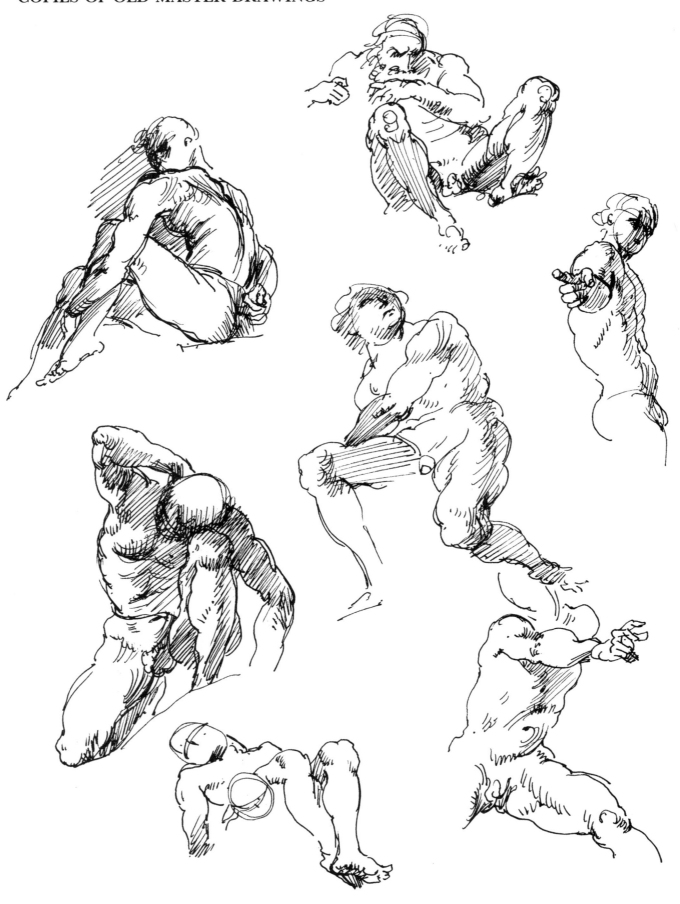

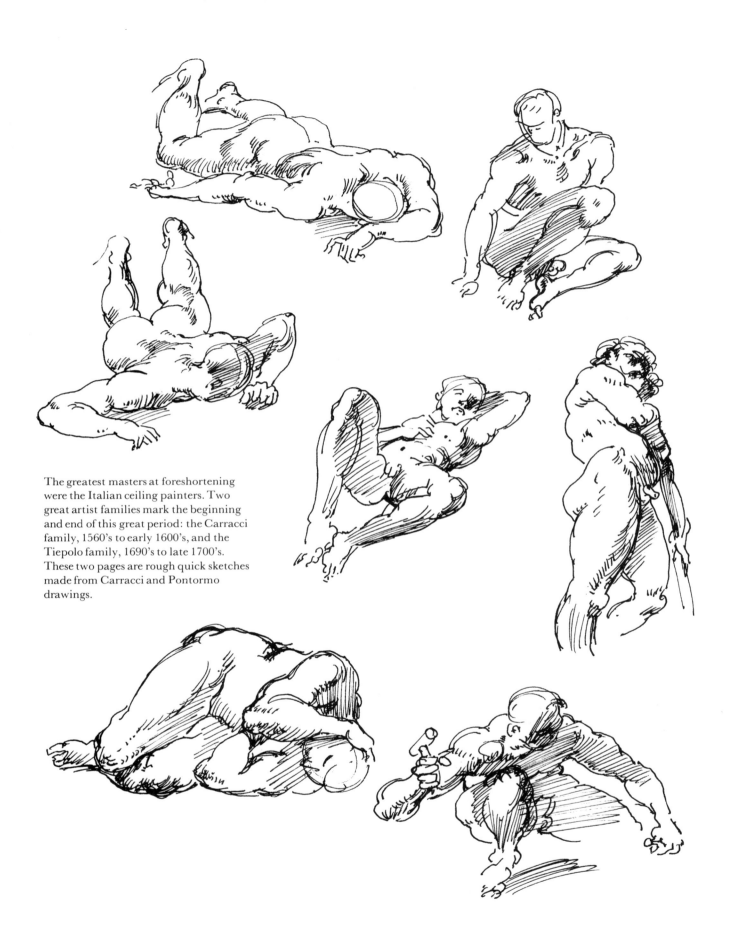

The greatest masters at foreshortening
were the Italian ceiling painters. Two
great artist families mark the beginning
and end of this great period: the Carracci
family, 1560's to early 1600's, and the
Tiepolo family, 1690's to late 1700's.
These two pages are rough quick sketches
made from Carracci and Pontormo
drawings.

10
THE FIGURE IN ACTION

To make a figure move, it must be drawn freely and not be over-rendered. There are three points of action that are the most expressive: the preparation for the movement; the actual movement; and the follow-through. Michelangelo was a master of the first and third points. Rubens was the great master of the actual movement.

The first essential thing to get down is the key line of the attitude. It is important to keep the figure off balance in order to make the action believable.

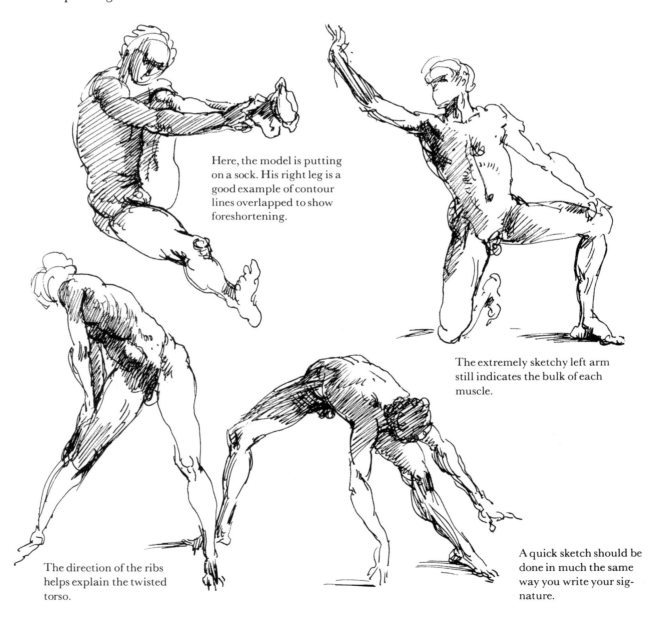

Here, the model is putting on a sock. His right leg is a good example of contour lines overlapped to show foreshortening.

The extremely sketchy left arm still indicates the bulk of each muscle.

The direction of the ribs helps explain the twisted torso.

A quick sketch should be done in much the same way you write your signature.

Here are two different stages of a model putting on his sweater. Attention is given to the area between the light and shadow where the inside forms are explained.

The foreshortened legs are explained by overlapping lines.

This two-minute sketch was made as the model put on pants. Action was stopped and held at the position that seemed most desirable.

The cast shadow on the chest suggests foreshortening.

Memorizing the contour shapes of each section of the body helps when drawing a quick pose.

The ribcage and pelvis are evident here. The darker areas come forward; the light areas recede.

BACK VIEW

The "key" line of the attitude or pose is the sweeping line from the bottom of the right leg to under the right arm.

The model's weight and balance is maintained by his outstretched right hand.

This sketch gives about as much information as needed in order to reconstruct the pose to make a finished drawing.

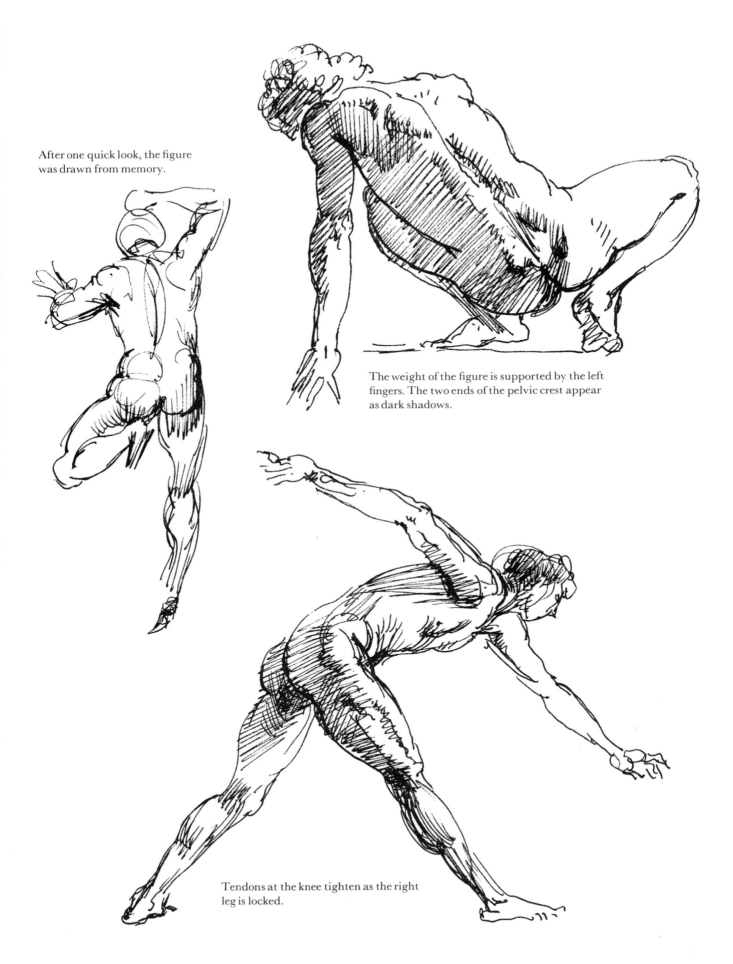

After one quick look, the figure
was drawn from memory.

The weight of the figure is supported by the left
fingers. The two ends of the pelvic crest appear
as dark shadows.

Tendons at the knee tighten as the right
leg is locked.

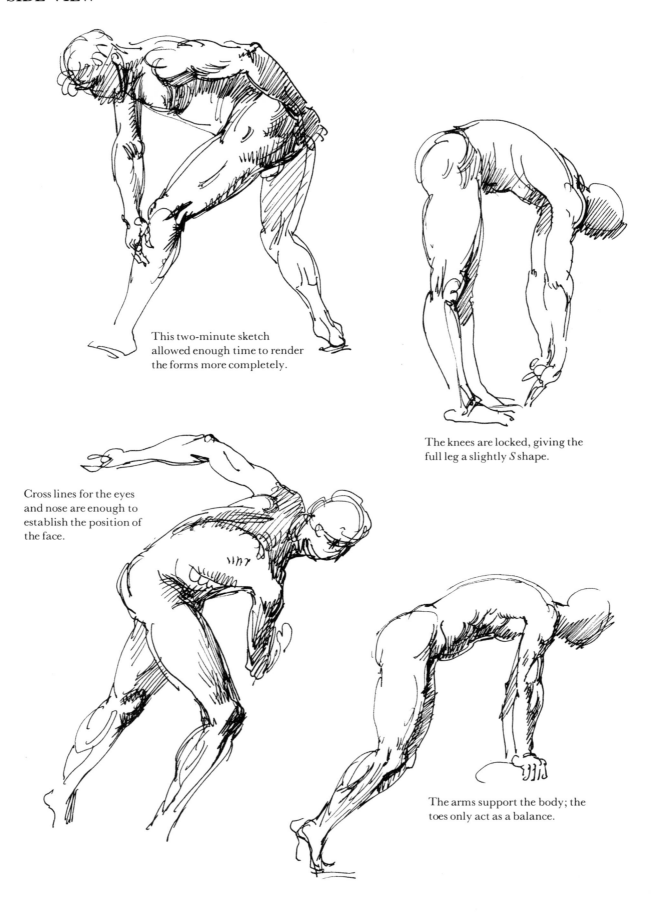

This two-minute sketch allowed enough time to render the forms more completely.

The knees are locked, giving the full leg a slightly *S* shape.

Cross lines for the eyes and nose are enough to establish the position of the face.

The arms support the body; the toes only act as a balance.

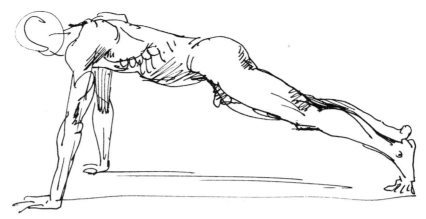

The figure is drawn with schematic shapes representing muscle and bone forms.

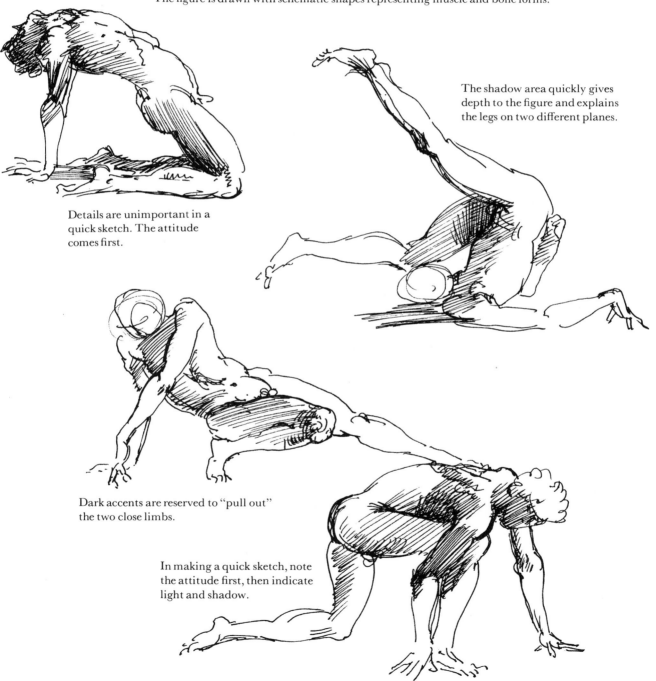

Details are unimportant in a quick sketch. The attitude comes first.

The shadow area quickly gives depth to the figure and explains the legs on two different planes.

Dark accents are reserved to "pull out" the two close limbs.

In making a quick sketch, note the attitude first, then indicate light and shadow.

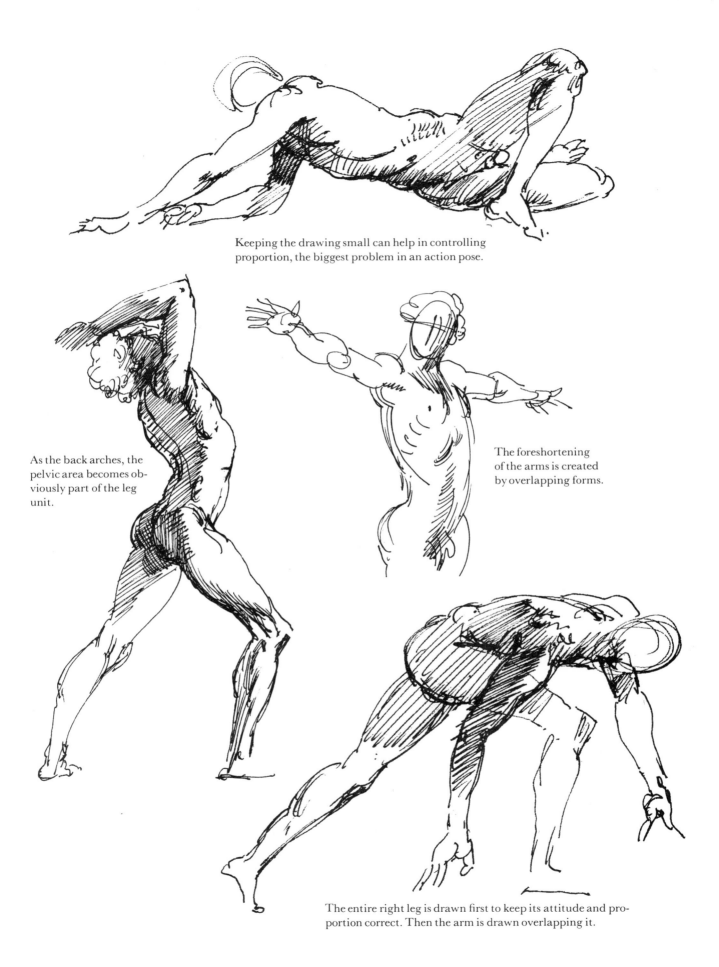

Keeping the drawing small can help in controlling proportion, the biggest problem in an action pose.

As the back arches, the pelvic area becomes obviously part of the leg unit.

The foreshortening of the arms is created by overlapping forms.

The entire right leg is drawn first to keep its attitude and proportion correct. Then the arm is drawn overlapping it.

SUGGESTED READING

Goldscheider, Ludwig. *Michelangelo Drawings.* 2nd ed. New York and London: Phaidon, 1966.

Held, Julius S. *Rubens: Selected Drawings.* 2 vols. New York and London: Phaidon, 1959.

Judson, J. Richard. *Drawings of Jacob De Gheyn II.* New York: Grossman, 1973.

Marsh, Reginald. *Anatomy for Artists.* Dover, 1970.

Rearick, J.C. *The Drawings of Pontormo.* Harvard University Press.

Richer, Paul. *Artistic Anatomy.* Translated and edited by Robert Beverly Hale. New York: Watson-Guptill, 1971. London: Pitman, 1973.

Sheppard, Joseph. *Anatomy: A Complete Guide for Artists.* New York: Watson-Guptill, 1975. London: Pitman, 1975.

Sheppard, Joseph. *Drawing the Female Figure.* New York: Watson-Guptill, 1975. London: Pitman, 1975.

Edited by Bonnie Silverstein
Designed by Bob Fillie
Set in 11 point Baskerville by Publishers Graphics Inc.
Printed and bound by Interstate Book Manufacturers